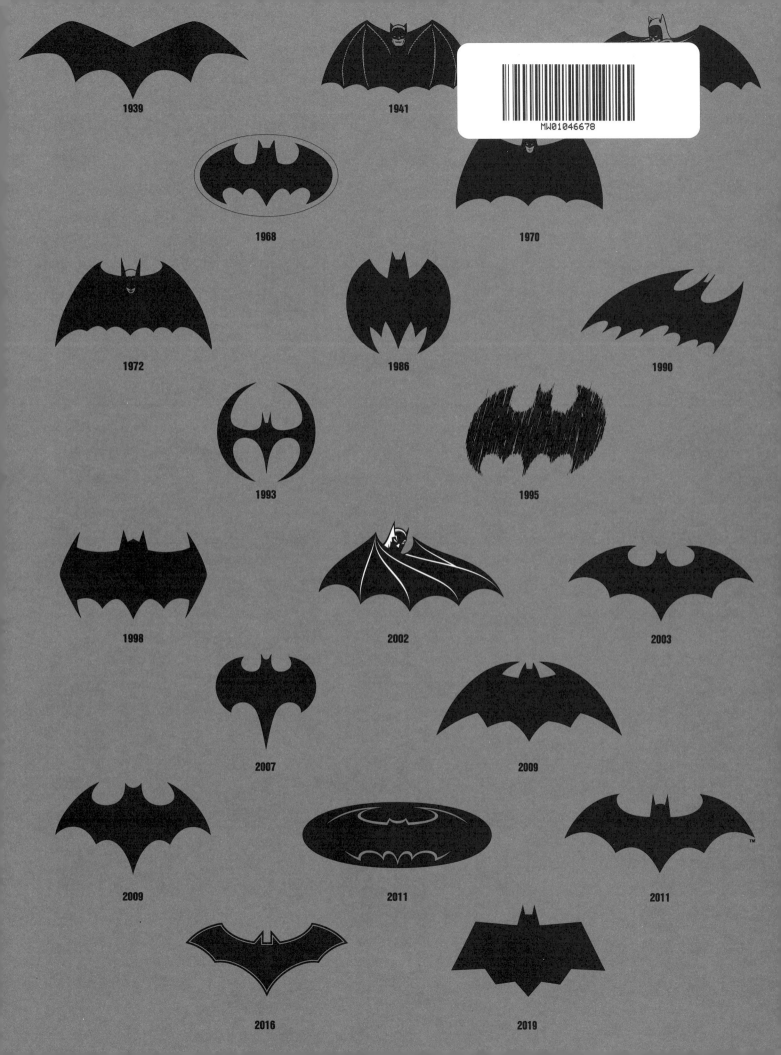

1939

1941

1968

1970

1972

1986

1990

1993

1995

1998

2002

2003

2007

2009

2009

2011

2011

2016

2019

BATMAN

100

GREATEST MOMENTS

HIGHLIGHTS FROM THE HISTORY OF THE DARK KNIGHT

BATMAN

100

GREATEST MOMENTS

HIGHLIGHTS FROM THE HISTORY OF THE DARK KNIGHT

ROBERT GREENBERGER

chartwell
books

Brimming with creative inspiration, how-to
projects, and useful information to enrich your
everyday life, quarto.com is a favorite destination
for those pursuing their interests and passions.

First published in 2019 by Chartwell Books, an imprint of The Quarto Group,
142 West 36th Street, 4th Floor, New York, NY 10018, USA
T (212) 779-4972 F (212) 779-6058 www.Quarto.com

This edition published with permission of and by agreement with DC Entertainment
2900 W. Alameda Ave, Burbank CA 91505, USA

Chartwell Books are also available at discount for retail, wholesale, promotional, and bulk purchase. For details, contact the Special Sales Manager by email at specialsales@quarto.com or by mail at The Quarto Group, Attn: Special Sales Manager, 100 Cummings Center Suite 265D, Beverly, MA 01915, USA.

10 9 8 7 6 5 4 3 2 1

ISBN: 978-0-7858-3873-9

Editor: Michelle Faulkner
Editorial Project Manager: Leeann Moreau
Cover and Book Designer: Anna D. Puchalski
Design Assistant: Steven Puchalski
Project Editor: Su Wu

Library of Congress Cataloging-in-Publication Data
Names: Greenberger, Robert, author. Title: Batman: 100 greatest moments : highlights from the history of the Dark Knight / Robert Greenberger.
Description: New York : Chartwell Books, [2019] | Series: 100 greatest moments of DC Comics |
"Superman created by Jerry Siegel and Joe Shuster. Supergirl based on characters created by Jerry Siegel and Joe Shuster, by special arrangement with the Jerry Siegel family. Batman created by Bob Kane with Bill Finger. Wonder Woman created by William Moulton Marston."
Library of Congress Control Number: 2020937862 | ISBN 978-0-7858-3873-9
Subjects: LCSH: Batman (Fictitious character)--Comic books, strips, etc.--History. | Batman (Comic strip)--History. | DC Comics, Inc.--History.
Classification: LCC PN6728.B36 G7325 2019 | DDC 741.5/973--dc23 LC record available at https://lccn.loc.gov/2019019481

Printed in China

All identification of writers and artists in this book utilized information provided by the Online Grand Comics Database.

Author's Note

Once more, my longtime friend and ace researcher John Wells kept me honest and accurate, providing insight. This time, in addition to the social media input from fans around the world, I also received help from writers Michael Eury, Jim Beard, and John Trumbull.

CONTENTS

INTRODUCTION

HE'S CALLED THE DARK KNIGHT, THE CAPED CRUSADER, THE GOTHAM GUARDIAN, THE WORLD'S GREATEST DETECTIVE, THE WORLD'S GREATEST ESCAPE ARTIST. HE'S A FATHER, A LOVER, A FRIEND, AND AN ALLY. AT HIS CORE, THOUGH, HE IS AN ANGRY LITTLE BOY WHO LOST HIS PARENTS IN A GRUESOME ROBBERY GONE WRONG.

The moment of young Bruce Wayne vowing to his deceased parents that he will fight a war on crime is the moment the boy became the Batman. From that oath, he dedicated himself to training, preparing to wage this war, and it took him many years to perfect both mind and body. Then came the moment of inspiration, the bat fortuitously flying in the window of the Wayne Manor study, just as he sought a way to inspire terror in the cowardly hearts of the underworld.

The boy had become the man. Bruce Wayne effectively became the mask of the Batman so people would never confuse the millionaire playboy with the black-cloaked avenging figure who was either an urban myth or a costumed vigilante who could do what the Gotham City Police Department failed to accomplish.

A legend was born.

Phantom, the first costumed comic strip hero. One publisher, though, sought all-new material and launched several titles that proved successful. When National Allied Publications wanted a fourth book called *Action Comics*, they sought something powerful for the cover, and the editors were directed to an unsold comic strip pitch from their regular contributors Jerry Siegel and Joe Shuster. It wasn't long before Superman created a brand-new genre, and as other imitative publishers climbed aboard, National, later known as Detective Comics, sought another costumed hero. Editor Vin Sullivan shared as much one evening in October 1938 with cartoonist Bob Kane.

Kane had been contributing humorous one- and two-page features to National after dipping his toe in the new comic book world elsewhere. The Bronx-born Kane, son of a *Daily News* printer, was

The roots of Batman go further back. The idea of a vigilante for righteousness is the stuff of myth, dating back to Robin Hood and even earlier. The dawn of the 20th Century saw the concept of the dual identity, allowing the rich to mete out justice, as Baroness Emma Orczy turned one of her short stories into a play and then a novel featuring the exploits of Sir Percy Blakeney, an English aristocrat who masqueraded as the Scarlet Pimpernel to rescue aristocrats during the French Revolution.

As the pulp magazines of the era began introducing new two-fisted crimefighters, several also wore disguises to fight for law and order, none as famously as the Shadow, who fronted an eponymous twice-monthly magazine. At much the same time, the comic strips were adding their own adventurers, the most successful of which were reprinted in magazine-shaped publications called comic books. In 1936, Lee Falk gave daily readers a masked avenger in the jungle, the

captivated by comic strips and the swashbuckling heroes of the pulps and silent movies, including Zorro, the Pimpernel descendant set in Mexico-controlled California. He recognized the shifting taste from humor to adventure strips and came up with his own, but struggled to make them compelling stories.

Thankfully, he struck up a friendship with budding writer Bill Finger, and a silent partnership was formed. Finger began writing the scripts for Kane. Sullivan's desire for a new hero inspired Kane, who, according to legend, created the new hero over a weekend. Finger made a series of suggestions that helped Kane sharpen the look of the new hero, called Batman. Sullivan liked what he saw and ordered a new series, which would debut in *Detective Comics* #27, released in March 1939.

Batman became a huge success for DC Comics (as the company came to forever be known), the second character to spin into his own self-titled

BATMAN: 100 GREATEST MOMENTS

series. Right before the debut of *Batman* #1 in 1940, *Detective Comics* #38 broke new ground with the introduction of Robin the Boy Wonder, a young sidekick designed to give the hero someone to talk to, and to give the readers someone to identify with. At much the same time, the villains were switching from pulp-inspired criminals, vampires, and mad scientists to more original grotesques such as the white-faced murderer the Joker.

The characters were so popular that they, and Superman, anchored the new *World's Finest Comics*, and as it and *Batman* increased in frequency, the demand for stories taxed even Kane and his studio's ability to keep up. In time, Kane's partner Finger and their young art assistant Jerry Robinson were hired away by DC directly and augmented with writers such as Don Cameron and artists that included newcomer Dick Sprang.

As Batman's rogues' gallery grew in variety, America entered World War II, so the series grew lighter in tone, something upbeat and positive for the eager readers. And after the war ended and tastes in reading changed, Batman and Robin were among the few costumed heroes to survive the funny-animal, teen-humor, romance, war, western, and crime fads.

Senator Estes Kefauver was worried and chaired a committee investigating causes for the rising tide of juvenile delinquency, focusing on radio, movies, this newfangled device called television, and comic books. To protect themselves, the publishers banded together, formed the Comic Magazine Association of America, and wrote a strict Comics Code, which was to be administered by highly educated reviewers. In a flash, the colorful criminals were gone, and Batman's challenges grew more fanciful as the creators came up with new threats, many of which came from space, given the 1950s' fascination with science fiction.

However, as the 1960s dawned, comic book tastes were changing, and editor Jack Schiff was slow to catch up. Sales of *Batman* and *Detective* were slumping. The titles were assigned in 1963 to editor Julius Schwartz, who had proved he could revivify moribund titles and characters. He and artist Carmine Infantino were given six months to

turn around sales or there was a real possibility the titles would be canceled.

Neither was particularly desirous of the assignment but they were professionals. Schwartz brought in new writers and assigned the Kane-ghosted *Batman* stories and Infantino's *Detective Comics* to inker Joe Giella to smooth over the visual differences in style, and the advertised "New Look" arrived early in 1964. The trick worked.

A good thing, too. After failing to obtain the rights to Superman and Dick Tracy, ABC settled for Batman and assigned the adaptation to producer William Dozier, who was totally unfamiliar with the hero. After a crash course, he went to work on the show, which shot its pilot in 1965. Then, when *Hootenanny* failed in the ratings, the new show was rushed onto the schedule for a January 1966 debut.

Batmania swept America and then the world, allowing DC's parent company to manage the plethora of tie-ins through the rise of the Licensing Corporation of America. Batman was heavily featured on as many DC covers as management could find, and the show burned brightly from January 1966 through March 1968, when it fizzled out.

Schwartz was once more challenged to revitalize the title, and with writers Frank Robbins

10

and Denny O'Neil, he went all the way back to its 1939 roots. Artists Bob Brown and Irv Novick stepped in to replace Kane (who was bought out in 1968) and Infantino (who was put in charge of the company once it sold itself to Steve Ross's Warner Communications) and the response was positive. But things really took off when Neal Adams, who brought a grim, photorealistic approach to Batman in the team-up title *The Brave and the Bold*, came over to Schwartz's books.

There was a Batman for comic readers and one for younger fans because of his animated appearances, which began in 1968 and were going strong thanks to *Super Friends*. With the live-action series in highly rated syndication, he remained one of the world's best-known characters. This prompted producers Michael Uslan (a former DC employee) and Benjamin Melniker to license the character for a feature film, a deal announced in 1980. Nine years later, Tim Burton's *Batman* arrived, a forerunner of today's successful cycle of super-hero films.

As the film gestated, tastes in comics had changed again, with a growing interest in street-level threats, and the heroes operating in the shadows and relying more on their grit. Leading the way was writer/artist Frank Miller, who set the pace with his *Daredevil* at Marvel. When DC publisher Jenette Kahn wooed him to DC, he conceived of a fifty-year-old Bruce Wayne, battered and worn-down, yet forced to don the cape and cowl one more time to save a dystopic Gotham from itself. *The Dark Knight* was a seminal moment for the hero and for comics, garnering mass media attention and pioneering both its miniseries format and launching DC's collected editions program.

A fresh wave of more adult Batmania swept America as Tim Burton's *Batman* became the first film to hit $100 million at the box office in just ten days. The well-reviewed movie meant the comics were free to continue to explore dark and noirish themes, but in a larger number of titles. Suddenly, there were one-shots and miniseries plus new ongoing titles with even spinoffs for the first Robin, now Nightwing, and the third Robin, Tim Drake. The cast of supporting players, allies, and enemies grew exponentially.

Batman has proved remarkably adaptable, reflecting the tastes and interests of each generation who have thrilled to his exploits. He has managed to be a friendly hero to the youngest readers and a deep psychological study in today's titles, where the biggest names in the field clamor for a chance to write or draw his stories.

So what are his one hundred greatest moments? Well, let's start with some parameters. As with the other volumes in this series, we are working with the core continuity from DC Comics' main line of titles. The various live-action, animated, and prose adventures were not considered. Then it was determining who *had* to be here and what their great moments with Batman were. After all, these are Batman's greatest moments, so whereas Bane breaking his back was a great Bane moment, a healed Dark Knight's revenge was Batman's moment. Consideration was given not only to the characters but to the great writers and artists who have helped sustain the comics for the last eighty years.

No doubt there will be quibbles and debates, but rest assured, what follows has been carefully weighed and measured, certainly enough to entertain and perhaps provoke a thought or two.

CHAPTER 1
ORIGINS

MUCH LIKE THE PULP HEROES HE EMULATED, BATMAN ARRIVED FULLY FORMED. FOLLOWING THE PULP FORMULA, MILLIONAIRE BRUCE WAYNE WAS CHATTING WITH COMMISSIONER GORDON WHEN HE HEARD OF AN INTERESTING CASE AND WENT TO INVESTIGATE AS BATMAN. THAT SIX-PAGER WAS MERELY A TASTE OF THINGS TO COME, AND WHEN IT WAS CLEAR THE CHARACTER HAD STAYING POWER, EDITOR VIN SULLIVAN ASKED FOR AN ORIGIN. BILL FINGER WHIPPED UP A NIFTY ONE IN A MERE TWO PAGES, MUCH AS JERRY SIEGEL AND JOE SHUSTER HAD DONE FOR THEIR SUPERMAN LESS THAN A YEAR BEFORE.

In both cases, there was plenty of room to fill in the gaps and expand upon what was there. Where were the Waynes coming from that night, and why go down a dark alley so late? What was Mrs. Wayne's first name? What time was the crime committed, and who was the first to respond to the gunshots? Who took custody of the newly orphaned Bruce, raising him to be an adult? Whereas those questions didn't really need answering in the slam-bang pacing of comics' Golden Age of the 1940s, in time, the questions lingered.

1. THE FIRST ORIGIN

Interestingly, the notoriously slow Bill Finger needed help generating stories within the first few months of Batman being sold to National. Sullivan asked his old friend turned prolific scribe Gardner Fox to step in for a few stories. Still, Sullivan also asked for an origin, which was used to introduce readers to the character with the seventh installment, which was then reused to introduce readers to the first quarterly issue of *Batman* in 1940.

Here, Finger used all the film noir story-telling techniques, a shadowy alley, a robbery gone wrong, and a young boy of eight left to grieve. However, Bruce Wayne didn't cry for long, as he is seen praying at his bedside, making an oath that would fuel him into adulthood. We see him training and studying, elements that would receive far greater exploration in the decades that followed. Visually, Bob Kane uses the evening and shadows to good effect, making you feel for Bruce and cheering him on.

2. CRIME ALLEY

Batman's origins hadn't been touched much between the addition of Lew Moxon to the mythos in the 1950s and then a 1968 retelling that added the element that a Mrs. Chilton had been retained to help uncle Philip Wayne raise Bruce. Unbeknownst to all, she was Joe Chill's mother, inextricably linking the two grieving people. Outside of a 1980 recap, Uncle Philip and Mrs. Chilton were never seen again, their existence ignored before reality was forever altered by the Crisis on Infinite Earths.

This is one reason why "There Is No Hope in Crime Alley!" may have resonated so strongly in 1976. Now we have a name for where the Waynes were gunned down—Park Row, forever renamed by the public as Crime Alley for what happened there. We see how Batman returns once a year to lay flowers in his parents' memory. He is shown to be particularly vindictive toward any criminal attempting to commit an illegal act in that space.

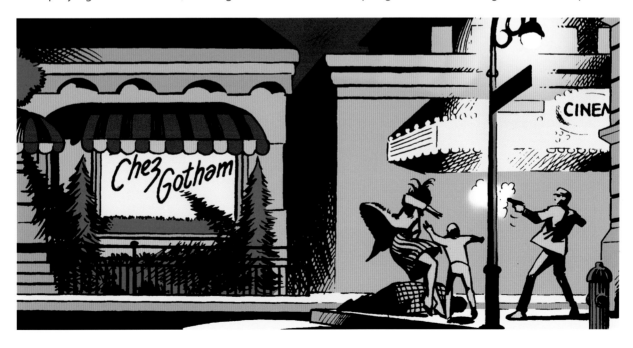

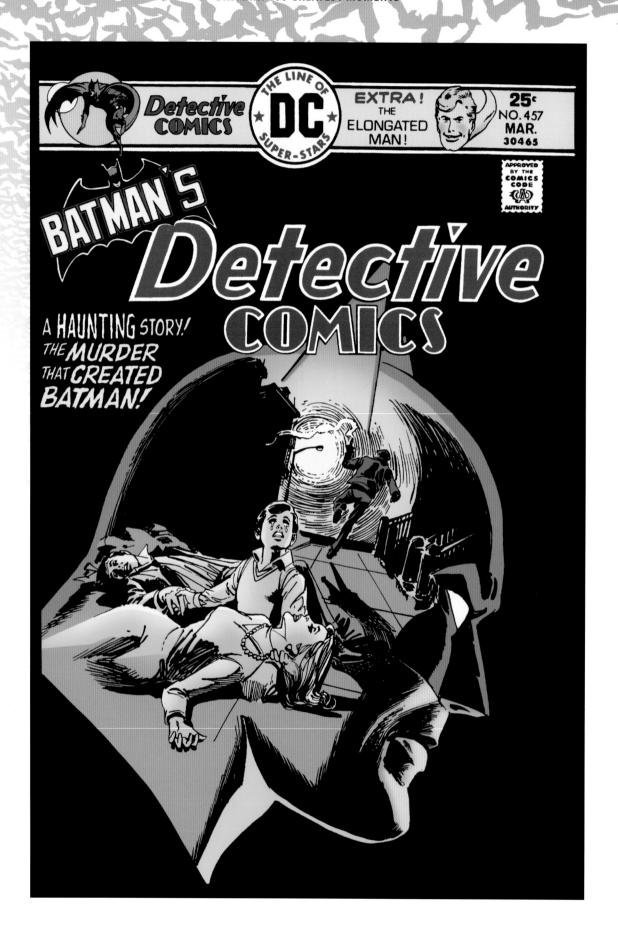

The story is significant in that it also introduced us to social worker Leslie Thompkins, based on Catholic pacifist Dorothy Day. Alone amid the respondents to the Wayne murders, Leslie embraced the traumatized young Bruce and gave him comfort in a moment when he desperately needed it. Affected in her own way by the tragedy, Leslie devoted her life to the poor people of the neighborhood and returned to the site of the Waynes' deaths on each anniversary even as Batman did.

Leslie's impact on the future Batman's life was magnified in post-Crisis history. Now a medical doctor and former colleague of Thomas Wayne, she and Alfred Pennyworth became surrogate parents to Bruce, and she was romantically involved with the Wayne manservant for a time.

As Park Row fell into decline, earning the nickname Crime Alley, Thompkins remained in place, giving up her practice in favor of creating a community clinic to care for the area's indigent and drug-addled locals. Over time, people learned not to prey on Thompkins, as she had the favored protection of the urban legend known as the Batman.

Thompkins remained a part of Bruce's life, patching up him and his allies through the years, although she grew more pacifist with time and was philosophically opposed to his war on crime. More recently, she died, a victim of the Joker's deadly toxin.

3. REVISITING THE ORIGIN

By the time the creative team of Mike W. Barr, Alan Davis, and Paul Neary took over *Detective Comics* in 1987, Dr. Leslie Thompkins was operating the Thomas Wayne Memorial Clinic located within Crime Alley. Barr, an avowed fan of "There Is No Hope in Crime Alley!," fittingly began his story there, as Batman brought Dr. Thompkins a seriously injured Jason Todd to be healed.

As she ministered to the second Boy Wonder, Batman stepped back and relived the horrible events of that evening decades earlier. In this recounting of the classic origin tale, Joe Chill still shows up to commit a routine stickup, and both Thomas and Martha Wayne die from gunshots. But

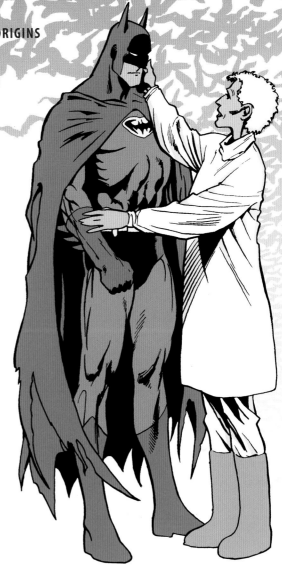

Barr adds two new elements to the mythos: First, an angry young Bruce is not afraid of the robber and tries to hit Chill, who runs as he hears a nearby police siren. Of special interest is that Barr has Chill dispose of the gun in nearby bushes, answering a question that readers may have wondered about for years: Whatever became of the gun that turned Bruce into Batman?

Long before, it had been established that Batman hated guns and would never use one because of this very weapon. We see Thompkins take in the young boy, who makes the same vow over the graves, but we also get a new scene: Bruce returning to the alley and finding the gun, which he kept hidden. That proved a seed for Barr's "Batman: Year Two" story, which made the gun a focal point. The rest of the issue focused on the relationship between Thompkins and Bruce, a special bond that was tested time and again.

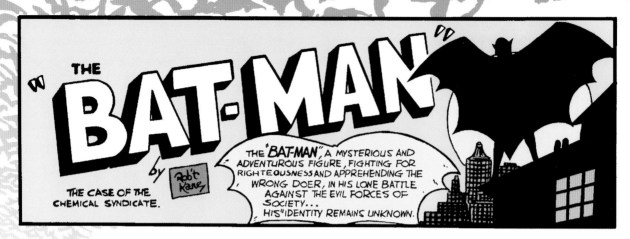

THE "BAT-MAN", A MYSTERIOUS AND ADVENTUROUS FIGURE, FIGHTING FOR RIGHTEOUSNESS AND APPREHENDING THE WRONG DOER, IN HIS LONE BATTLE AGAINST THE EVIL FORCES OF SOCIETY... HIS "IDENTITY REMAINS UNKNOWN.

4. "CASE OF THE CHEMICAL SYNDICATE"

The very first Batman mystery had nothing to do with the chemical syndicate and everything to do with writer Bill Finger. In a rare interview for Jim Steranko's *History of Comics*, Finger explained that the first script was a takeoff from a Shadow novel, which was fitting considering how influential the pulp hero was to Finger and Kane's approach to Batman. Odds are, once Kane sold the feature to National in late October–early November 1938, it was scheduled in a hurry, slated for *Detective Comics* #27, which would be on sale in March, so the job had to be done likely by the new year.

Oddly, since that 1971 anecdote, no one tried to determine which pulp provided the inspiration until 2007. By then, former DC Comics production artist Anthony Tollin had begun issuing facsimile reprints of *The Shadow* pulps and came across *Partners in Peril*. Published in *The Shadow* #113, it was cover-dated November 1936 and was Theodore Tinsley's first contribution under the house name of Maxwell Grant.

As Tollin told ComicMix at the time, "I had expected the lift to be less blatant. It turned out to be the same story with basically nothing changed. I mean, it was a chemical syndicate in both stories! Finger didn't even change it to some other kind of business. And the Shadow is described as 'bat-like' in the rooftop scene where Batman makes his first appearance in costume."

Regardless of provenance, this introduced eager readers to a brand-new hero, and it clicked. The story has been retold, first in the 30th anniversary issue of *Detective Comics* #627, retold by Mike Friedrich, Bob Brown, and Joe Giella. In retelling Batman's origin in *Secret Origins* #6, Roy Thomas and Marshall Rogers wove the story in. Four versions of the story appeared in *Detective Comics* #627: the original, the 30th anniversary retelling, and, two new iterations, one from Marv Wolfman and Jim Aparo, the other by Alan Grant and Norm Breyfogle. More recently, novelist Brad Meltzer and Bryan Hitch retold it in the New 52 edition of *Detective Comics* #27.

5. INVITING DICK GRAYSON HOME

A problem for many solo heroes in novels, pulps, and radio serials is having no one to talk to. Often a sidekick of some sort is required, hence the additions of Tonto and Kato, among others, prior to the rise of kid sidekicks in comics. Bill Finger quickly came to this realization as he was crafting Batman stories with Bob Kane. Kane decided the sidekick should be a young boy, someone the readers could identify with. He would be colorful, exhibiting his youthful exuberance in contrast to the somber colors of the adult hero. Jerry Robinson, who joined the growing studio, says he suggested the name of Robin after Robin Hood.

The idea was met with approval by incoming editor Whitney Ellsworth, although publisher Jack Liebowitz had his qualms about a boy being in harm's way. "The sensational character find of 1940" was introduced that year on the cover of *Detective Comics* #38, an oft-imitated pose. Crime had to result in Dick Grayson being orphaned, and the colorful

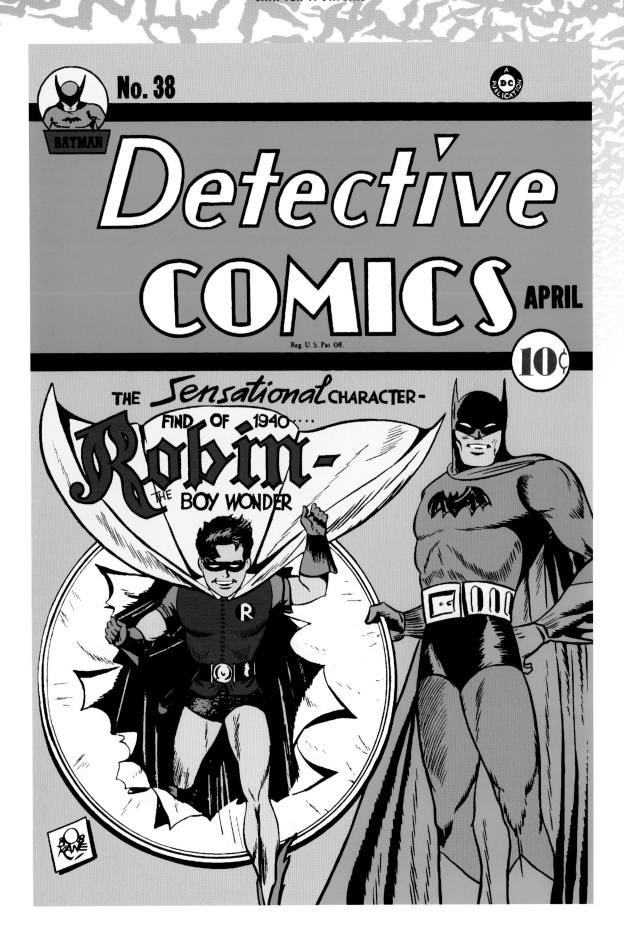

world of the circus suggested itself as a scene. Once Dick's parents, John and Mary, known as the Flying Graysons, fell during an acrobatic display, thanks to acid-frayed ropes, he was a grieving young boy. This image touched Batman's heart, and he offered to take the boy home. In short order, Dick learned Bruce Wayne's secret and, by candlelight, swore the same oath young Bruce had not that long before.

"Millionaire Bruce Wayne and his youthful ward Dick Grayson" became a phrase easily recalled thanks to its endless usage on ABC's *Batman* television series.

6. ADOPTING DICK GRAYSON

The notion of Bruce Wayne formally adopting Dick Grayson was dismissed for decades, with the millionaire's bachelor status cited as the reason that the boy could only be his legal ward. As the latter character aged and matured, he never resented that the final step in making him a part of the family wasn't taken. That all changed at the turn of the millennium as incoming writer Devin Grayson explored the characters and the entire matter of adoption.

The loss of family plays a heavy role in the mythos. First Bruce Wayne, then Dick Grayson,

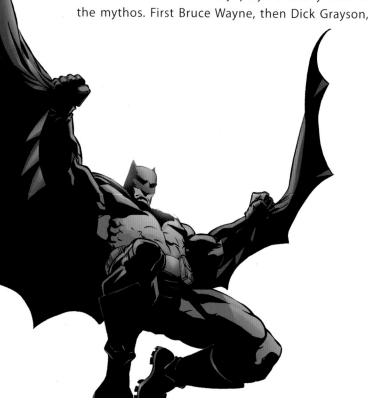

and subsequently just about every member of the extended Batman family suffered some form of familial loss. While their mission to protect Gotham's populace bound them, the more enduring legal connections remained elusive.

It took an earthquake to get Bruce to finally act. After a devastating quake hit Gotham City, Bruce began thinking about the future and formally began the adoption process. A complication arose when a man named Yoska Graesinka arrived, claiming to be Dick's paternal grandfather. As a suspicious Batman and Oracle investigated the claim, it was revealed that Yoska was not related to Dick but was a dupe arranged by Ra's al Ghul.

In his hesitant way, Batman explained that he was finally doing this as a gesture of love, one gratefully received. Once this was accomplished, in subsequent years, Bruce Wayne would formally adopt Tim Drake, the third Robin, and Cassandra Cain, who was a Batgirl and now operates as Orphan.

7. UNMASKING BEFORE JOE CHILL

In the early days of comics, you didn't need much space to provide an origin. Two pages were sufficient for Superman and Batman, while other heroes needed barely much more. What was important was for the hero to exist and operate for the cause of justice. Once told, the stories were rarely referenced again.

In 1948, both Batman and Superman had their origins retold in expanded form, possibly because management felt that a new generation of readers had arrived and deserved the backstory. In the first expansive retelling of Batman's origins, the gunman, Joe Chill, is finally named, and we see what happens when they meet again.

Eight-year-old Bruce Wayne gazed at the man who shot his parents with such deadly eyes that it scared the hit man, who ran off. As Bruce grew up, studying and training to become Batman, Chill also advanced, rising through the ranks of Gotham's underworld until he became a low-level mob boss. At that stage, Chill earned Batman's interest, which brought the two men

back together for the first time in years. Arriving at Chill's office, Batman confronted him only to pause, recognizing the man who slew his parents. With an angry flourish, the cowl came off and the hero was revealed as Bruce Wayne. Batman swore to haunt Chill until he was arrested.

The problem was, Chill rushed from the office and told his underlings he was responsible for the Gotham Guardian's creation. Miffed at this, they all drew their guns and shot Chill dead.

In 1956, it was later revealed that mobster Lew Moxon hired Chill to kill the Waynes. That twist was dropped in the post-Crisis continuity but teased anew early in the 21st Century, before it was ultimately confirmed that Joe Chill had acted alone.

A 1968 retelling of the origin added the character of Mrs. Chilton, mother of Joe, who changed her name after her son became notorious. She worked as a housekeeper for Philip Wayne and therefore helped raise Bruce. This version of events was quickly dropped from the mythos.

In the first major post-Crisis on Infinite Earths recounting, Chill was still responsible but later wound up forming a tense partnership with Batman to help rid Gotham of the Reaper's scourge. Reality was altered after Infinite Crisis, and Chill was ultimately arrested and jailed for the murders.

8. CONFRONTING LEW MOXON

In what is known as the Earth-1 reality, mobster Lew Moxon and his men crashed a costume party that was attended by Dr. Thomas Wayne, wearing an eerily familiar Bat-themed outfit. Wayne prevented the robbery and subsequently testified against Moxon in court. Years later, Moxon was freed and almost immediately hired Joe Chill to kill Wayne in revenge.

Bruce Wayne discovered the tattered remains of his father's costume and investigated this heretofore unknown piece of his past. Moxon denied all knowledge of Chill, a result of mental impairment following a car accident. When Wayne donned his father's costume, the frightening visage jarred Moxon's memory. He ran from Batman, only to be fatally hit by an oncoming car.

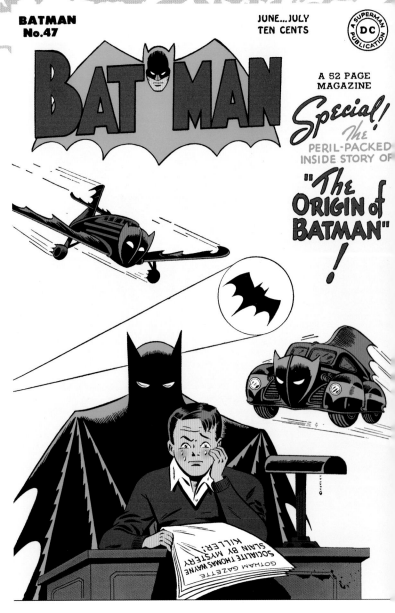

In the post-Crisis on Infinite Earths reality, Moxon was the preeminent crime boss of Gotham, living among Gotham's elite. His daughter Mallory and Bruce Wayne were childhood friends. At one point, a robbery went wrong and Moxon's lieutenant was shot, prompting the boss to invade a costume party and insist that Dr. Wayne, dressed now as Zorro, treat the man.

Wayne testified against Moxon, and the crime boss relocated his family to Europe. This removed Moxon from having any connection to Joe Chill killing the Waynes. Moxon has not been seen in the Prime Earth reality.

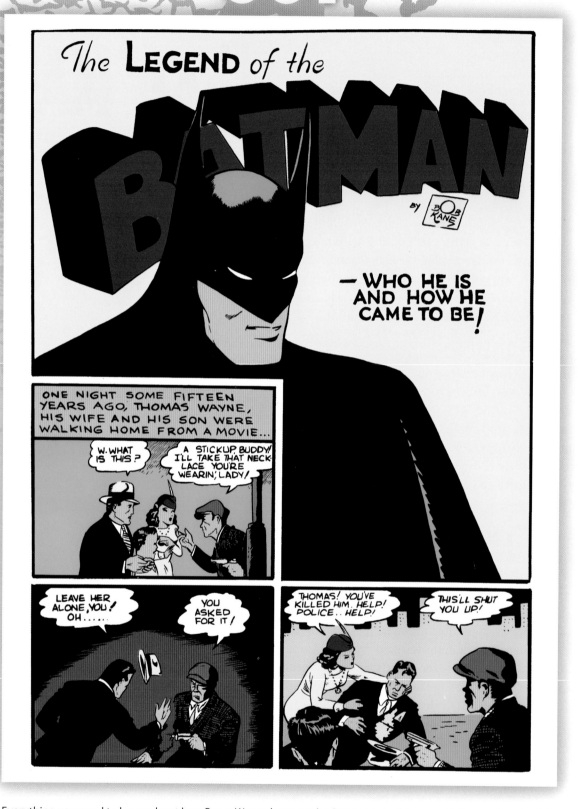

Everything you need to know about how Bruce Wayne became the Batman is in this powerfully emotional origin story, told and retold with embellishments ever since.

Batman #1, April 1940
Writer: Bill Finger *Artists:* Bob Kane & Sheldon Moldoff

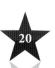

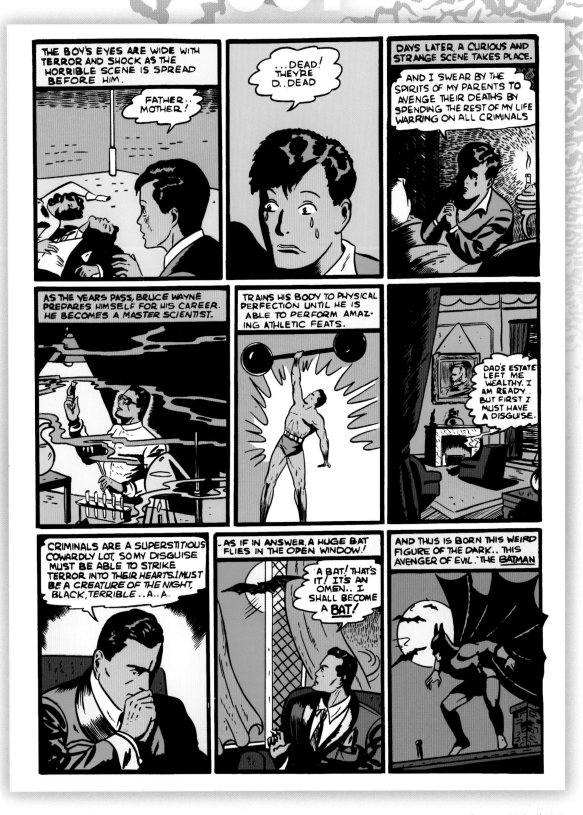

Batman #1, April 1940
Writer: Bill Finger Artists: Bob Kane & Sheldon Moldoff

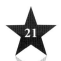

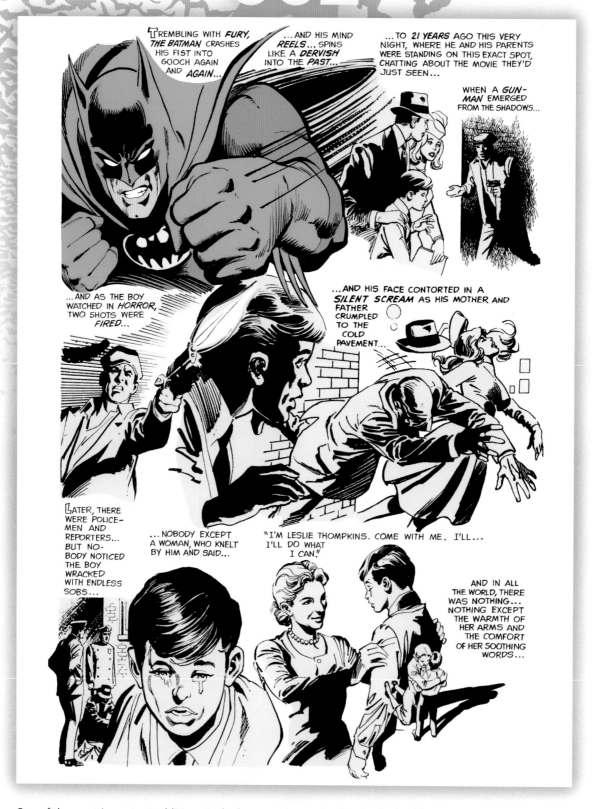

One of the most important additions to the lore was the setting for the fatal robbery, a story that also gave us pacifist Leslie Thompkins.

Detective Comics #457, March 1976
Writer: Dennis O'Neil *Artists:* Dick Gordano & Terry Austin

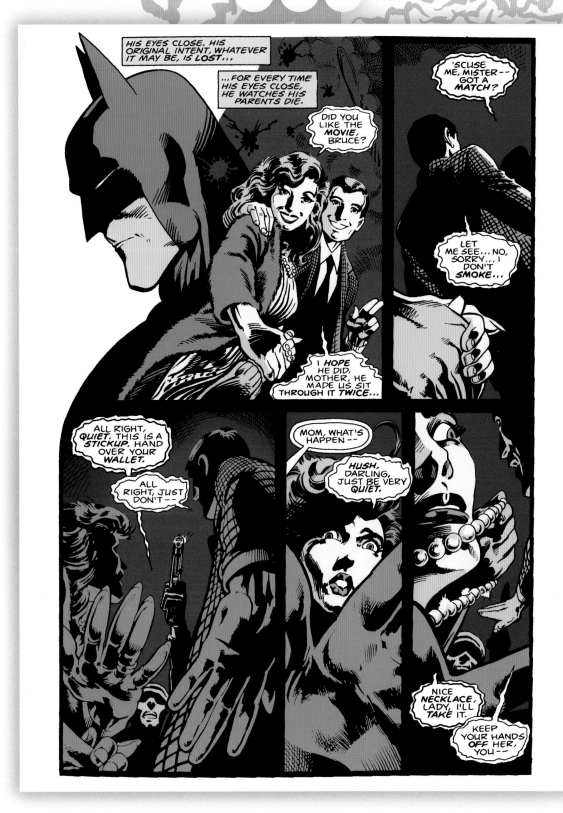

It seemed to be almost a requirement that a new creative team retell the classic origin, each adding an element, either visually or stylistically. This is one of many fine examples.

Detective Comics #574, May 1987
Writer: Mike W. Barr *Artists:* Alan Davis & Paul Neary

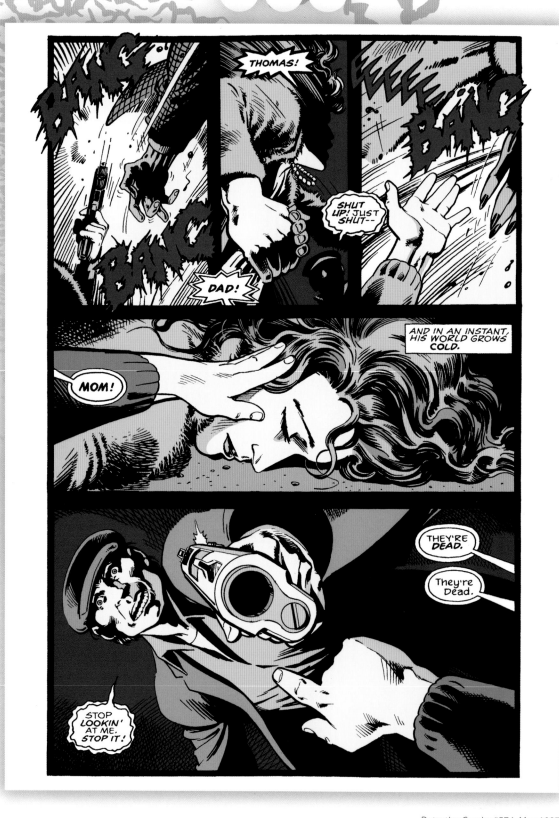

Detective Comics #574, May 1987
Writer: Mike W. Barr *Artists:* Alan Davis & Paul Neary

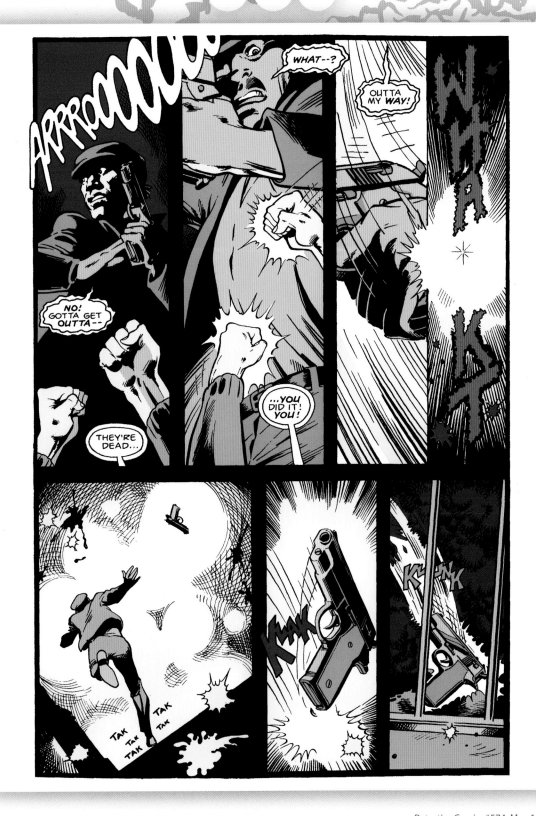

Detective Comics #574, May 1987
Writer: Mike W. Barr *Artists:* Alan Davis & Paul Neary

Detective Comics #574, May 1987
Writer: Mike W. Barr Artists: Alan Davis & Paul Neary

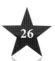

Detective Comics #574, May 1987
Writer: Mike W. Barr *Artists:* Alan Davis & Paul Neary

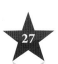

Detective Comics #574, May 1987
Writer: Mike W. Barr *Artists:* Alan Davis & Paul Neary

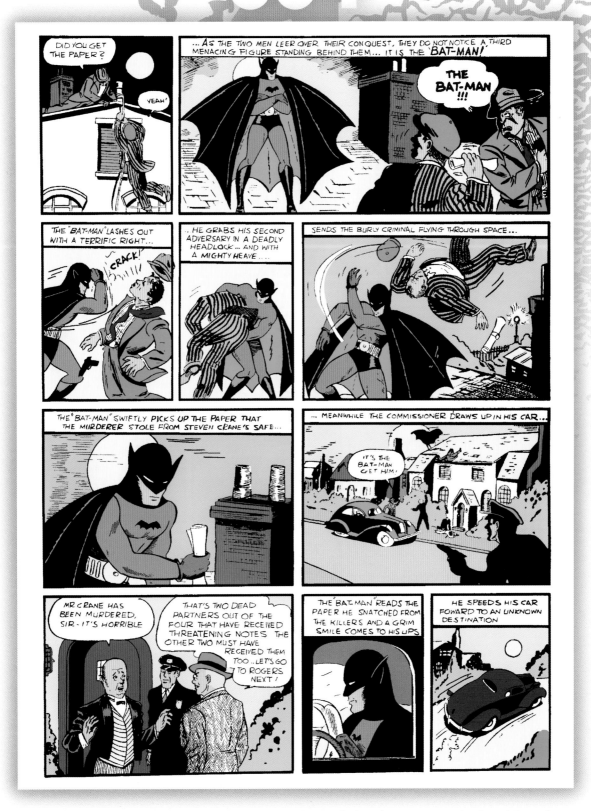

Batman's very first case was inspired by a Shadow pulp novel, directly connecting the Caped Crusader to his pulp roots.

Detective Comics #27, May 1939
Writer: Bill Finger *Artist:* Bob Kane

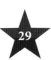

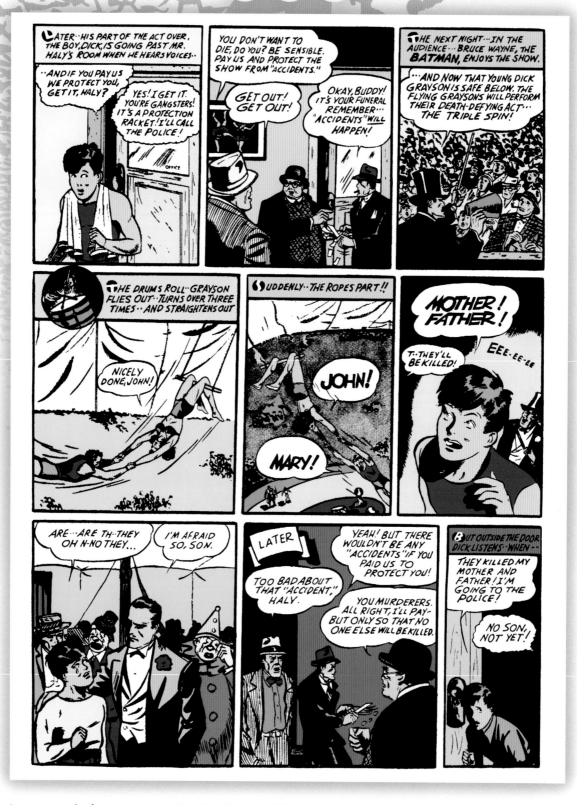

It was a spark of genius to give the crime fighter a kid partner so he had someone to talk to and audiences had someone to identify with. Robin created a trope that's been in use ever since.

Detective Comics #38, April 1940
Writer: Bill Finger Artists: Bob Kane & Jerry Robinson

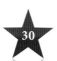

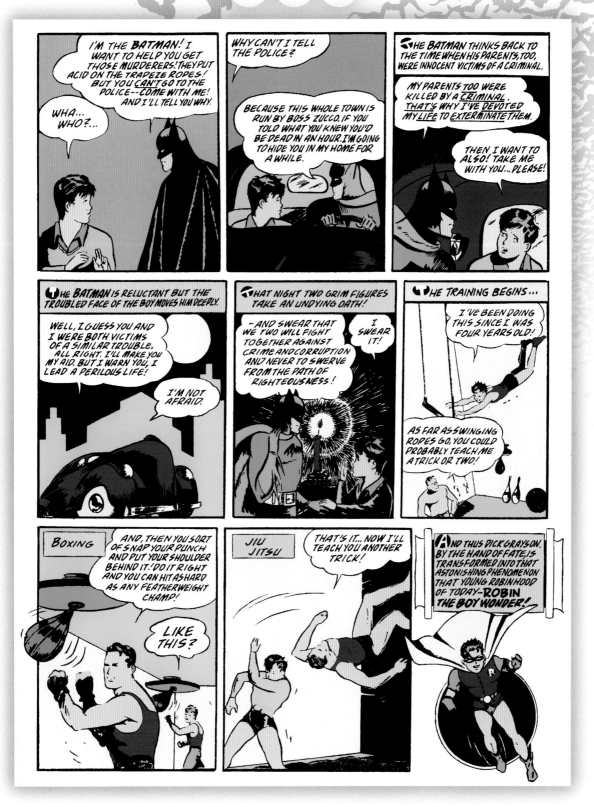

Detective Comics #38, April 1940
Writer: Bill Finger *Artists:* Bob Kane & Jerry Robinson

END

Hard to believe, but it wasn't until 2001 that Bruce Wayne finally formally adopted Dick Grayson as his son, a fitting coda to a story that focused on Dick's past connections.

Batman: Gotham Knights #21, November 2001
Writer: Devin Grayson *Artists:* Roger Robinson & John Floyd

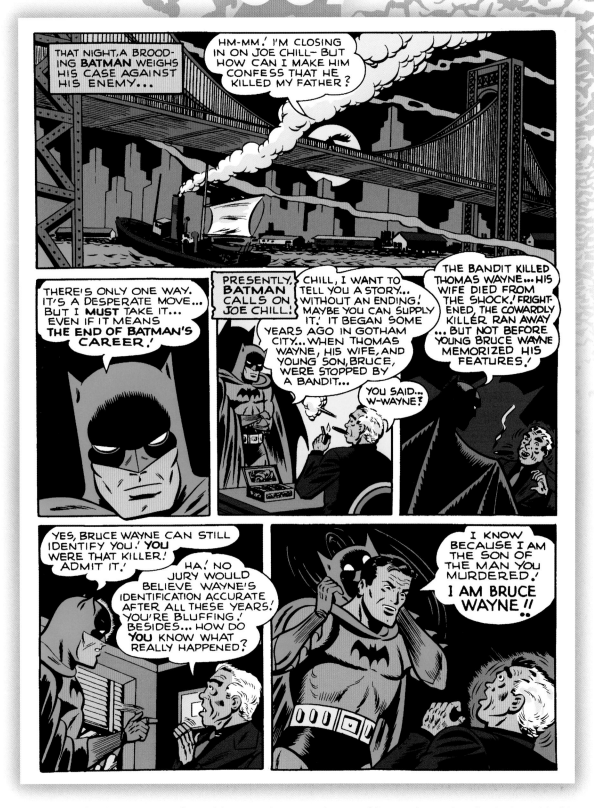

Nine years after his origin was first told, Batman's creators began adding to the mythos, beginning with this powerful story as he tracks down the man who murdered Thomas and Martha Wayne. Joe Chill entered the continuity and hasn't left regardless of reboots and retellings.

Batman #47, June 1948

Writer: Bill Finger *Artists:* Bob Kane & Charles Paris

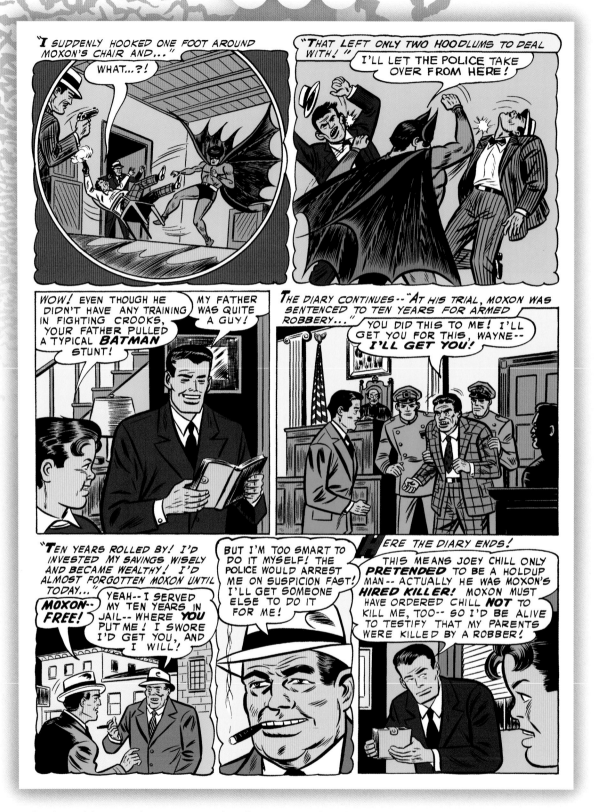

In his last addition to the creation myth, Bill Finger introduced underworld boss Lew Moxon, who sought revenge against Dr. Thomas Wayne, hiring Joe Chill to kill him.

Detective Comics #235, September 1956
Writer: Bill Finger *Artists:* Sheldon Moldoff & Stan Kaye

CHAPTER 2
CREATING THE MYTHOS

BACK IN THE GOLDEN AGE, A SERIES DIDN'T NEED A LOT OF PLANNING IN ADVANCE. IT WAS MOSTLY A HIGH CONCEPT AND A LOT OF ENTHUSIASM. ONCE BATMAN CAUGHT ON, THE NEEDS OF THE STORY HELPED DICTATE WHAT THE CHARACTER OR SETTING REQUIRED AND IF IT WORKED, IT GOT REPEATED UNTIL IT WAS A REGULAR ASPECT OF THE FEATURE.

As a result, it was a little while before the familiar gadgets and people began appearing, starting with his amazing utility belt and batarang. He first flew an autogyro before switching to a dark sedan without a bat motif while the Batcave, initially under a barn on the Wayne estate, grew in scope.

Along the way, the familiar periodically needed to be updated to reflect changing times and technology. Wisely, these were turned into cover feature events. On the other hand, it was twenty-four years before the first major overhaul of the feature's look occurred, when editor Julie Schwartz was told to shake things up. His plans were interrupted when Batmania arrived, but then he was free to return to Batman's roots as the world grew darker and crime became more rampant, and a dark avenger was the solution.

Editors over time allowed their artists to constantly redesign the Batcave or Batmobile, while newer tools were introduced to aid in crime fighting. The changes came with greater rapidity but always served the mythos regardless of era.

9. WHAT IF THE WAYNES WERE ALIVE?

While Crisis on Infinite Earths was the first major event that altered reality as the DC Universe knew it, it was far from alone. The time-twisting events of Zero Hour were considered the second of the seven major crises, as the cosmic beings understood reality. Here, waves of time displacement sent the various characters into familiar territory, such as Batman returning to Wayne Manor only to discover it was a manor from the past, when Bruce

Wayne was eight. Here, Thomas and Martha Wayne survived Joe Chill's botched robbery, but it was young Bruce who died.

Enraged, Batman sought out Chill to exact vengeance but found the criminal strung out on drugs. In this warped version of the past, perhaps Chill was not the killer, and Batman wasted precious moments when he could have been with his parents. Upon returning to Wayne Manor, a wave of time altered events and once more he was an adult orphan returning to an empty home.

Many a story has involved the Waynes, alive and dead. Their coffins have been stolen and used as pawns by Ra's al Ghul, for example, and other stories show one or the other still alive. The Waynes, their ancestors, and their secrets have fueled countless stories through the years and realities.

10. INTRODUCING THE BAT-SIGNAL

Perhaps the most unique aspect of the mythos was the ability for the police to summon Batman when needed thanks to a giant signal placed on the rooftop of police headquarters. When we first see it, oh so casually introduced at the beginning of a story, it is said to be activated by a button on Commissioner Gordon's desk or by actually going to the roof to turn it on. The meetings between Batman and Gordon, and the Dark Knight's silent departure, have become a recurring moment in comics, film, television, and beyond.

Many versions of the story tell of Batman giving the signal to Gordon, a physical manifestation of the trust they placed in each other. Smashing its

bulletproof glass was also a sign of mistrust, most recently when Gordon thought Batman had gone too far in his belief that Bane was secretly ruining his life.

When Batman was thought an urban legend, it was said that the Bat-Signal was used by the police to further the myth, helping them keep crime in check.

Some stories were built around those who operated the signal, such as Sergeant Harvey Hainer, who was tasked with maintaining the signal when his eyesight worsened, making him unfit for the streets. More recently, Gotham law stipulated that the police could not summon a vigilante, so a civilian named Stacy had the job.

design was a muscle car and then some, remaining a fixture for over thirteen years.

It was first rolled out of the Batcave to capture the very criminals who dynamited a bridge in an attempt to kill the heroes.

When that story sold well, it was decided it was time to update the Batplane as well, another cover story that introduced a new space-age design.

Ever since, as times and tastes changed, so, too, did Batman's vehicle, although once George Barris's Batmobile design arrived in January 1966, it became the one most closely associated around the world with the Dynamic Duo.

11. INTRODUCING BATMOBILE II

The bat motif was slow to evolve during the early days, so Batman's first automobile was a red sedan, immediately followed by a blue one. Soon after, a bat symbol was affixed to the roof and then replaced with the scalloped fin.

At one point, Batman broke his leg and was laid up at home. Rather than sit idly, he designed and constructed a brand-new vehicle, a state-of-the-art rolling arsenal and lab. The driver's section was a bubble-topped area, and the extended trunk contained a working lab, communications gear, and extra equipment. The bat-headed grille and lengthy

12. THE NEW LOOK DEBUTS

Comic book tastes were changing throughout the 1950s and into the 1960s. Across DC Comics, a more photorealistic art sensibility could be found in Robert Kanigher's line of war titles and Mort Weisinger's Superman family of comics, not to mention the more varied visuals at upstart Marvel Comics. What remained static, though, were *Batman* and *Detective Comics*. Editor Jack Schiff had Bill Finger and other writers create science-fiction-themed stories or bizarre gimmicks, which were dutifully illustrated by Bob Kane's ghost Sheldon Moldoff and usually inker Charles Paris.

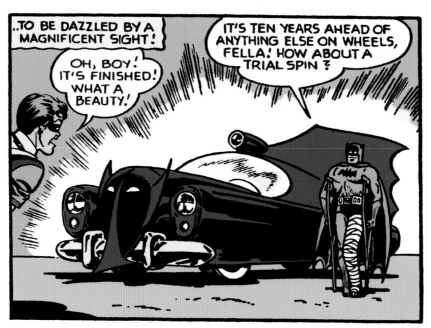

As a result, sales were dropping rapidly enough to alarm management, who took the books away from Schiff and gave them to Julie Schwartz. A DC veteran who had been there since 1944, Schwartz had handled a variety of genres, preferring the science fiction stories of his youth. Yet, that was the first element he jettisoned. Schwartz wasn't a fan of the character or the work being done and returned to the notion of Batman as costumed detective, a crime fighter dealing with earth-bound problems.

He brought in his regular writers Gardner Fox and John Broome to overhaul the series, with Carmine Infantino penciling *Detective* and Kane/Moldoff contractually remaining on *Batman* with Joe Giella inking both for consistency. Visually, the biggest change was the addition of the yellow circle around Batman's chest emblem, giving the company something they could trademark and merchandise. This New Look—so named in a full-page house ad in DC's titles—arrived with *Detective Comics* #327, the 301st issue to feature the Caped Crusader.

There were two gaffes in that first issue released in March 1964: first, Batman used a gun, with Schwartz unaware the hero had eschewed using them since 1939; and second, on the text page he dared mention Bill Finger, whose contributions to the character were never publicly discussed. Readers were immediately taken with it and sales quickly rose.

13. INTRODUCING THE NEW LOOK BATMOBILE

"Chicks dig the car."

As Julie Schwartz was overseeing the revamping of Batman and all his mythos, attention had to be paid to the Batmobile, which was a large, lumbering vehicle in an age where fans watched James Bond tool around in the Aston Martin. George Barris drew his inspiration a year later from the concept model Lincoln Futura, and an artist, likely Carmine Infantino, designed the sleeker new vehicle after the C1 Corvette and Porsche. The top was open, with a bat head on the hood, and it retained bat fins in the rear but looked speedier.

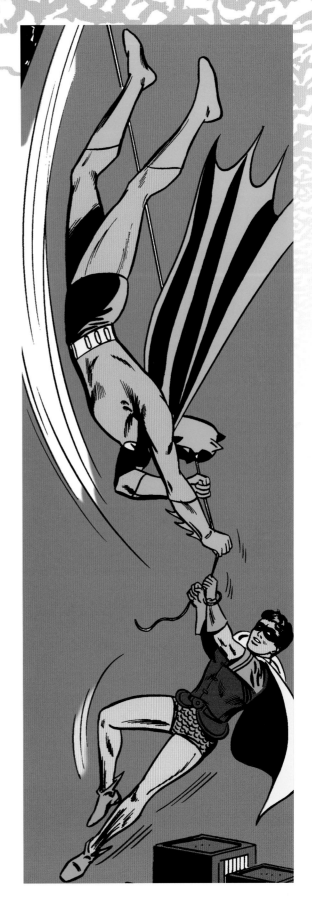

The vehicle rolled out of the Batcave for the first time in *Batman* #164, the second New Look comic to be released. This model contained a hotline phone to police headquarters, something to be imitated on the forthcoming television series.

Frequent letter writer and later comic writer Mike Friedrich wrote in to complain, "I feel the Batmobile should have a bullet proof windshield that encloses the driver's seat because it's during this time that [the] Dynamic Duo is highly susceptible to an attack from above and behind."

As vehicles go, it was a visible sign of change but not necessarily beloved. Depending on the source, variations of the new vehicle were seen in the comics until the model was scrapped in 1968 in favor of one more closely resembling the television one, but even that didn't last. Once the series was canceled, the 1970s saw a succession of Batmobiles come and go, with nothing capturing the imagination until the turbocharged black beast introduced in Tim Burton's 1989 *Batman*. The car was designed atop a Chevy Impala chassis by the team of Burton, Anton Furst, Terry Ackland-Snow, John Evans, and Keith Short.

While no one remembers the other shows, no one can forget *Batman*. In an era when Beatlemania swept the world, the Fab Four were challenged by the Caped Crusader. The ratings were beyond anything ABC or DC Comics could have anticipated. Suddenly, companies could brand anything with the Batman logo and it would sell, a bonanza that sparked an evolution in media licensing.

Comic book sales soared, and executive vice president Irwin Donenfeld insisted Batman be plastered wherever possible, edging out his fellow Justice Leaguers, much to the consternation of fans. It resulted in stories hewing closer to the television series than the detective crimes editor Julie Schwartz wanted to explore.

A feature film, planned to introduce the series, had been postponed but was rushed into production to hit screens between the short season one and full season two. At the same time, comics introduced Batgirl in late 1966, and she was added to the show to spark declining ratings for the third season. Alas, the Batmania fad didn't last as long as the Beatles, although its influence forever altered comics and readers' perceptions of the Dynamic Duo.

14. BATMANIA

It was a fairly audacious concept: a color television series based on the popular but far from best-selling comic book, splitting the hour over two nights with an old-fashioned cliffhanger designed to make you come back.

At the time, ABC may have been the first to go all color with their shows, but they were a distant third in the ever-important ratings. This gave them the freedom to be more experimental in their dramas and comedies. During the 1965–66 television season, ABC had a number of misfires that prompted quick cancellations. One result was rushing Batman into production and on the air in January along with three other series—*The Double Life of Henry Phyfe*, *Blue Light*, and *The Baron*. Someone in the marketing department decided to bill this as the second season, promoting all four at once as a fresh start for the new year.

15. THE DARK KNIGHT ARRIVES

Batman was so popular that he was installed as cohost of *The Brave and the Bold*, a comic that teamed up various characters. He'd already partnered with Eclipso and Green Lantern, but starting with issue #68, he became the regular fixture. Writer Bob Haney claims it was his idea, and so Batman remained in place (there were two brief interruptions) through issue #200, with the majority of those written by Haney, who had just the right storytelling sensibilities to play into the groovy sixties and the ABC series. He was partnered with a variety of artists until issue #79.

Newcomer Neal Adams began drawing for DC in 1967, mostly covers and the occasional story, but his photorealistic style led him to lobby for a shot at the Caped Crusader. Schwartz had no room or interest at first, so Adams lobbied *Brave and the Bold* editor Murray Boltinoff. Appropriately enough, Batman was

paired with Deadman, the cover feature of *Strange Adventures*, a series Adams had inherited and made his own before its cancellation. With Boltinoff's approval, the artist deviated from Haney's script in just one detail: daytime scenes were changed to night. There was a fresh athleticism and dynamism to the work. Adams also insisted on having a hand in the coloring, which added another layer of atmosphere, setting this Batman apart from his own titles.

Sales rose, and fans clamored for Schwartz to start using him. Adams didn't remain in place long, drawing eight issues before Schwartz finally relented and paired Adams with incoming *Batman* writer Denny O'Neil, starting with *Detective Comics* #395 (January 1970), the dawn of a new age.

There were hints of the changes to come in *Detective Comics* #393 (November 1969), as the cover proclaimed this the end of the Dynamic Duo, and inside, the story said that Labor Day weekend would be the last time Bruce Wayne, Dick Grayson, and Alfred would be together. A few weeks later, *Batman* #217 saw Dick off to Hudson University, Batman closing up the Batcave, and Bruce Wayne moving into a penthouse atop the Wayne Foundation. Deciding to get more active both day and night, he founded Victims, Inc. Program, a way to help those like himself. The move to Gotham lasted a dozen years, while VIP was gone within a year, a failed concept.

This big change ended the New Look era and opened a fresh chapter, one eagerly received by fans, who gave this return to the roots a big thumbs-up.

16. BATMAN MOVES TO GOTHAM CITY

One of the hallmarks of the New Look era was that Robin began growing up. He no longer looked like a twelve-year-old, getting taller, filling out, and developing his own personality. This was played up to a degree in the *Teen Titans*, where he led the team, and finally in *Batman*.

With the television series over in March 1968, sales returned to normal, so Julie Schwartz was free to return to his own ideas of what made Batman unique. At the time, there were protests against America's involvement in the Vietnam War, civil rights remained a cause, and women's liberation was gaining attention. Suddenly, it was hard to avoid the social consciousness of the times, and Schwartz decided to work with it here and elsewhere in his stable.

17. CELEBRATING CHRISTMAS

It's hard to explain why the Dark Knight and Santa Claus worked so well together, but ever since they shared a cover in 1942, there have been quite a few Christmas-themed stories. Don Cameron and Jerry Robinson retold Charles Dickens's *A Christmas Carol* in 1944's "A Christmas Peril." Earlier, *Batman* #10 featured a Christmas tale featuring characters Tim Cratchit and his father Bob, totally unrelated to Dickens, of course.

After 1947, holiday tales fell out of fashion in Gotham City but returned in a big way two decades later. From 1969 through 1985, the Dark Knight was touched by the Christmas season almost annually (missing only 1970, 1974, 1977, and 1982), sometimes amid fellow heroes like the JLA and Outsiders.

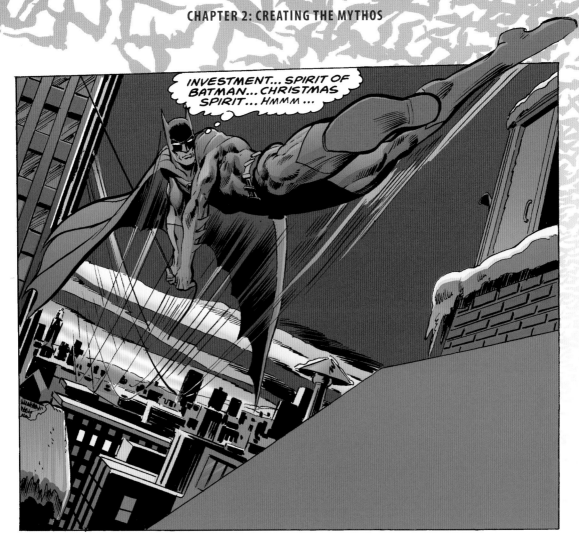

In 1976, Batman stopped Dr. Tzin-Tzin from making everyone in Gotham City forget about Christmas, something too dastardly to contemplate. Two years later, Bob Haney, Jim Aparo, and Joe Staton paired Batman and Plastic Man and they headed for Florida in "The Night the Mob Stole Xmas!" Before the 1978 holiday was over, Len Wein, John Calnan, and Frank McLaughlin told a touching story featuring the nearly mindless Blockbuster coming to rescue a woman who tried to overdose on pills, but both get caught on an ice floe, requiring Batman's aid.

Frank Miller is best remembered for the Dark Knight, but he debuted with the Caped Crusader in 1979's "Wanted: Santa Claus—Dead or Alive!" written by O'Neil and inked by Steve Mitchell. Here, a Salvation Army Santa is coerced into committing a department store robbery. A different criminal disguised as St. Nick comes across Batman in 1981's *The Brave and the Bold* #184, from Mike W. Barr

and Jim Aparo. That creative team continued the tradition of an annual Christmas story in *Batman and the Outsiders* from 1983 through 1985 (the last of which found Alan Davis subbing for Aparo).

After that, holiday sentiment once again fell into the shadows of Gotham, with rare exceptions, like a Dave Gibbons/Gray Morrow tale in 1989's *Christmas with the Super-Heroes* #2. In 1995, Mark Millar, Steve Yeowell, and Dick Giordano told a tale whose motivation revolved around Batman tracking down the stolen final Christmas gift he'd received from his parents. Elsewhere, Denny O'Neil and Teddy Kristiansen told how Batman hunted down a murderer dressed as Batman in a story from 1996's *Batman: Black and White* #3.

Still, the best remembered of the stories is Mike Friedrich and Neal Adams's "The Silent Night of Batman," a short story from 1969 that reflects his influence over the citizens, especially during that time of year.

18. "BOO"

Batman #234 is best remembered for Two-Face making his first new appearance in a comic book since 1954. He'd been gone for so long because under the Comics Code Authority his visage was considered too gruesome. He'd nearly returned earlier, when famed author Harlan Ellison drafted a treatment for the *Batman* television series, but it went unproduced. Likewise, a seeming revival in 1967's *World's Finest* #173 had only involved an imposter.

Still, the story in question came out two years into the return-to-the-roots era that saw Batman as a gothic figure, a moving shadow in the night, who continued to strike fear into the hearts of criminals everywhere. It was during this point, in the early 1970s, that Batman would begin disappearing from the police headquarters rooftop after talking to Commissioner Gordon.

Writer Denny O'Neil was exploring social issues here and in *Green Lantern*, which meant that every now and then political figures would turn up. In this sequence, we have public works commissioner Arthur Reeves talking big about the costumed vigilante, someone he felt should not be condoned by Gordon. Since his 1970 introduction, Batman continued to poke fun at the blowhard, such as in this memorable moment.

Other times, Batman would remove Reeves's toupee or frighten him in new manners. Eventually, Reeves ran for mayor on an anti-Batman platform, losing thanks to the political machinations of crime boss Rupert Thorne. Years later, he was even featured in the 1993 animated feature *Batman: Mask of the Phantasm.*

19. BACK TO THE BATCAVE

Bruce Wayne had been operating out of the penthouse atop the Wayne Foundation building for some time, eventually converting a subbasement into a miniaturized Batcave. For Wayne and Alfred, it was spacious and comfortable, allowing Batman to arrive more quickly as needed.

Then came a moment when Two-Face bested the Dark Knight, capturing the hero and imprisoning him in a small cell with just a food slot. Each day, Two-Face flipped his coin to see if this was the day he would kill Batman. For eight straight

days, the good side came up, sparing his life. While Two-Face was committing his crimes, Batman was busily melting a plastic tray, fashioning it into a Two-Face mask. The following day, the scarred side came up and Two-Face had "permission" to kill his enemy, only to be confronted by a look-alike, prompting him to free his captive.

While in captivity, Batman reassessed his future and informed Robin and Alfred that the time had come to return home. He has effectively never left it since that period.

20. RETRIEVING THE MANTLE

Bane arrived in Gotham City determined to beat Batman, first exhausting him by unleashing the imprisoned inmates of Arkham Asylum and prisoners at Blackgate. Then the weary hero returned to the Batcave to find Bane waiting for him. The brutal fight was brief, ending when Bane snapped Batman's back over his knee.

The city needed protecting, and Bruce Wayne was no longer up to the task. He asked Jean-Paul Valley—who had been trained in The System by the Order of St. Dumas, and had been operating as Azrael, the Avenging Angel, in Gotham—to be his replacement. The new Batman went to work to cleanse the city and stop Bane but soon alienated himself from Robin. The System forced Valley to go beyond the parameters of how a Batman should act, evolving the uniform into armor and meting out vicious and fatal justice.

During this time, an anguished Bruce Wayne tried to heal himself, but it took the mutant touch of Shondra Kinsolving to finish the job. Bruce Wayne was ready to resume his role, but Valley didn't want to relinquish the name.

The pair had a showdown in the Batcave, which Wayne had known intimately since childhood. He forced Valley to follow him into the narrower tunnels, requiring Valley to strip away the armor so he could fit until finally they were faced man to man. Bruce Wayne prevailed and regained the mantle of the bat. Valley was rehabilitated and resumed his role as Azrael, now an Agent of the Bat.

21. REJECTING HAPPINESS

Since first crossing paths with Catwoman in *Batman* #1, there has been sexual tension between the Bat and the Cat. She has teased him, kissed him, reformed her life for him, and battled him across Gotham's rooftops.

When Tom King took over writing the series in 2016, he turned up the heat on their relationship, bringing them to the eagerly awaited moment when Batman finally proposed. We then spent a lengthy while adjusting to the impending nuptials. He introduced her to Clark Kent and Lois Lane, rescued her best friend Holly Robinson from his former lover Talia al Ghul, and asked Alfred to be the best man.

Impulsively, Bruce told Selina they should elope and begin the next phase of their lives together. In the days leading up to the moment, though, Catwoman was nearly killed by the Joker, who began whispering in her ear that Batman couldn't be happy, how he needed his pain. Soon after, Holly told her, "He always seemed to need his misery, y'know."

Selina doesn't show up, leaving behind a heartfelt letter. "If we're happy . . . and we could be

so happy . . . if I help that lonely boy with the lonely eyes, I kill that engine. I kill Batman. I kill the person who saves everyone."

Of course, we learn this was all a plot masterminded by Bane to completely break the Bat. And the story is far from over. King intended their romance to be the spine of his 85-issue magnum opus, with the broken wedding at the midway point. Polygon comics editor Susana Polo noted, "Tom King really leaned into the idea of Batman and Catwoman as a Great Literary Love Story. More than that, he's talked about his arc as one that bends toward Batman's happiness; that making him happy creates more interesting conflict than making him sad."

Bruce Wayne's final scene in issue #50 includes him leaping off a rooftop, about to resume work as Batman. Over the next several months, he is a brutal avenger, dishing out very rough justice. He could have chased after Selina, convinced her to reconsider, but Bane's work was too complete. He is Batman at his worst: dark, obsessive, and dangerous. There is no chance of happiness now, and he will make everyone pay for robbing him of this.

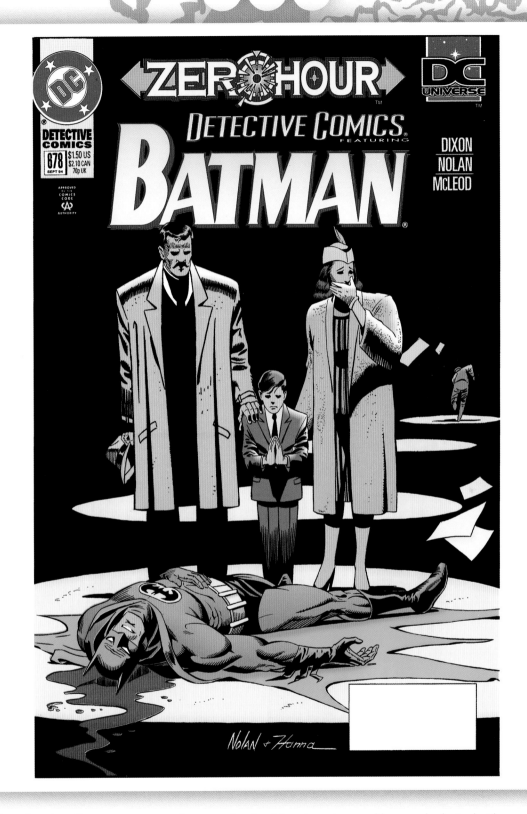

What-if stories allow creators to explore new facets of the characters, and here we look at what happened should Joe Chill have killed only young Bruce Wayne.

Detective Comics #678, September 1994
Artists: Graham Nolan & Scott Hanna

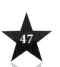

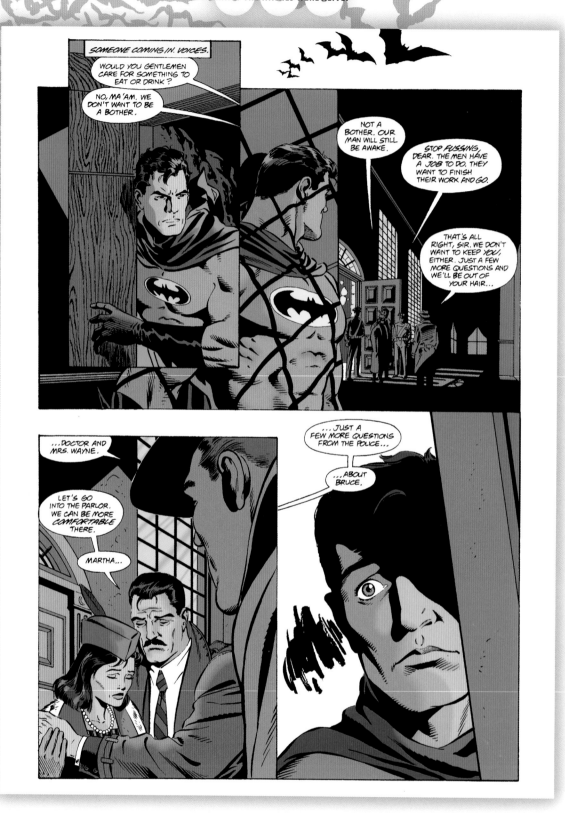

Detective Comics #678, September 1994
Writer: Chuck Dixon *Artists:* Graham Nolan & Bob McLeod

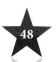

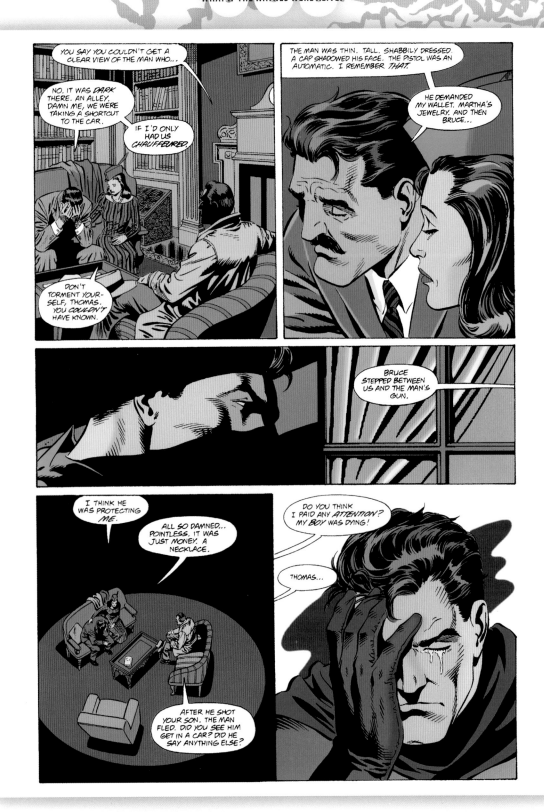

Detective Comics #678, September 1994
Writer: Chuck Dixon Artists: Graham Nolan & Bob McLeod

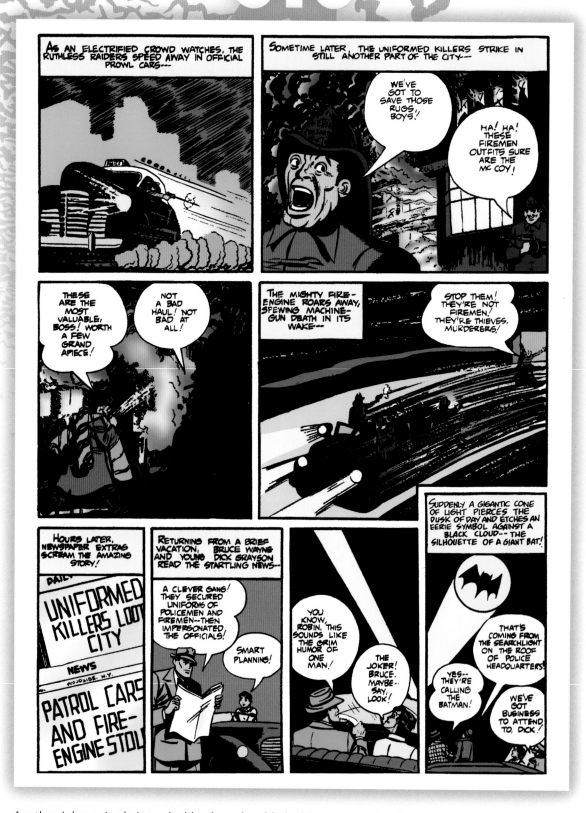

Another Joker episode is marked by the unheralded addition of the Bat-Signal, summoning the Dynamic Duo to police headquarters. It has remained a part of the mythos ever since.

Detective Comics #60, February 1942
Writer: Jack Schiff *Artists:* Bob Kane, Jerry Robinson & George Roussos

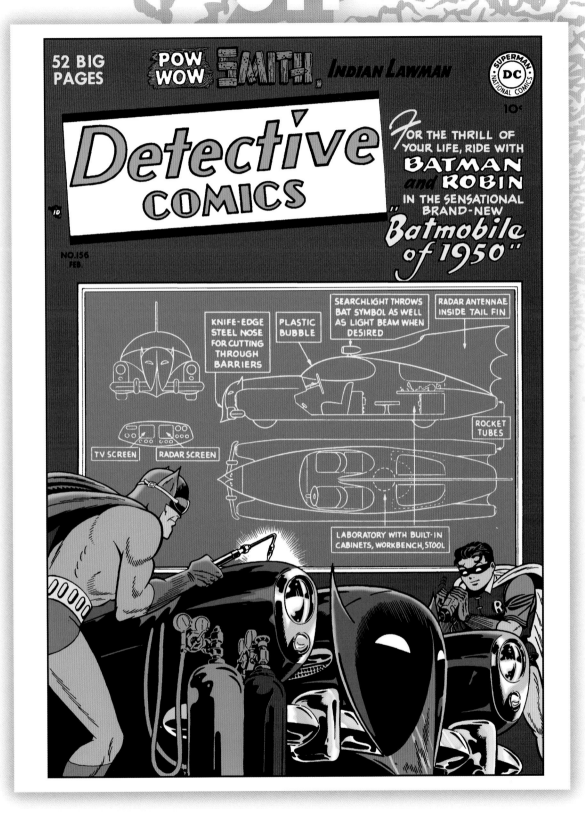

Reflecting changing times and tastes, a brand-new, memorable Batmobile is introduced, one of the most enduring vehicles in all of comic book history.

Detective Comics #156, February 1950
Artist: Dick Sprang

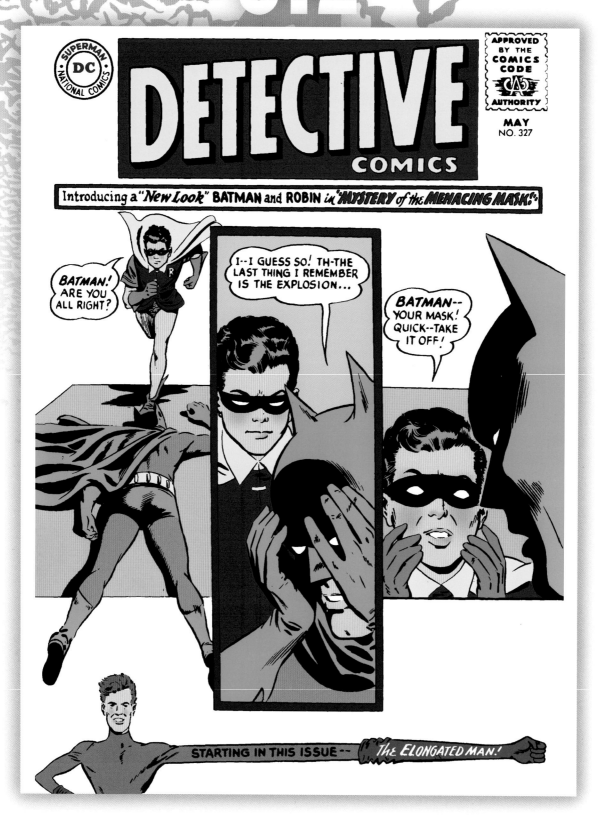

Given just six months to turn things around, editor Julie Schwartz didn't waste time and told readers on the first cover that everything had changed, from Ira Schnapp's logo to the more realistic art style.

Detective Comics #327, May 1964
Artists: Carmine Infantino & Joe Giella

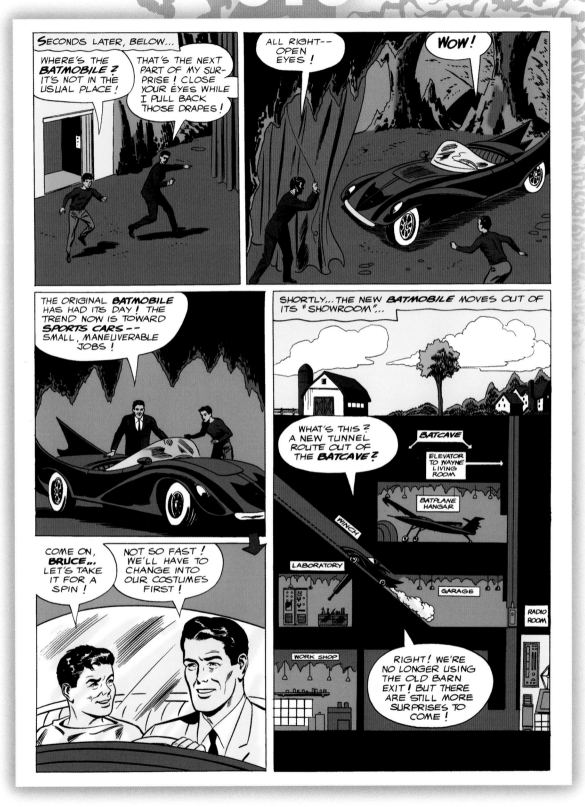

While the first New Look story showed changes in storytelling, this issue introduced modifications to the Batcave and, more importantly, a new, sleeker Batmobile, once more reflecting changing technology.

Batman #164, June 1964
Writer: Ed Herron *Artists:* Sheldon Moldoff & Joe Giella

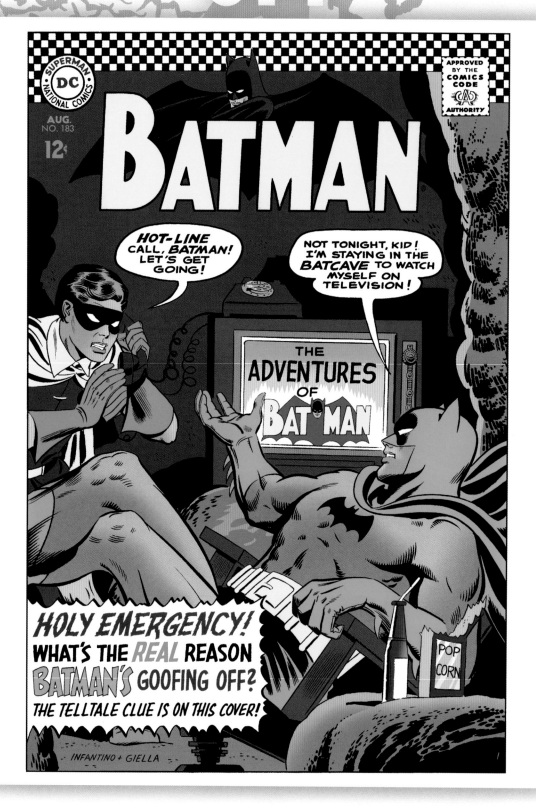

Once the ABC TV series proved a blockbuster hit, orders were to emphasize Batman wherever possible. Editor Julie Schwartz directly references the show in this meta cover.

Batman #183, August 1966
Artists: Carmine Infantino & Joe Giella

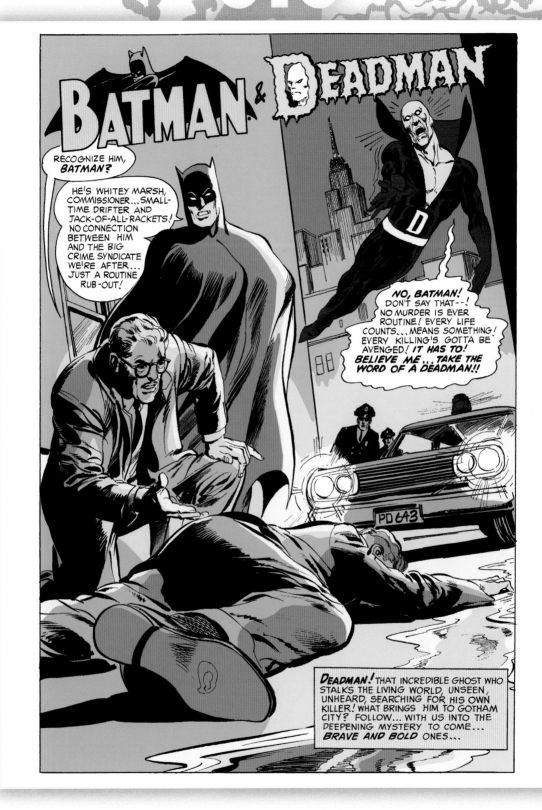

Editor Murray Boltinoff took a chance on relative newcomer Neal Adams and made him the regular artist on *The Brave and the Bold*, immediately adding gravitas to Bob Haney's fanciful stories.

The Brave and the Bold #79, September 1968
Writer: Bob Haney *Artist:* Neal Adams

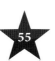

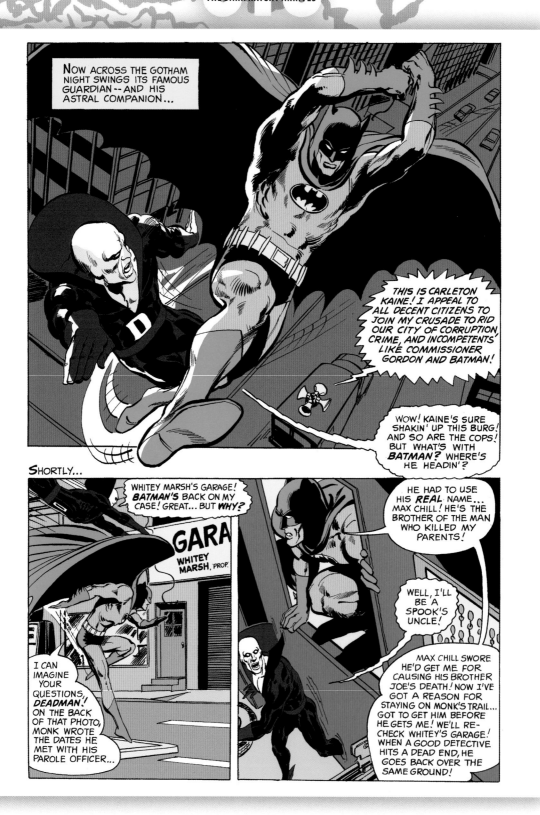

The Brave and the Bold #79, September 1968
Writer: Bob Haney *Artist:* Neal Adams

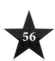

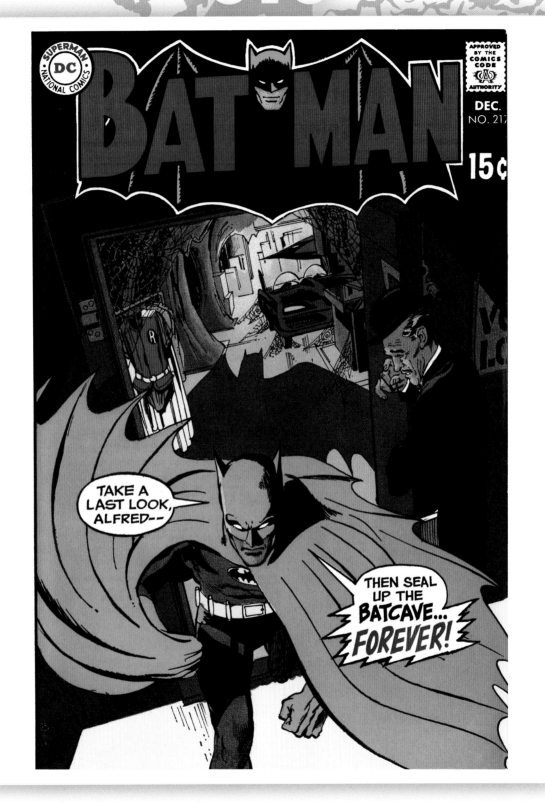

Over time, Dick Grayson was allowed to age, until finally it was time to send him off to college, allowing the status quo to be updated for a new generation.

Batman #217, December 1969
Artist: Neal Adams

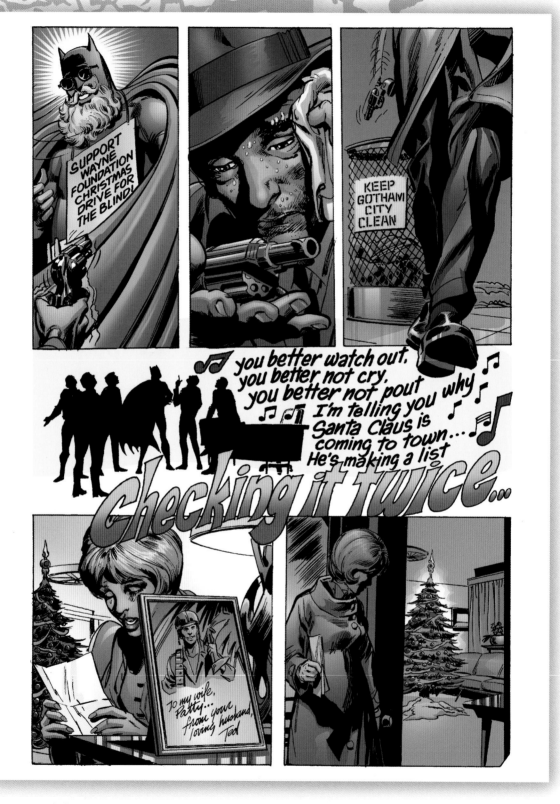

Batman and Christmas were an oddly successful combination, never more effective than in this oft-repeated short story, making the Gotham Guardian part of the spirit of the season.

Batman #219, February 1970
Writer: Mike Friedrich *Artists:* Neal Adams & Dick Giordano

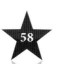

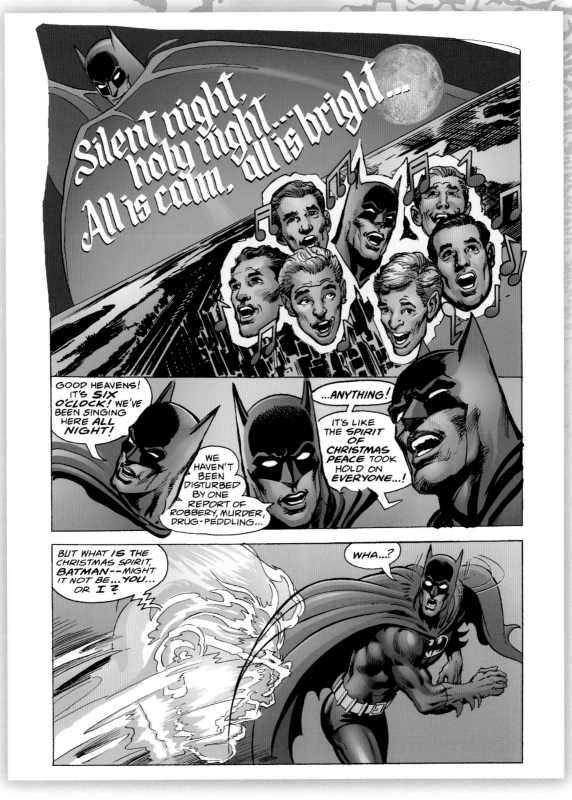

Batman #219, February 1970
Writer: Mike Friedrich *Artists:* Neal Adams & Dick Giordano

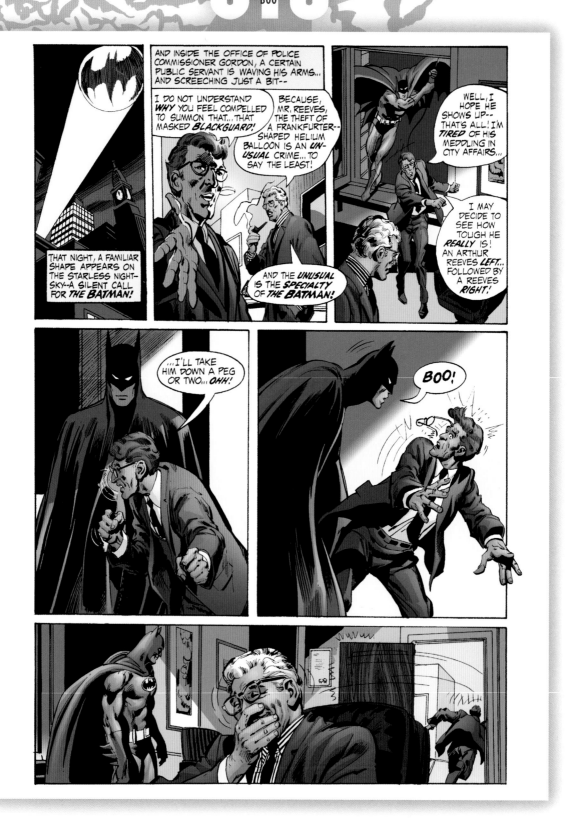

While the O'Neil/Adams collaboration was known for its back-to-the-roots approach, it was not without moments of mirth, such as playing with Batman's reputation of striking fear into cowards.

Batman #234, August 1971
Writer: Dennis O'Neil *Artists:* Neal Adams & Dick Giordano

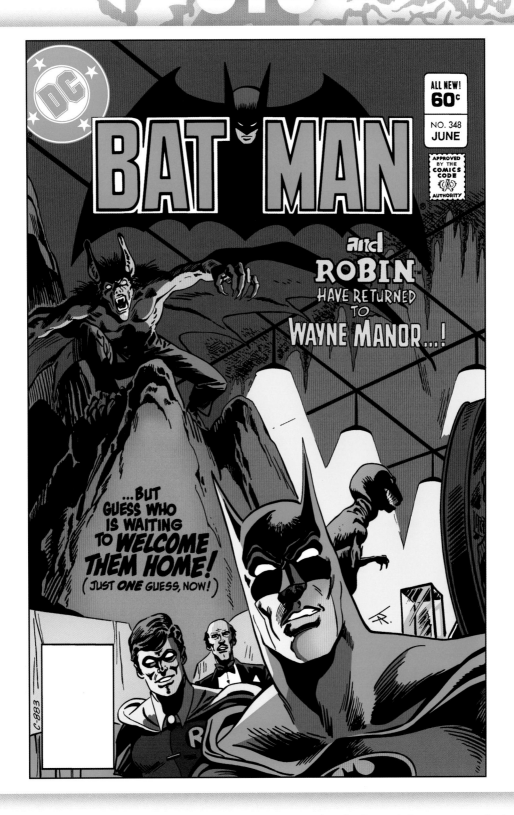

Editor Dick Giordano and writer Gerry Conway felt it appropriate that the Dynamic Duo return to the basics,
which meant reopening Wayne Manor and relocating operations to the Batcave, a move welcomed by fans.

Batman #348, June 1982
Artist: Jim Aparo

A recovered Bruce Wayne wants the mantle of the bat back, but Jean-Paul Valley doesn't want to return it, forcing this final confrontation.

Legends of the Dark Knight #63, August 1994
Writer: Dennis O'Neil *Artists:* Barry Kitson & Scott Hanna

Legends of the Dark Knight #63, August 1994
Writer: Dennis O'Neil *Artists:* Barry Kitson & Scott Hanna

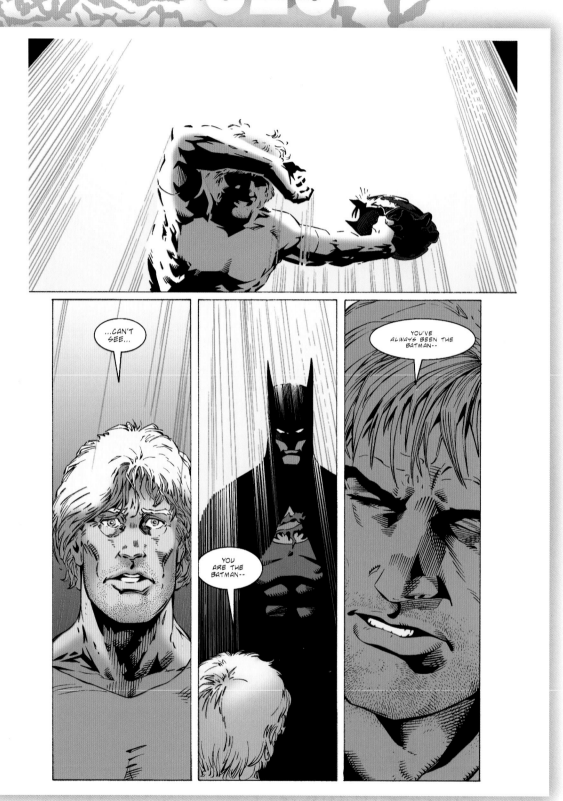

Legends of the Dark Knight #63, August 1994
Writer: Dennis O'Neil *Artists:* Barry Kitson & Scott Hanna

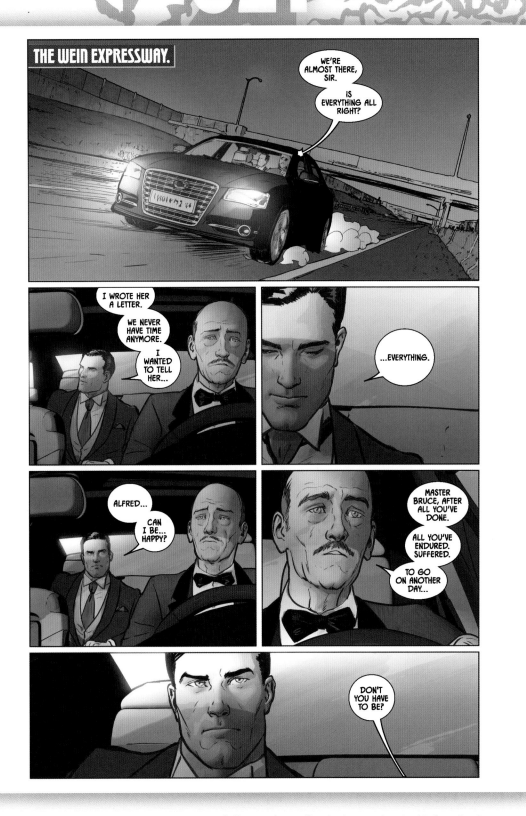

Bruce Wayne is uncomfortable with the notion of allowing himself to be happy despite his love for Catwoman. When jilted at the altar, he puts those thoughts behind him.

Batman #50, September 2018
Writer: Tom King *Artist:* Mikel Janín

Batman #50, September 2018
Writer: Tom King *Artist:* Mikel Janín

CHAPTER 3
THE BATMAN FAMILY

BATMAN HAS BEEN STYLED AS A LONER, A DARK AVENGER IN THE MOLD OF THE PULP HEROES. IT BECAME CLEAR TO BOB KANE AND BILL FINGER THAT HE WAS BETTER OFF HAVING SOMEONE TO TALK TO. AS A RESULT, ROBIN THE BOY WONDER WAS ADDED, AND THE DYNAMIC DUO WAS BORN. IN SHORT ORDER, ALFRED TOOK UP RESIDENCE IN WAYNE MANOR AS THE FAMILY BUTLER, SOMEONE ELSE TO SHARE IN THE ADVENTURES. AND SO IT REMAINED UNTIL THE MID-1950S.

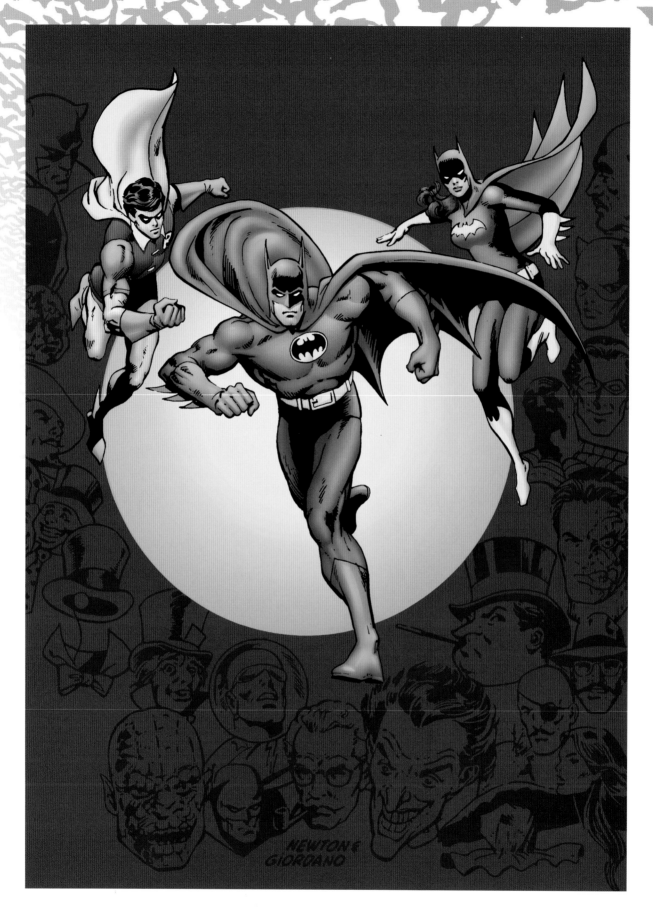

At that point, Dr. Fredric Wertham's *Seduction of the Innocent* theorized that the chummy closeness between Bruce Wayne and Dick Grayson was depicted in a way that promoted homosexuality. To combat that, editor Jack Schiff added circus owner Kathy Kane, who donned a yellow and red outfit, showing up as Batwoman. To round things out, her niece Betty became Bat-Girl, so both males had counterparts, adding romantic elements that had been largely absent from the goings-on.

The New Look Batman in 1964 jettisoned the women along with other elements, until late 1966, when a brand-new Batgirl arrived on the scene. The Dynamic Duo became an occasional trio, which is how things stood until the 1990s. The success of the 1989 feature film generated a growing demand for Batman material, giving the creative teams a chance to expand the mythos and the family. We gained a few versions of the Huntress, a Spoiler, new Batgirls, second and third Robins, and so on. Despite protestations otherwise, Batman was now the head of a family of crime fighters and in time came to embrace the concept.

But with that acceptance came the realization of the responsibility involved in granting others a place beside him. There was training and discipline, trust and acceptance, and not everyone met with approval or agreed with his methods. And from these conflicts came great stories.

22. ALFRED DISCOVERS THE SECRET

Alfred Beagle showed up at Wayne Manor, announcing he had promised his father Jarvis, the Wayne family's previous butler, that he would take up the role. Bruce Wayne didn't anticipate a third party living in the manor, fearing it would compromise his and Dick Grayson's alter egos of Batman and Robin.

They invented good excuses for their nocturnal absences, but in time, Alfred stumbled into the Batcave and kept the secret to himself. That is, until one night when the Bat-Signal shone in the sky and Alfred arrived with their freshly pressed uniforms on his arm. He then became a welcome addition.

It was believed that the writers of the 1943 *Batman* serial—Victor McLeod, Leslie Swabacker,

and Harry L. Fraser—developed Alfred, and editor Whitney Ellsworth had the character added to the comics. When they cast William Austin in the role, the portly Alfred was slimmed down and grew a mustache to match, and that look has pretty much remained ever since.

The Earth-1 and all subsequent realities have Alfred Pennyworth, with a proper British upbringing, as the manservant. Depending on the reality, he was a would-be actor or former freedom fighter working with the French underground. In the pre–Infinite Crisis reality, Alfred Beagle served in the British army, training as a field medic before being recruited to work with MI5 until circumstances required that he change his identity and relocate. Alfred Pennyworth arrived at Wayne Manor to take over from his father as the Wayne butler, where he formed a close attachment with young Bruce, becoming a surrogate father in the wake of Thomas and Martha Wayne's murders.

23. ALFRED, BATMAN'S BEST FRIEND

Alfred Pennyworth has been a mentor, friend, and surrogate father to Bruce Wayne in most retellings of the origin. He maintained the manor during the years Wayne traveled the world, training to become a feared vigilante. Often, Alfred disapproved of the life choices being made by Bruce, but rather than walk away, he remained, acting as his conscience and aide-de-camp.

The bond between the two men has only deepened since the 1990s, as countless stories explored how Alfred helped raise a grieving young Bruce or helped him turn a cave into a crime-fighting headquarters. Whereas earlier stories comically depicted Alfred as either a sleuth on his own or a badly disguised Caped Crusader, he has generally remained back at Wayne Manor or deep in the Batcave. His field training has allowed him to tend to the unending series of wounds and injuries suffered by Batman and other members of his team.

Alfred has also become well-versed in the high-tech gear used to aid the campaign against

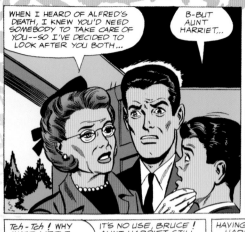
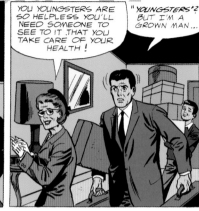
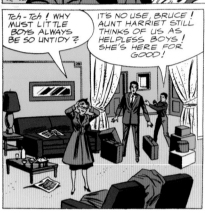
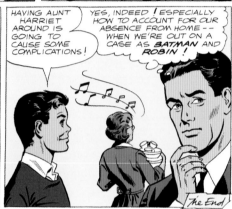

evil, adopting the call sign "Penny One" to provide support and guidance to Batman. His skills have earned not only Batman's trust but that of many other heroes, from Superman on down.

Still, he remains the consummate man-servant, able to cook and serve Michelin-caliber meals and keep the manor in spotless condition.

24. THE DEATH OF ALFRED

There came a time when Alfred died. Incoming editor Julie Schwartz was keenly aware of Dr. Fredric Wertham's accusations of an unhealthy relationship between Bruce Wayne and Dick Grayson. As he readied the New Look, Schwartz deemed that the series needed a female presence and a convincing way to add her to the series.

He concocted a plot to have Alfred die, a noble death, of course, and replace him with Dick Grayson's aunt Harriet Cooper. She arrived to take care of the two men and in time found the Batcave and then contrived to find ways to prove the

Dynamic Duo were her charges. She left the manor only when Dick left for Hudson University.

However, you can't keep a good manservant down for long. When ABC committed to a Batman series, Alfred *and* Aunt Harriet were added to the show. In fact, Alan Napier was the first actor cast on the show, which required Schwartz to resurrect the butler. This dovetailed with a preestablished series wherein the heroes were plagued by a powerful foe named the Outsider. In time, Batman learned that Alfred's corpse had been stolen from a refrigerated mausoleum by scientific genius Dr. Brandon Crawford, who experimented on the body, resurrecting the man but twisting his mind. It took Batman luring the Outsider near the regeneration machine's radiation to restore his friend to normal. Alfred resumed his duties as if nothing had happened.

In the wake of Alfred's death, Bruce Wayne had founded the Alfred Memorial Foundation, and once Alfred returned to life, he renamed it the Wayne Foundation, and so it has remained ever since, providing charitable works in Gotham and around the world.

25. ROBIN PASSES THE TEST

In 1940, it was easy to accept that Dick Grayson, a budding trapeze artist, would easily transition to the slingshot-wielding Robin the Boy Wonder. Later realities and retellings of the origin story added elements that made the sidekick's debut more plausible.

He tried his first acrobatic effort at age two, earning him the nickname Robin from his mother. He loved traveling the country with the Flying Graysons, a star attraction of Haly's Circus. Dick joined the family act while still young, only to watch his parents plunge to their deaths, a result of Boss Zucco's efforts to exhort protection money from Haly.

In a 1997 account, the angry boy tried to attack the man who had sliced the ropes, only to be injured, receiving a concussion. Batman brought the youth to a hospital for treatment before he was placed in a Catholic orphanage. Wayne couldn't get the grieving boy's image from his mind and finally gained legal custody.

When Bruce Wayne took in the orphan, he saw the youth's potential and, after revealing his alter ego, agreed to train the boy. Six grueling months of physical and mental preparation followed.

There came one final test: Robin had to elude Batman for an entire evening. The young man proved himself more than capable, not only avoiding the Dark Knight but apprehending minor criminal Joe Minette. Only then was Robin given permission to join Batman on patrol.

"Dad was right," Dick once said. "He taught me to be careful, to know my limitations and never over-reach myself . . . and Mom taught me to keep on trying to extend my reach, by learning about myself . . . my skills . . . my potential. They made it safe to work without a net."

26. DICK GRAYSON LEAVES FOR COLLEGE

With the *Batman* series canceled and Batmania fading, Julie Schwartz felt it was time to get back to his original vision of Batman as a creature of the night. Times, though, had changed, and it was now acceptable to add social themes to the stories. Working with comic strip veteran Frank Robbins as writer, they determined that Batman would go back to being a solo act. That raised the issue of what to do with Dick Grayson.

Throughout the 1960s, Schwartz allowed artist Carmine Infantino to begin drawing Robin as a teenager, no longer a ten-year-old. Artist Nick Cardy did the same in *Teen Titans*, and then Burt Ward's interpretation of the character made it more acceptable to see that Dick Grayson had grown up. Writing him out of the series and sending him away to college was the next logical step.

This also allowed Schwartz to replace the Elongated Man in the back of *Detective Comics* with a Robin solo series, depicting what was happening

at Hudson University, also written at first by Robbins. It wasn't long before letter column regulars Mike Friedrich and then Bob Rozakis began writing for Schwartz, with Robin among their assignments. Being closer in age to Grayson, their sensibilities infused the series with fresh energy. Taking a cue from Robbins, Friedrich used contemporary events, such as campus protests and the Kent State tragedy, to fuel the stories. Friedrich's take on the character was influential through the 1980s.

Robin gained new foes, new loves, and a new sense of self as he operated on his own. Still, he returned to Gotham often, partnering with Batman and still leading the Titans. In the post-Crisis continuity, his college studies lasted just one semester as his adventuring took precedence in his life.

27. PRAISING ROBIN

Slowly but surely, Batman and Bruce Wayne accepted the idea that Robin and Dick Grayson had grown into a capable adult. They remained partners more often than not, but over the years, writers began exploring the differences in their approaches and styles. This created conflict, with Robin chafing at being given "my way or the highway" orders.

Robin was resistant because he had more than proved himself a capable field leader. While Batman served with the Justice League of America in its various incarnations, he remained a step removed from them, rarely leading them. Dick, though, had bonded early with fellow sidekicks Kid Flash, Aqualad, and Wonder Girl, forming the Teen Titans. They grew up together, learning from one another and, perhaps more importantly, forming bonds that could only occur because they each had mentors that occasionally frustrated the adolescents.

Because of Batman's training, Robin was a proven leader, trusted by all, and his strategies never questioned.

It was inevitable that Batman and Robin would find themselves with their respective teams, though in this case, Batman was leading the Outsiders, having quit the League. Here, the two teams were in pursuit of Dr. Helga Jace, who

had been kidnapped by members of the Fearsome Five, in order to force her to augment their powers. It was during this time that the teams learned that their respective members Geo-Force and Terra were siblings. More than that, the sharp-eyed Caped Crusader noted how well his ward handled his team.

In the aftermath, the two shared a moment, with Batman offering rare praise to his partner, noting how Dick excelled as a leader. Years later, this would prove pivotal when Batman's emergency contingency plans recruited a replacement JLA with Dick, now Nightwing, as its leader.

28. BATWOMAN—PARTNER AND LOVER?

Created in 1956 as a Comics Code–approved replacement for Batman's criminal crush Catwoman, socialite Kathy Kane was inspired by the Caped Crusader to become the heroic Batwoman. Somewhat nonplussed to see the heroine and her utility pocket book, Batman and Robin soon welcomed her help. As Batman had inspired Kathy, her new alter ego inspired her niece Betty Kane to become Bat-Girl.

Batman kept asking Kathy to give up this dangerous work, but she refused. This proved potentially fatal when she and Batman were drained of their life energy, which was transported to an alien world. Their teen sidekicks were similarly sent to a different planet. In both cases, without their vital life essences, the humans weakened, nearing the brink of death. At one vulnerable moment, Batman and Batwoman admitted their romantic feelings for each other and kissed.

Once they managed to be reunited with their life energy, the two seemed embarrassed by the moment and never spoke of it again. Alfred had long been aware of the attraction, however, and had been writing a series of imaginary tales about a prospective marriage even before that harrowing moment on an alien world.

A year later, Batwoman hung up her cape and threw her energies into the circus she owned. Years later, a new Batgirl encouraged her to come out of retirement, but her return was short-lived. Murdered by the League of Assassins, Kathy was

avenged by a grieving Batman. In the current Prime Earth reality, Bruce Wayne and Batwoman Kate Kane are cousins on his mother's side and are more often than not allies.

29. BATGIRL JOINS THE TEAM

In spring 1966, producer William Dozier was already worrying about the ratings for *Batman* despite the incredible response to the short first season. He asked Julie Schwartz about adding a female bat-character to the comics who could then be featured on the show. By June, Gardner Fox had written the script, and the story, illustrated by Carmine Infantino and Sid Greene, arrived in November. By February, dancer turned actor Yvonne Craig had been selected to play the new hero, and a short demo reel was shot based on the debut story, with Killer Moth as the villain. By September 1967, fans everywhere met Batgirl and her alter ego, Commissioner Gordon's librarian daughter Barbara (not that we ever met Mrs. Gordon).

The cover had a huge impact on readers and has been imitated repeatedly. According to the letter column in *Detective Comics* #363, fans were five to one in favor of her arrival, and she made increasingly frequent appearances. Later, when Robin took over the backup berth in *'Tec*, he eventually began alternating with Batgirl solo stories. She was also featured in the syndicated comic strip, arriving there in April 1967, five months before her television debut. There, she was portrayed as more of a mystery—was she heroine or criminal?

Once she hit the four-color pages, she was quickly used elsewhere. Editor Mort Weisinger began pairing her with Supergirl in *World's Finest Comics* stories, pitting them against their male counterparts.

Between 1966 and today, Barbara has been through a lot, periodically ceding her Batgirl persona to others (Stephanie Brown, Cassandra Cain, Helena Bertinelli), but has been restored to her cape and cowl since the Rebirth and Prime Earth eras.

30. MEETING THE HUNTRESS

On Earth-2, Bruce Wayne and Selina Kyle married and had a daughter, Helena. By then, both had retired as Batman and Catwoman, but they trained their child to be a proficient athlete and scholar. She earned a law degree, joining the firm of Cranston, Grayson & Wayne, working alongside Dick Grayson. Then came the day a criminal coerced Selina into putting on her costume one final time, and she died while committing a crime. Enraged, Helena designed her own outfit and sought the man responsible for her mother's death. The Huntress succeeded and remained operating as a hero, eventually joining the Justice Society of America. Once again, fate intervened and Batman was needed one final time, giving his life to save others. The Huntress honored both parents by continuing her fight, occasionally alongside Grayson, the one-time Robin.

Periodically, the two crossed the dimensional barrier to Earth-1, where she met her father's counterpart. Once the oddness of the moment had passed, she sought advice from her father's counterpart, leading to an adventure with her

Earth-1 mother and also the first Batwoman. They worked together on several occasions, with Helena coming to call him "Uncle Bruce."

All of that ended as the multiverse was collapsed during the Crisis on Infinite Earths.

31. JASON TODD STEALS BATMOBILE TIRES

DC Comics decided it was time for Dick Grayson to really grow up. He had been moving further and further away from Batman's shadow and came into his own leading the New Teen Titans. Creators Marv Wolfman and George Pérez were given permission to sever Robin from Batman. A series of stories was produced wherein Bruce Wayne adopted a driven new youngster and inspired a soul-searching Dick Grayson to graciously retire as Robin, donning a new uniform and taking the code name Nightwing, honoring a Kryptonian persona previously used by Superman.

While Editorial was comfortable with this milestone, the company's licensing arm argued that they continued to need a Robin. Batman editor Len Wein was asked to create a new one, and he huddled with writer Gerry Conway, creating Jason Todd. His origins were remarkably similar to Dick Grayson's. His parents were performers for the Sloan Circus and died when they tried to expose Killer Croc's protection racket. The redheaded Jason was taken in by Bruce Wayne, and he dyed his hair to hide his identity, so after a time, the second Boy Wonder was barely distinguishable from the first.

After the events of Crisis on Infinite Earths, it was decided to revamp Jason. Incoming writer Max Allan Collins made him a nine-year-old street urchin, first found in Crime Alley trying to rip off the Batmobile's tires. He explained that his criminal father was dead and he believed his mother was as well, so he had learned to fend for himself.

32. JASON TODD BECOMES ROBIN

There was something in the youth that spoke to the Caped Crusader, so he took Jason Todd to Ma Gunn's School for Boys, which turned out to be a criminal front. Jason aided Batman in bringing an end to that threat to other youth, and it was decided that he would come home and be trained to be the new Robin. In time, he was approved to go public and was first introduced to Commissioner Gordon.

Unlike the obedient and trustworthy Dick Grayson, Jason proved stubborn and headstrong. His life on the streets had hardened him, and his moral compass was somewhat askew. Time and again, Batman had to restrain him or carefully explain why things were done a particular way. Despite not growing into the role, Jason was allowed to continue as Robin while Batman patiently worked with him.

When he went searching for his mother, he finally located her, only to discover she was working for the Joker, who was delighted to see the Boy Wonder. So much so that he beat the boy to near death with a crowbar before a detonated bomb finished the job.

It took a reality-altering wave caused by Superboy-Prime to resurrect him, now an adult. He was discovered by Talia al Ghul, who bathed him in a Lazarus Pit, completing the revival. Today he operates as the Red Hood, a vigilante.

33. BRUCE AND DICK DISCUSS JASON

After splitting from Batman, Dick Grayson kept his distance, letting the new Robin, Jason Todd, settle in. Although they had parted on good terms, it was an awkward time for the Dynamic Duo as Dick retired his Robin persona and became Nightwing. In his own way, it was a declaration of independence while he maintained the dark colors and bat-like mask to honor his mentor.

At the wedding of Donna Troy, Wonder Girl, the two found themselves in a contemplative moment. At this point, Batman and Jason were estranged and the boy had fallen under the sway of Natalia Knight, known to most as the criminal Nocturna. She played the maternal role the youth sought, and he allied himself with her while she used him as a pawn, trying to marry the millionaire. When she petitioned the courts to adopt the boy, mayor Hamilton Hill persuaded the judge to approve it since Wayne was backing his rival during an election.

When the two men saw each other, Dick was consumed with the notion that Bruce wanted to formally adopt Jason, something he never did for Dick.

The conversation helped alleviate the father and son's underlying tensions, but revisions in the fast-approaching post-Crisis reality assured that Nightwing would not be a regular visitor to the Batcave for another decade.

34. TIM DRAKE JOINS THE TEAM

Jason Todd was dead, killed by the Joker. Batman was growing more obsessive and violent, a seemingly out-of-control loner. The brilliant teen Tim Drake realized the problem: Batman needed a Robin. As it happened, young Tim had attended a

Haly's Circus performance in Gotham City, having his picture taken with the Flying Graysons the night they plummeted to their deaths, and soon after saw Batman comfort a young Dick Grayson. Three years later, he recognized Robin performing Dick's quadruple somersault and realized the connection.

He noticed a change in Robin and then the absence of the sidekick. Then came the loner phase.

Tim tracked down Nightwing and explained his observations but could only get a promise that Nightwing would keep an eye on Batman. Deeming this insufficient, he made his way to Wayne Manor and convinced Alfred to let him borrow a Robin uniform from the Batcave. Untrained but eager to help, this third Robin came to Batman and Nightwing's aid in a fight with Two-Face.

Alfred and Nightwing agreed with Tim that Batman needed a Robin to temper him. Batman was unconvinced, feeling he'd failed Jason Todd. Finally, he relented but insisted the training would be harder and more intensive. Batman, Nightwing, and Alfred all tutored him until Tim's parents were kidnapped in Haiti. While Janet Drake died, Tim's father, Jack, was left in a coma, leaving Bruce Wayne to raise Tim.

Finally, when Tim saved Batman and Vicki Vale from the Scarecrow, the third Robin was officially sanctioned.

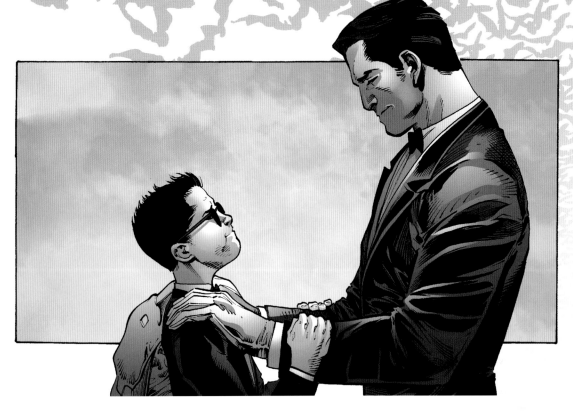

35. FATHER MEETS SON

In 1988, the first Batman graphic novel was released. *Son of the Demon*, by Mike W. Barr and Jerry Bingham, resurrected the rivalry between Ra's al Ghul and the Dark Knight. When the two realized they needed to ally themselves against a common enemy, the Demon's Head pressed his advantage. Having once kidnapped Batman and performed a wedding ceremony between Talia and the unconscious hero, he now insisted Batman take her hand.

In the course of events, Batman and Talia had consensual sex and she got pregnant. By story's end, after having lied about a miscarriage, she left her infant son at an orphanage.

So things remained until 2006 when Grant Morrison upended the status quo and introduced Talia with seven-year-old Damian at her side. In this New 52 reality, Damian was genetically perfected and grown in an artificial womb, but still the son of Batman and Talia. Trained from birth to be heir to the League of Assassins, Damian was brilliant, ruthless, and arrogant as hell. She finally brought him to meet his father when he was ten, a ploy designed to throw Batman off his game while she readied her global network known as Leviathan.

That first meeting did not go well. Damian was dismissive of Batman's no-killing and no-guns rules and thought Alfred was there to be ordered about and that the Batcave sucked.

After time together, the rougher edges were smoothed a bit, although the arrogant, superior attitude remained.

36. SCAVENGER HUNT

The fifth Robin, Damian Wayne, had settled in—mostly—as part of the Dynamic Duo. At one point, he had left Wayne Manor and instructed Alfred to inform his father that a scavenger hunt had begun. Damian would leave clues for the Dark Knight to follow, starting in London. Annoyed but intrigued, Batman followed the clues while Damian had actually remained in Wayne Manor. There, he donned a batsuit and relished the notion of patrolling Gotham City on his own.

In England, Bruce and Alfred learned that the first clue was left in a hotel once visited by

Thomas and Martha Wayne, along with their very young son, Bruce. There, Bruce had left a handprint on a hotel painting, something that charmed his mother. Thomas arranged for the hotel to keep the painting as is.

While in Barcelona, Bruce was directed to the very spot where his parents posed for a photo during their honeymoon. Soon after, he and Alfred wound up in Greece, and at the foot of a column, Bruce spied a stone with faint writing. Rubbing it with a pencil and paper, he revealed the message to read: "Martha, will you marry me? Thomas." He left the stone there as a memorial to his parents' love.

Returning to London, Bruce and Alfred met up with Damian, who had had his own successes in Gotham. Bruce told his son that the effort was a much-appreciated one.

37. BATWOMAN AND THE GOTHAM KNIGHTS

Call someone a knight, and you imagine shining armor and codes of chivalry. In Gotham, it makes you think of the local baseball team. But when Batman asks Batwoman to form a new team, it's the only name that fits the odd conglomeration.

Despite the blood connecting Bruce Wayne to Kate Kane, the relationship between the two costumed heroes has been fraught with conflict. As a result, it took a lot of persuading to get her to agree to use her military training to forge a new force for justice in Gotham City.

He had already selected the membership: Tim Drake, now known as Red Robin in the Prime Earth reality; Tim's former girlfriend Stephanie Brown, aka the Spoiler; Cassandra Cain, the almost mute fighter called Orphan; Jean-Paul Valley, Azrael the Avenging Angel; and Basil Karlo, the amorphous Clayface, a villain in need of redemption before he loses his sanity.

Working out of a headquarters dubbed the Belfry, they take the name Gotham Knights after a while, but it wasn't hard to coin considering their training and the round meeting table. They were gathered to form an army before opposing forces could take them one at a time, unaware that Kate's own father was involved with his secret government cabal.

While Batwoman was the leader, Red Robin was its heart and soul, so trouble began when he was believed dead, and the cracks that formed in his absence never fully healed, even when he came back.

The Knights functioned well until Clayface finally lost his sanity and Batwoman chose to end his life rather than let him endanger the citizenry, prompting the team to fall apart. Batwoman has continued to operate on her own, completely comfortable with her loner status.

No sooner does Bruce Wayne gain the unexpected services of Alfred, his new butler, than the manservant stumbles across his master's heroic secrets.

Batman #16, February 1943
Writer: Don Cameron *Artists:* Bob Kane, Jerry Robinson & George Roussos

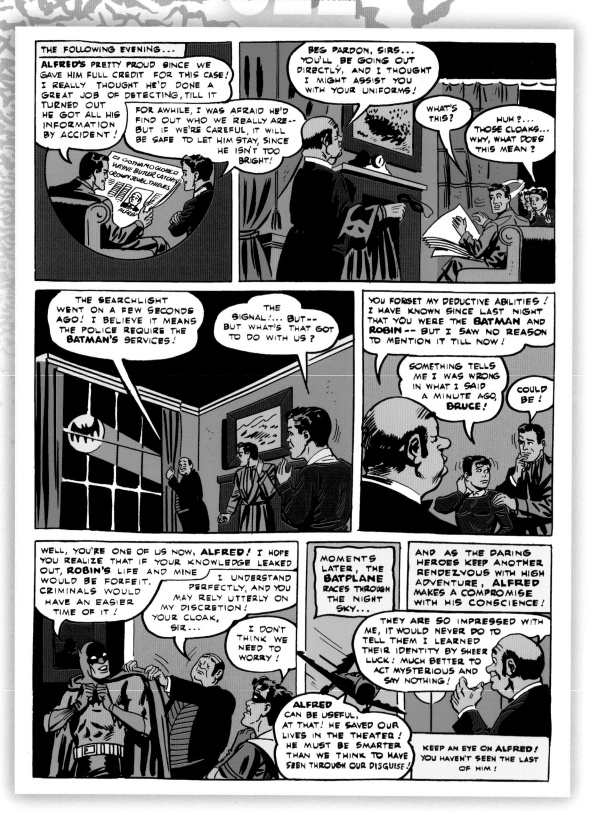

Batman #16, February 1943
Writer: Don Cameron Artists: Bob Kane, Jerry Robinson & George Roussos

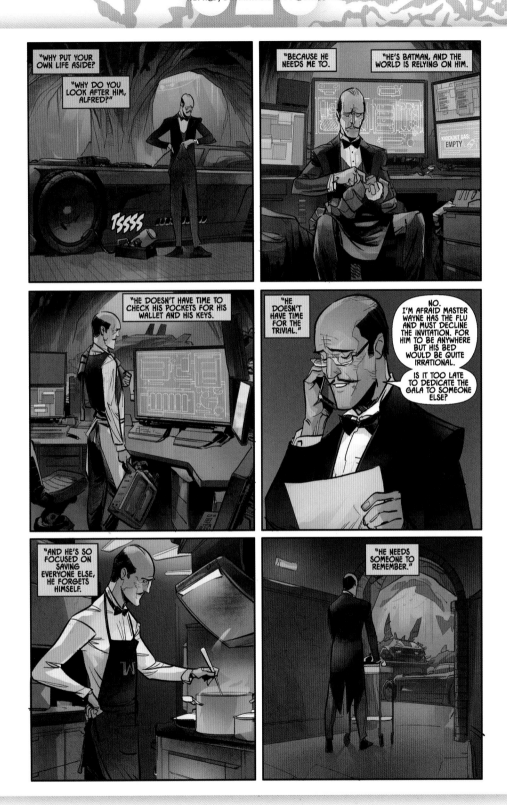

So vital is he to Bruce Wayne and Batman that Alfred manages to get away with the most arch comments and sarcastic statements about his friend's evening activities.

Batman Annual #3, February 2019
Writer: Tom Taylor *Artist:* Otto Schmidt

Batman Annual #3, February 2019
Writer: Tom Taylor *Artist:* Otto Schmidt

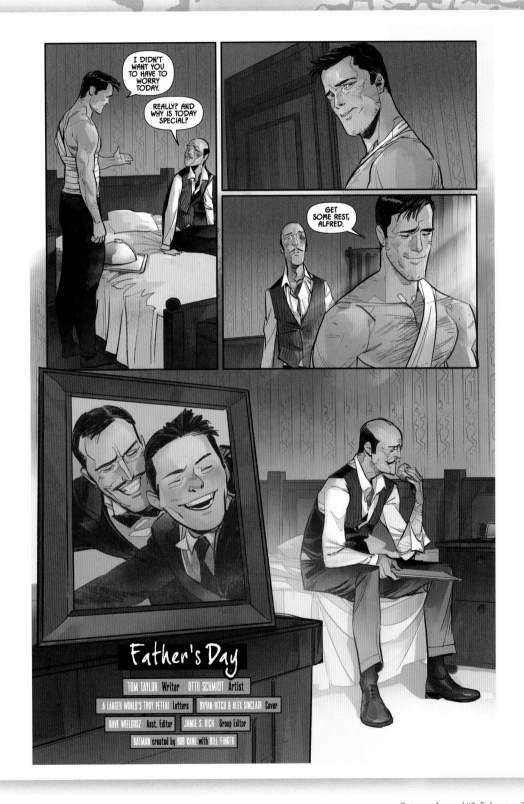

Father's Day

TOM TAYLOR Writer OTTO SCHMIDT Artist

A LARGER WORLD'S TROY PETERI Letters BRYAN HITCH & ALEX SINCLAIR Cover

DAVE WIELGOSZ Asst. Editor JAMIE S. RICH Group Editor

BATMAN created by BOB KANE with BILL FINGER

Batman Annual #3, February 2019
Writer: Tom Taylor *Artist:* Otto Schmidt

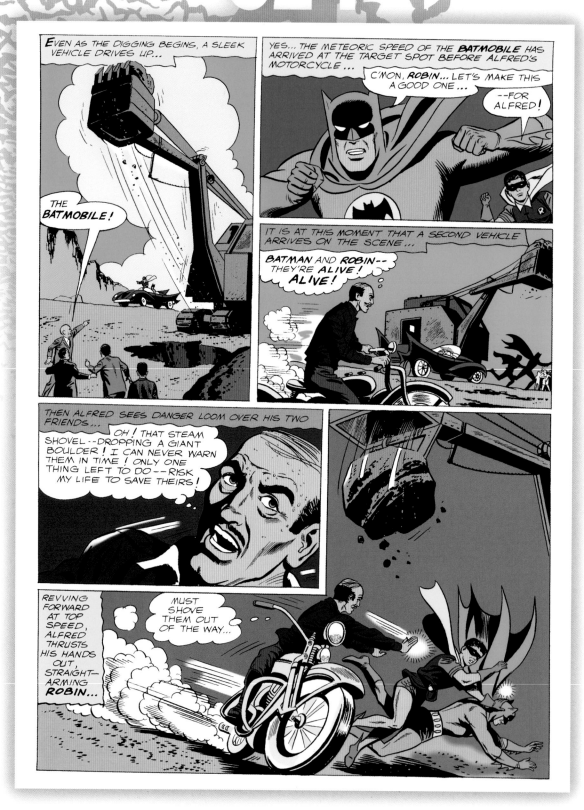

Furthering the alterations to the status quo, editor Julie Schwartz decided to add a feminine element to the series, adding Dick's Aunt Harriet, but her arrival was in response to Alfred Pennyworth's tragic death, as he aided his loved ones.

Detective Comics #328, June 1964
Writer: Bill Finger *Artists:* Sheldon Moldoff & Joe Giella

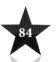

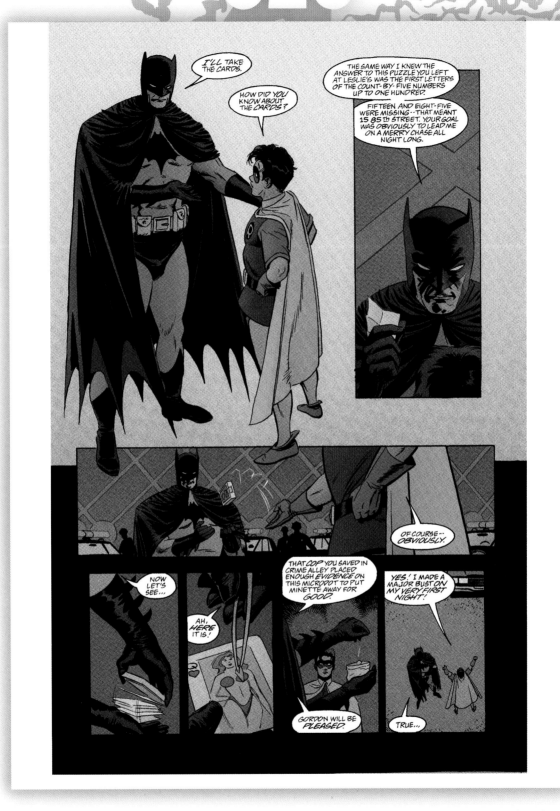

Filling in a gap of the legend, Robin the Boy Wonder is sent out on patrol solo and has to work without Batman's aid. Of course, he earns passing marks.

Batman Chronicles: The Gauntlet, September 1997

Writer: Bruce Canwell *Artist:* Lee Weeks

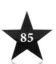

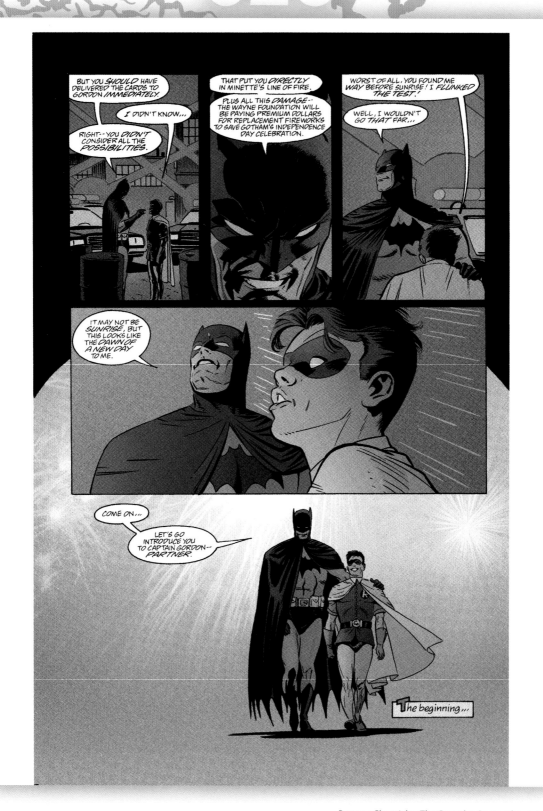

Batman Chronicles: The Gauntlet, September 1997
Writer: Bruce Canwell *Artist:* Lee Weeks

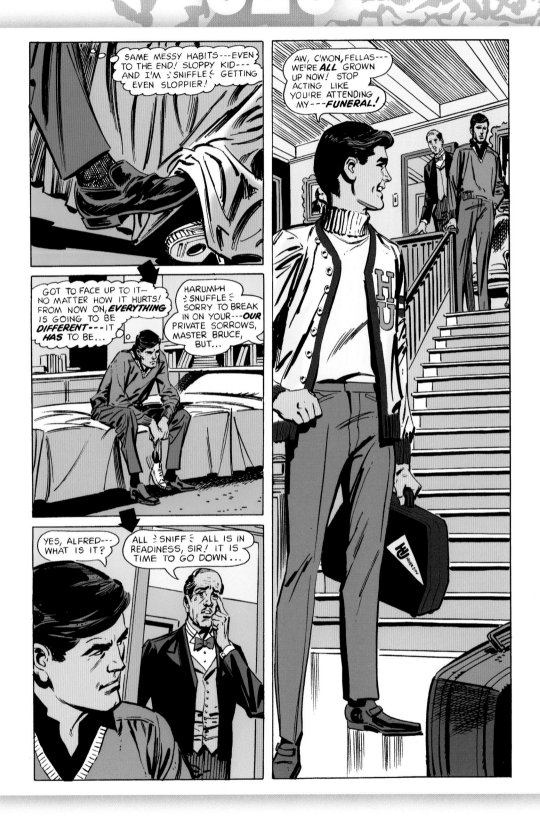

The first comic book sidekick took just over twenty years to grow up and move out of the house, going away to college. It was a seminal change for the series and the readership.

Batman #217, December 1969

Writer: Frank Robbins *Artists:* Irv Novick & Dick Giordano

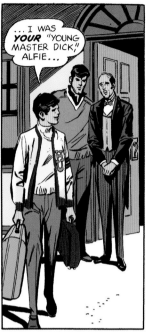

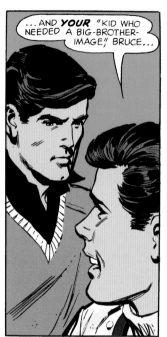

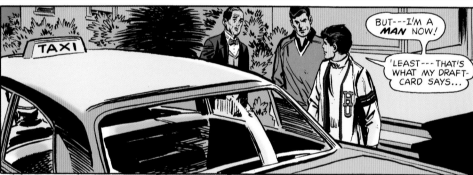

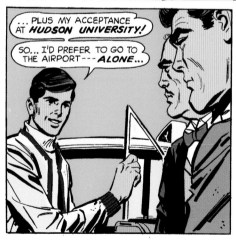

Batman #217, December 1969
Writer: Frank Robbins *Artists:* Irv Novick & Dick Giordano

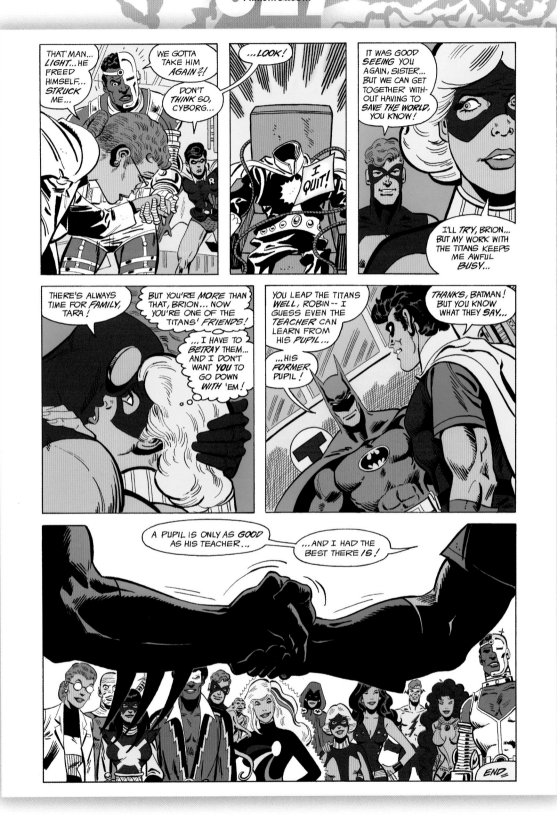

The adults versus the sidekicks theme is played out here, but in a twist, the Caped Crusader acknowledges that the Teen Wonder has actually surpassed him in one regard.

Batman and the Outsiders #5, December 1983
Writers: Mike W. Barr & Marv Wolfman *Artist:* Jim Aparo

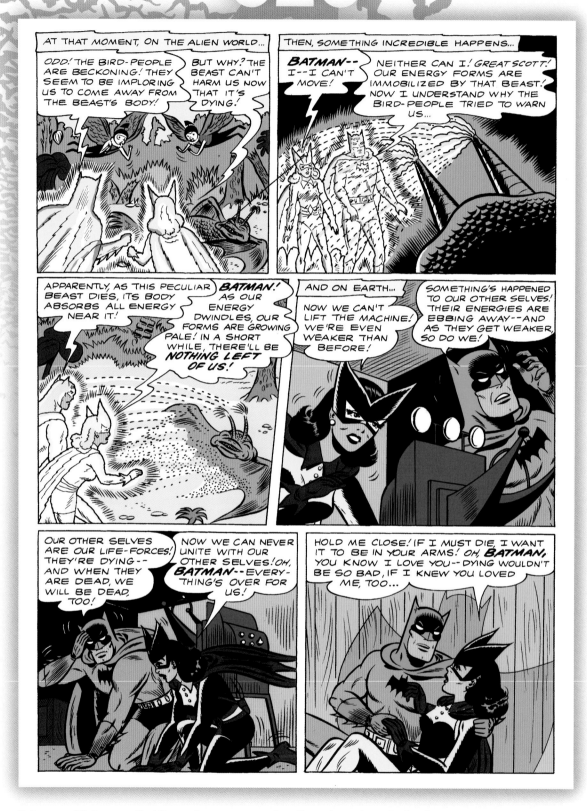

Batman and Batwoman find themselves sent to another dimension, where she finally gets to express her feelings toward the hero.

Batman #153, February 1963

Writer: Bill Finger *Artists:* Sheldon Moldoff & Charles Paris

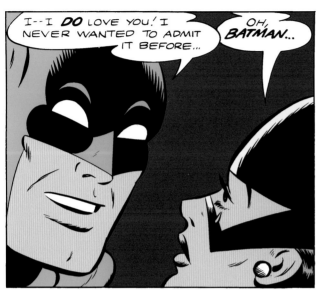

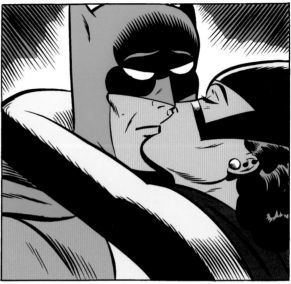

Batman #153, February 1963
Writer: Bill Finger *Artists:* Sheldon Moldoff & Charles Paris

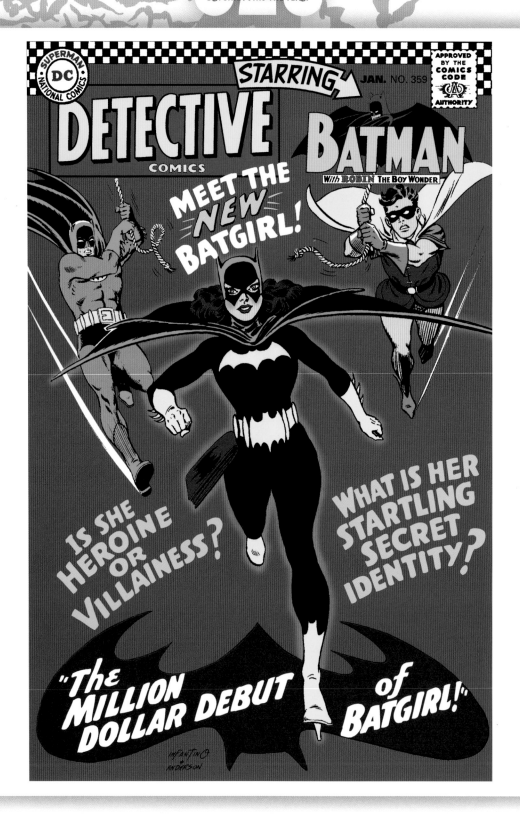

The first significant addition to the New Look Dynamic Duo arrived in the form of Commissioner Gordon's heretofore unknown daughter, Barbara. Her Batgirl has become a fixture ever since.

Detective Comics #359, January 1967
Artists: Carmine Infantino & Murphy Anderson

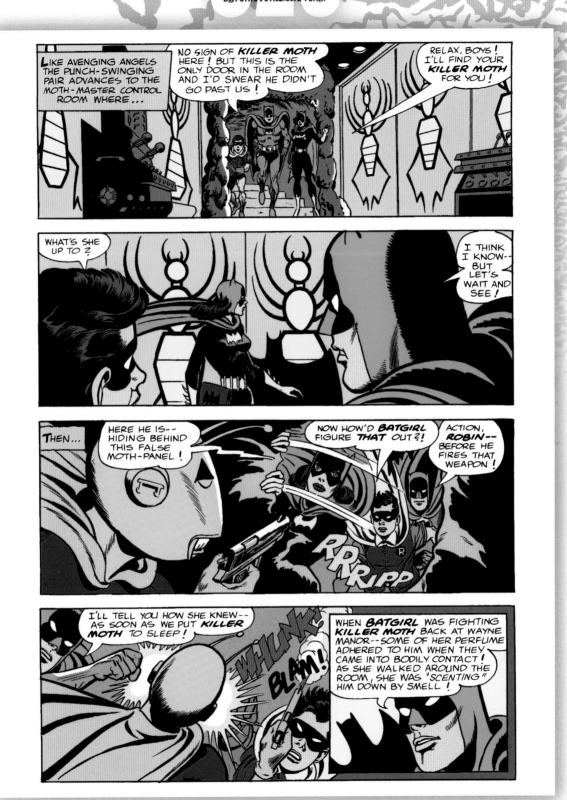

Detective Comics #359, January 1967
Writer: Gardner Fox Artists: Carmine Infantino & Joe Giella

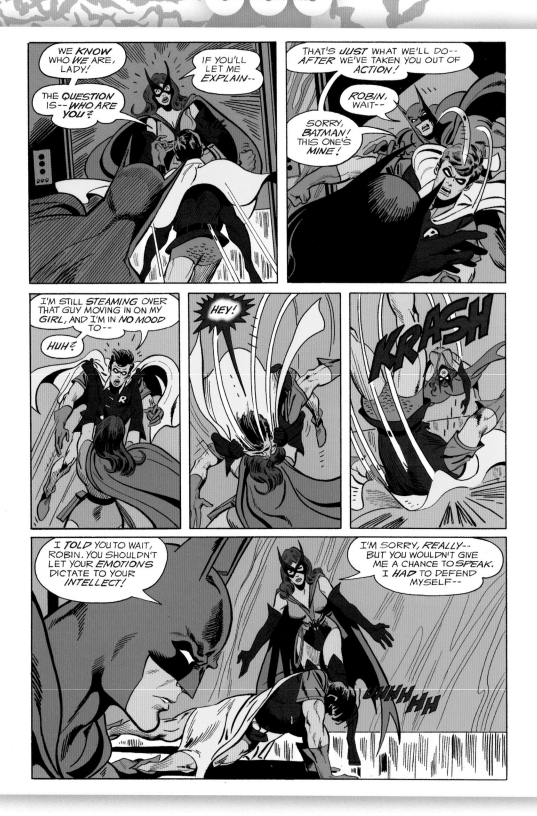

It was inevitable that the Earth-2 Huntress, daughter of her world's Batman and Catwoman, would meet the Earth-1 Batman, and it left the Caped Crusader wondering about the possibilities.

The Batman Family #17, May 1978
Writer: Gerry Conway *Artist:* Jim Aparo

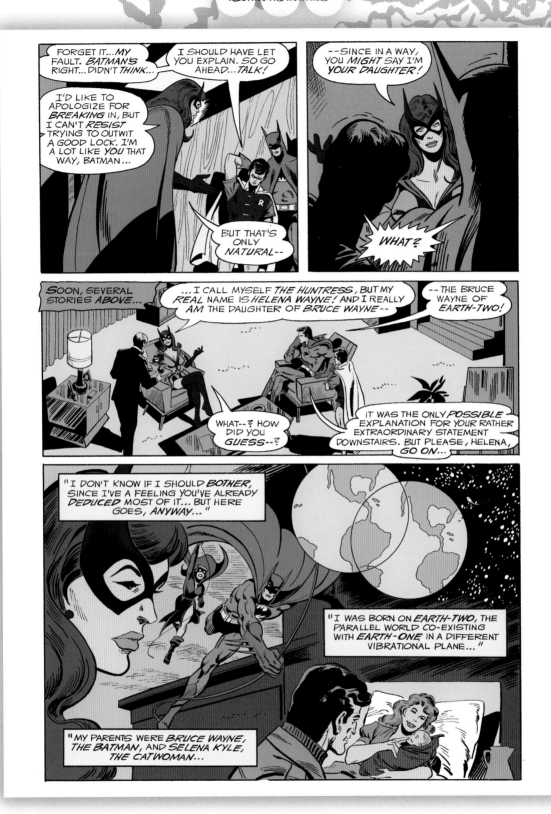

The Batman Family #17, May 1978
Writer: Gerry Conway *Artist:* Jim Aparo

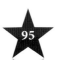

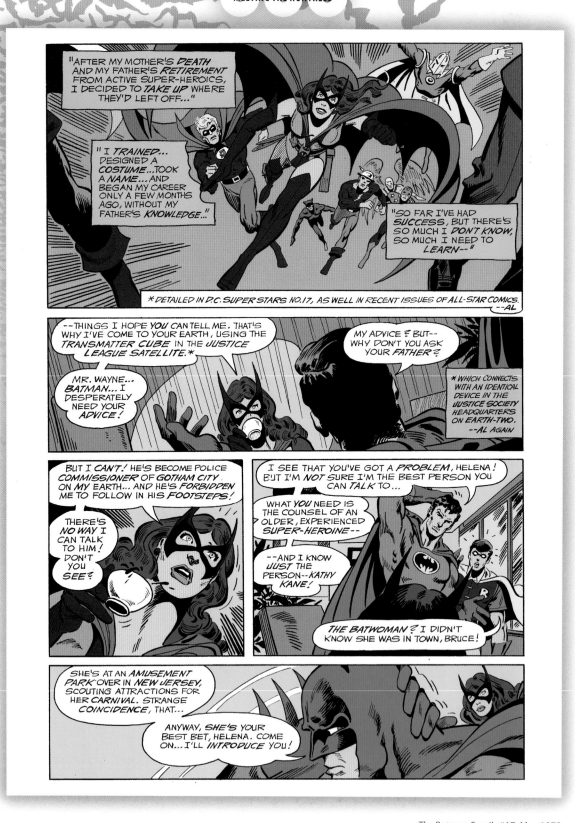

The Batman Family #17, May 1978
Writer: Gerry Conway Artist: Jim Aparo

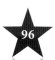

A major post-Crisis alteration introduced readers to street urchin Jason Todd, who didn't think twice about boosting the Batmobile's tires in an effort to make some money.

Batman #408, June 1987
Artists: Ed Hannigan & Dick Giordano

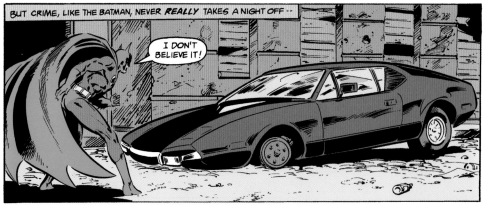

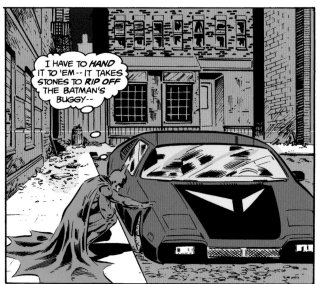

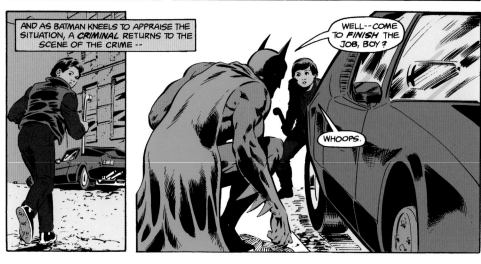

Batman #408, June 1987
Writer: Max Allan Collins *Artists:* Chris Warner & Mike DeCarlo

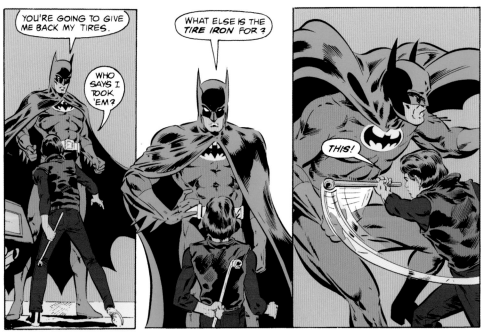

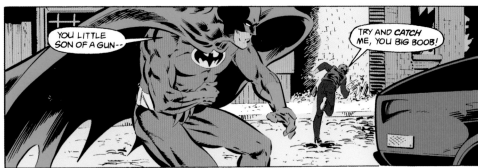

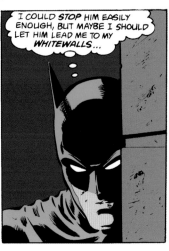

Batman #408, June 1987
Writer: Max Allan Collins *Artists:* Chris Warner & Mike DeCarlo

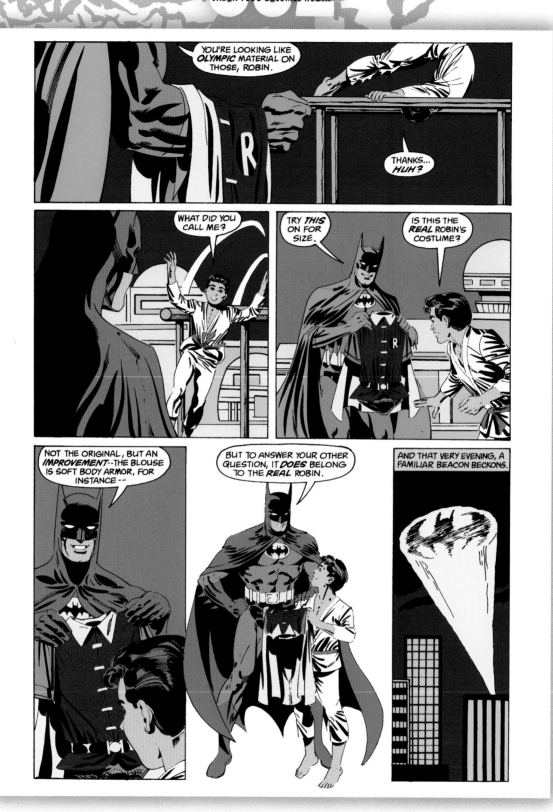

Seeing something in the street-smart kid, Batman decided to recruit the teen and train him to become the second Robin, a decision he would come to regret.

Batman #410, August 1987

Writer: Max Allan Collins *Artists:* Dave Cockrum & Mike DeCarlo

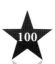

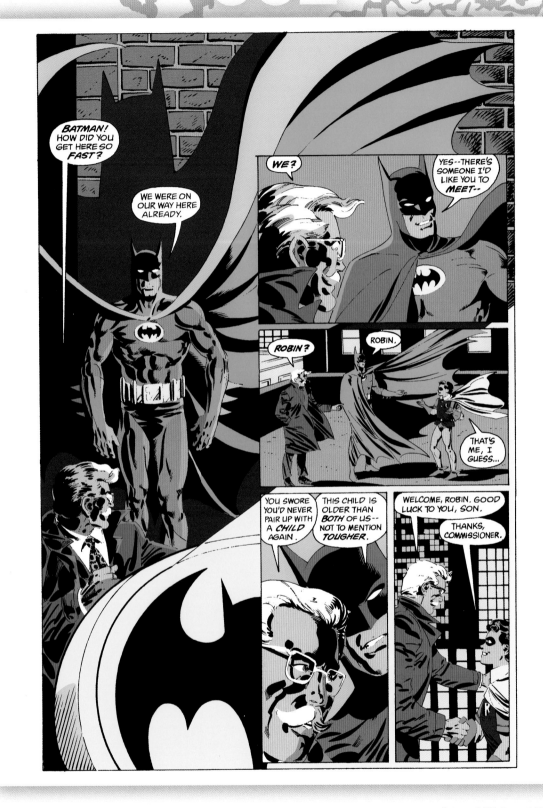

Batman #410, August 1987
Writer: Max Allan Collins *Artists:* Dave Cockrum & Mike DeCarlo

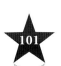

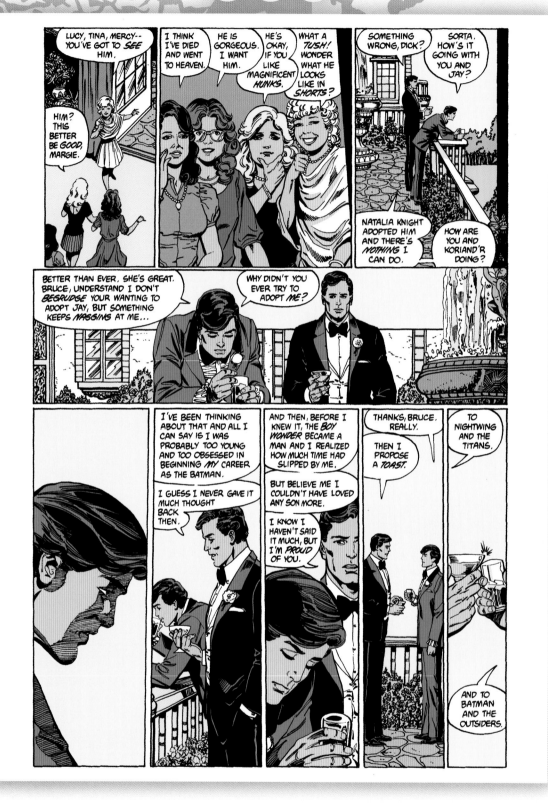

No one likes to be replaced, and the subject of Jason finally comes up at Donna Troy's wedding, where Bruce Wayne and Dick Grayson have a moment to talk.

Tales of the Teen Titans #50, February 1985
Writers: Marv Wolfman & George Pérez Artists: George Pérez, Dick Giordano & Mike DeCarlo

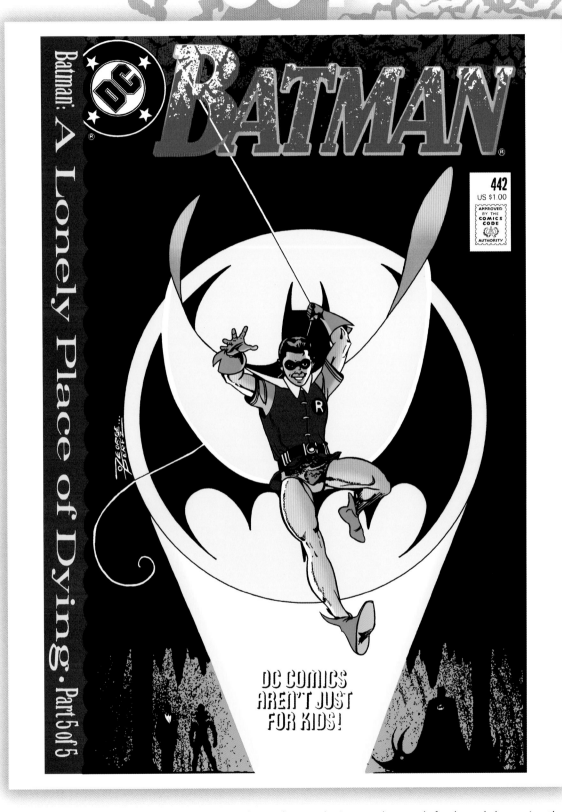

Tim Drake is convinced that Batman needs a Robin and proves he is more than ready for the task, becoming the third to fill the pivotal role.

Batman #442, December 1989
Artist: George Pérez

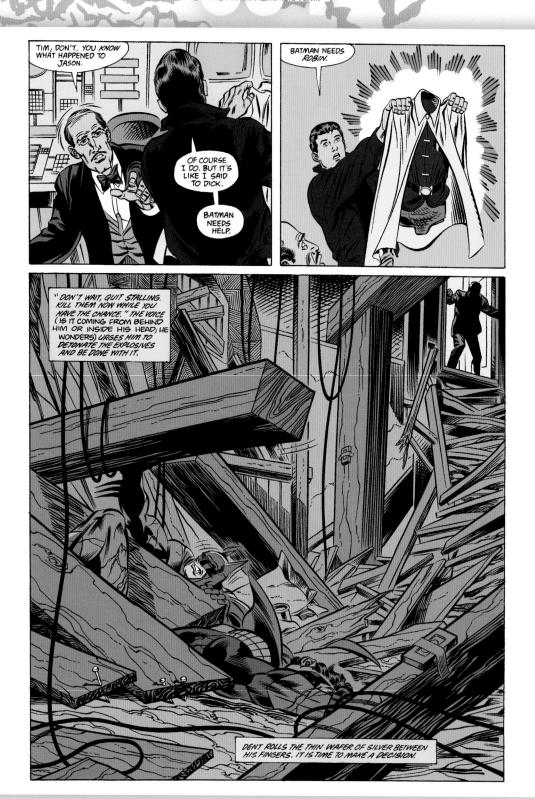

Batman #442, December 1989
Writers: Marv Wolfman & George Pérez *Artists:* Jim Aparo & Mike DeCarlo

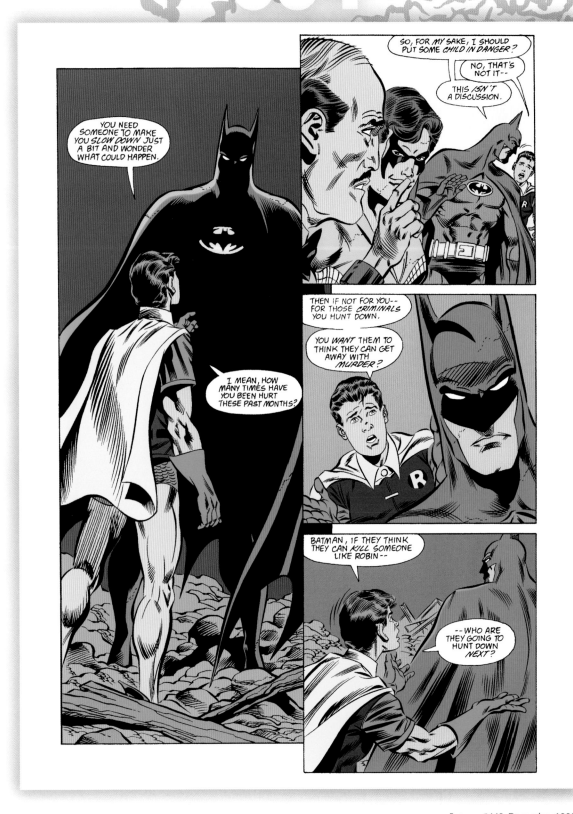

Batman #442, December 1989
Writers: Marv Wolfman & George Pérez Artists: Jim Aparo & Mike DeCarlo

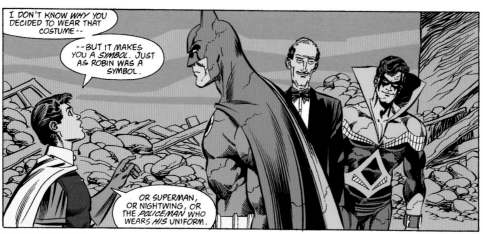

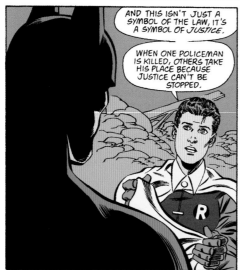

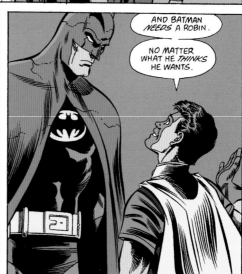

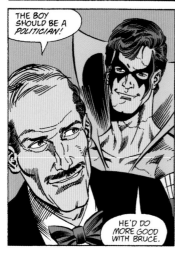

Batman #442, December 1989
Writers: Marv Wolfman & George Pérez *Artists:* Jim Aparo & Mike DeCarlo

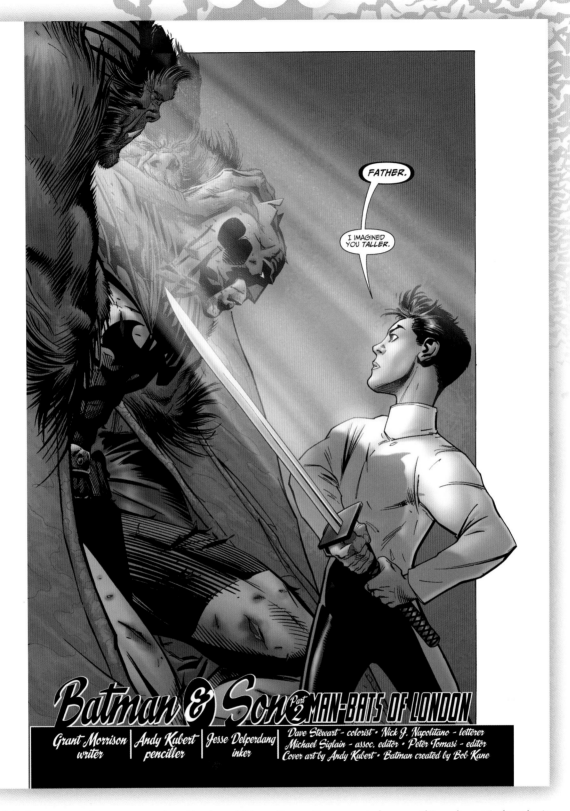

While Batman may have contemplated having children, the reality proves to be something else entirely as he is rudely introduced to his son, Damian.

Batman #656, October 2006
Writer: Grant Morrison *Artists:* Adam Kubert & Jesse Delperdang

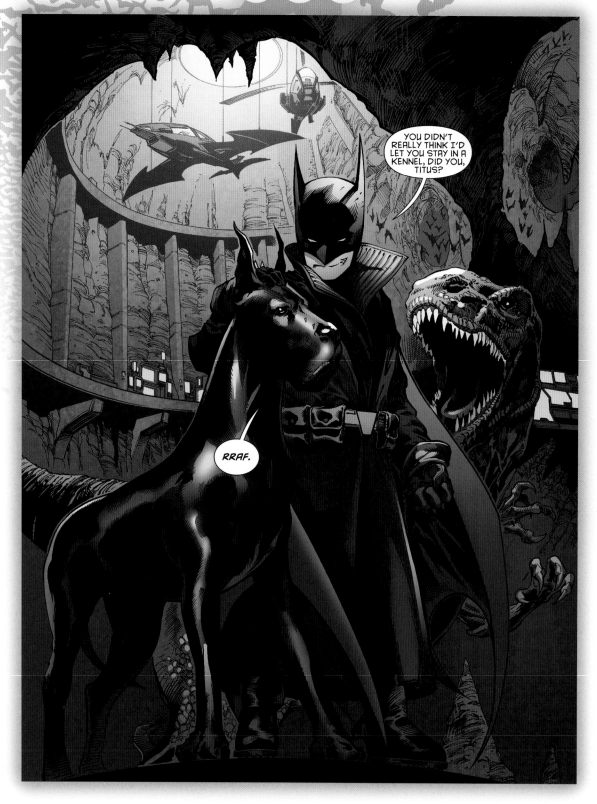

After a rough start, Damian proves to have a heart after all, showing his affection by sending his father around the world on a scavenger hunt with a purpose.

Batman & Robin Annual #1, March 2013
Writer: Peter J. Tomasi *Artists:* Ardian Syaf & Vincente Cifuentes

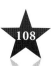

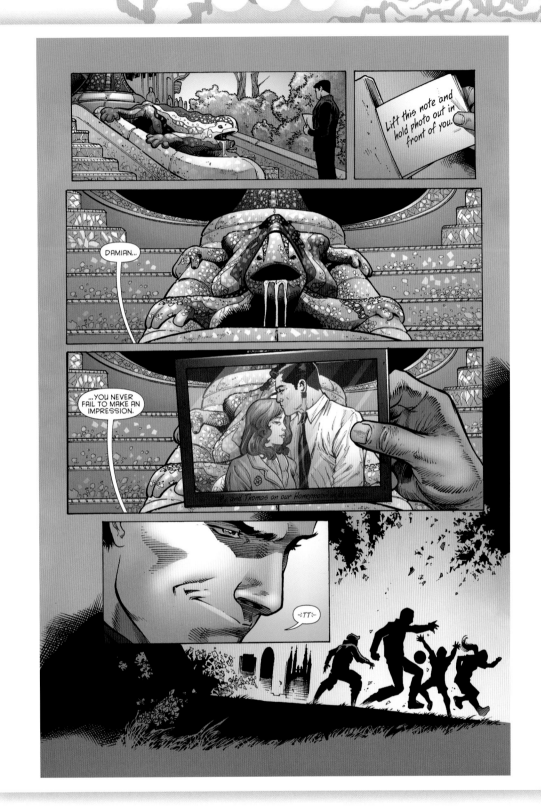

Batman & Robin Annual #1, March 2013
Writer: Peter J. Tomasi *Artists:* Ardian Syaf & Vincente Cifuentes

Batman & Robin Annual #1, March 2013
Writer: Peter J. Tomasi *Artists:* Ardian Syaf & Vincente Cifuentes

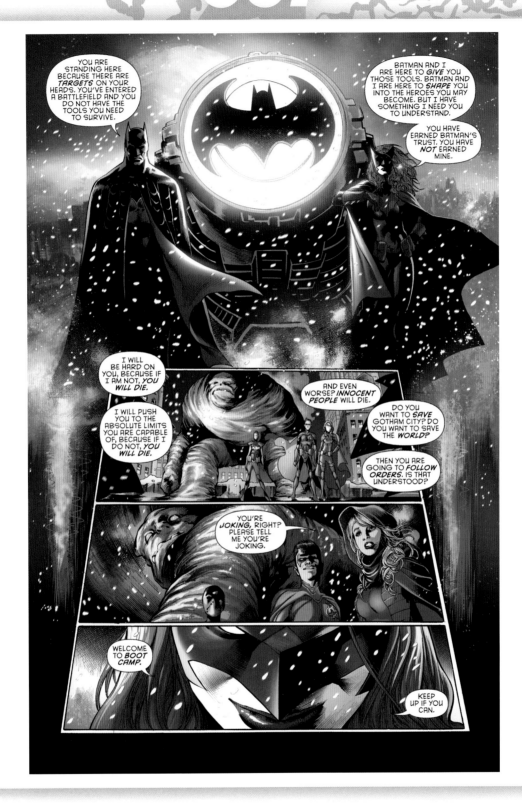

Recognizing that Gotham City's problems are more than one man can manage, Bruce Wayne asks his cousin Kate Kane to help recruit and train a new team, including redeeming the tortured soul that is Clayface.

Detective Comics #934, August 2016
Writer: James Tynion IV *Artists:* Eddy Barrows & Eber Ferreria

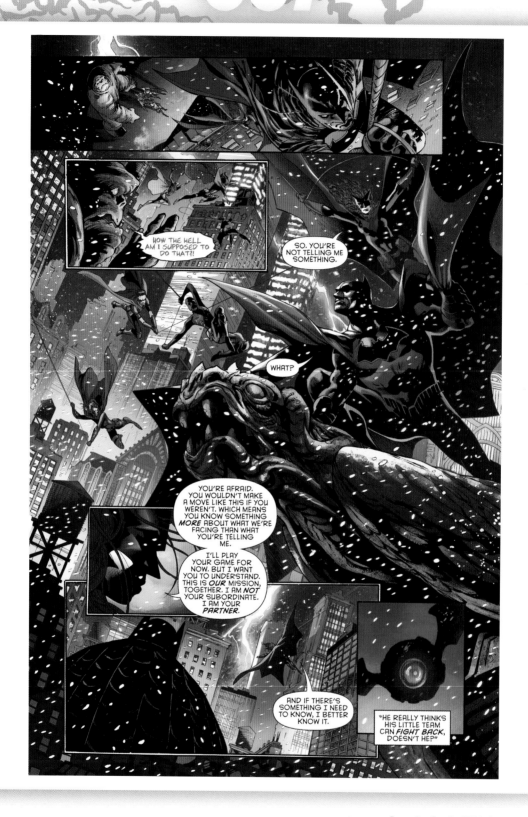

Detective Comics #934, August 2016
Writer: James Tynion IV *Artists:* Eddy Barrows & Eber Ferreria

ALLIES, FRIENDS, AND LOVERS

FROM THE OUTSET, BRUCE WAYNE HAD NO RECURRING FRIENDS IN HIS LIFE, SAVE FOR COMMISSIONER GORDON, AS WE MEET BOTH FOR THE FIRST TIME AND THEY SIT AND CHAT. AS STORY NEEDS DICTATED, NEWFOUND FRIENDS WERE INTRODUCED, AND OVER TIME, BRUCE WAYNE EVOLVED INTO A LEADING SOCIALITE, HOBNOBBING WITH THE REST OF GOTHAM'S ELITE, BUT HE HAD NO REAL PERSONAL BONDS WITH THEM.

The same could be said for the eligible bachelorettes who may have dated Wayne but never got close. In fact, one story showed how one hoped to bed the millionaire and failed but refused to admit it, one in a long line of women to lie about their relations.

Which is not to say that Batman has no friends. Despite their differing worldviews, Batman has grown deep attachments to Superman and Wonder Woman, forming a trinity among the earth's heroic community. He's certainly closer to some members of the various teams he's belonged to than others, but you won't catch him enjoying a meal with them—there's too much work to do.

Perhaps the one friend Bruce Wayne has is Wayne Enterprises CEO Lucius Fox, while Batman can count Commissioner Gordon as his sole nonpowered friend.

His family is Alfred and Dick, Clark and Diana.

And while he has given his heart to several women through the years, none have proved capable of keeping it, as circumstances or death have intervened on more than one occasion.

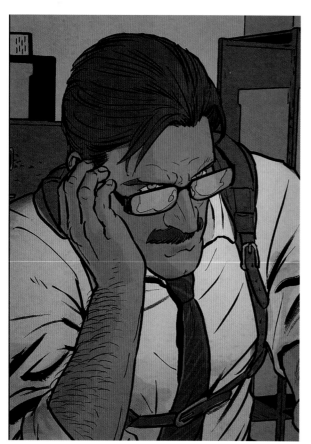

38. BATMAN AND GORDON

Regardless of the reality, Batman and Commissioner Gordon have an abiding respect for each other, which has grown over time into a friendship. This has been shown time and again, as Batman rallied to Gordon's side when he was shot, had a heart attack, or saw his own loved ones threatened. In the 1970s, they were seen exchanging Christmas gifts, atypical for the Dark Knight.

The exact nature of their meetings has evolved, with this sequence being the most relevant until Crisis on Infinite Earths altered reality and Gordon's backstory was dramatically changed. It has been modified over time until today, where Gordon first met young Bruce Wayne when the boy skipped school to go to the movies. He was also the first cop on the scene later that evening when the Waynes were gunned down.

Regardless of reality, Gordon was an intrepid and indefatigable police officer, easily earning his rise to the post of commissioner. While his personal life has never been easy—he was estranged and divorced from his wife, and his son, James Jr., is a murderous psychopath—he takes comfort in the successes his daughter Barbara has achieved as a student and business owner and as Batgirl.

During the events of Zero Year, Gordon saw Batman as a vigilante impediment to his work organizing the police force as the city was under siege from the Riddler. Slowly, their friendship and bond of trust was formed, although more recent events orchestrated by Bane tested those links in new ways.

39. UNMASKING BEFORE GORDON

Batman and Commissioner Gordon had been through much together in the world immediately after the Crisis on Infinite Earths. He lost his wife, Barbara, after he cheated on her with fellow cop Sarah Essen, took in his brother Roger's daughter Barbara after Roger and his wife died in a car accident, and had to manage a police department in an increasingly corrupt city. The colorful and deadly

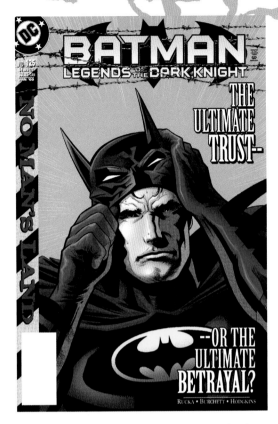

villains that threatened the city with frightening regularity were only leavened by Gordon's trust in Batman and Robin, and later Batgirl and Nightwing, in helping fight the good fight.

He watched in vigilant silence as people behind the various masks changed, knowing in his heart that it was all for a reason. Then came the contagion, a deadly virus that killed millions, followed by a devastating cataclysm, a man-made earthquake, resulting in the US government unwilling to pour more federal dollars into a failed city. It was cut off from the country, becoming a virtual No Man's Land.

During those first three chaotic months, as mobsters and police vied for territorial control, Gordon grew increasingly incensed and felt betrayed by Batman's absence. Gordon turned to his former district attorney, Harvey Dent, for help, only to be double-crossed. Two-Face put Gordon on trial, and he was finally reunited with Batman, who emerged from the shadows.

Their bond had been frayed, nearly broken, and toward the end of the yearlong hellish experience, the two met at Gordon's home. They discussed the broken trust, and Gordon questioned Batman's commitment to the city and the cause of justice. Batman was ready to do the only thing left to prove himself and entrust Gordon with his most precious secret.

40. TIME TRAVELING WITH PROFESSOR NICHOLS

On Earth-2, professor Carter Nichols was a scientist who befriended Bruce Wayne and Dick Grayson. He had developed a way to use hypnosis to somehow psychically tap into the timestream and could send the pair to specific locations and periods, starting with a trip to ancient Rome. With increasing frequency, their journeys took them to study mysteries that required the intervention of the Dynamic Duo. Over time, Nichols somehow met the costumed crime fighters, and he began sending them through history as well. He even managed to once send them forward in time.

The criminal Psycho-Pirate once influenced Bruce Wayne into writing a fictitious diary, accusing the legendary Justice Society of America of treason during World War II. Batman then gave the book to Nichols for safekeeping, instructing him to pass it on to the Man of Steel whenever the Caped Crusader died. This brought the heroes to trial, prosecuted by Dick Grayson, until the truth was learned.

On Earth-1, Professor Nichols periodically sent Superman to the past alongside Batman and Robin but eventually devoted all his energy to a post at the top-secret DNA Project. In the post–Infinite Crisis reality, Nichols abandoned his time experiments and became a recluse after a group of villains forced him to use his work for evil.

41. JULIE THE BOY WONDER

Julie Madison holds a place in the mythos as Bruce Wayne's first romantic interest, introduced early in his *Detective Comics* run as his fiancée. It was established that they had known each other since college, and when he began his costumed career as Batman, his thoughts turned once more toward

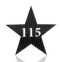

her. However, she was also a victim of the Monk, a hooded vampire/werewolf hybrid, who lured her to Europe. Batman followed, breaking her free of his powerful hypnotic control before killing the supernatural being.

Back in America, Julie pursued an acting career in film, starring opposite Basil Karlo before he became the deranged Clayface, and her fame rose. Her agent had her renamed Portia Storme, and she was annoyed by Wayne's playboy ways, so she left for California after breaking the engagement.

She remained in Gotham City long enough to dress up as Robin to aid Batman in a new fight with Clayface.

There was also an Earth-1 Madison, who was also engaged to Bruce but, as Storme, ultimately wed the king of Moldacia. In subsequent realities, Julie Madison remained a part of Wayne's life and in one even learned his identity, breaking up with him because she couldn't reconcile his twin lives. She and Wayne were college sweethearts in the Prime Earth reality, and she appeared to Wayne in one of his dreams during Gotham's Zero Year.

42. CATWOMAN'S FIRST KISS

At first, she was a criminal in fine clothing. Even then, it was clear there was something special about her.

Much as the Joker struck a chord in *Batman #1*, so, too, did Batman's first female nemesis as she returned in issues two and three. In fact, the Cat met the Joker in her second appearance, double-crossing the criminal and escaping from the Batplane. By the third appearance, she was in an orange gown, a forerunner of her traditional green and purple outfit, wearing the outsize head, now calling herself the Cat-Woman. After Batman arrested her for her latest attempted crime, she threw her arms around him and kissed him on the lips, and in his surprise, he allowed her to shove him away and escape. He was not too upset, saying at the end, "What a night! A night for romance!"

In their third meeting, though, the kiss was not a distraction. Here, the Princess of Plunder wore the cat mask and a seemingly black leather catsuit and purple cape. She hoped to use a costume party to hide her latest crime, but Batman was also on the scene, surrounded by a variety of other imitators. In their final confrontation, the Dynamic Duo wound up saving her life as her accomplices tried to shoot her. She doffed the mask and gave Batman a heartfelt kiss. "And before the startled Batman can recover his wits, the shadow Cat-Woman has slipped out of the room like some elusive phantom." Robin remained convinced that his partner, infatuated with her, had allowed the woman to escape.

So began one of comics' most enduring and involving romances, with highs and lows culminating in 2018's almost-wedding.

43. VICKI VALE CLAWED BY CATWOMAN

After Julie Madison, Bruce Wayne was next romantically involved, albeit briefly, with Linda Page. Then, in 1948, photojournalist Vicki Vale arrived in Earth-2's Gotham City. She was captivated with the Dynamic Duo, covering their exploits and occasionally trying to uncover their identities. She even dated Bruce Wayne on and off, never

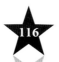

suspecting his alter ego. She was more an omnipresent pest than deep romantic partner.

There was an Earth-1 Vicki Vale, too, although this one was even less interested in loving Batman or Bruce. In fact, she wound up marrying a man named Tom Powers. That relationship didn't last long, and she divorced and wound up running *Vue Magazine*'s Paris bureau.

On her return to Gotham City, she found herself attracted to Bruce Wayne, unwittingly embroiling herself in a romantic rivalry that nearly killed her. At the time of her return, Wayne was actively involved with Selina Kyle, who had reformed, and her Catwoman was a frequent ally of the Gotham Guardian. Just prior to her return, Julia Remarque, Alfred Pennyworth's heretofore unknown daughter, had arrived, and she was also making a play for Wayne.

This was likely the one and only time Wayne found himself involved with three women at once, actually having feelings for at least one or two of them.

Vale was also suspicious that Wayne was Batman and assembled research to prove it, sharing the data with her editor, Morton Monroe, who in turn gave the information to political boss Rupert Thorne. He then hired Deadshot to assassinate Wayne, just in case the truth had been discovered.

During all this, Selina was increasingly agitated over her rivalry, so much so that she attempted to run Vale off the road, with Wayne inside the car.

Vale remained a Gotham fixture in subsequent realities, although she was never again romantically linked to Wayne. In the Prime Earth reality, she is an intrepid reporter for the *Gotham Gazette*.

44. UNMASKING BEFORE CATWOMAN

Catwoman had endured a lot in the post–Crisis on Infinite Earths reality. Her mind had been tampered with on several occasions, including being magically manipulated by Zatanna and reconditioned by Dr. Moon. As a result, Catwoman and Selina Kyle appeared at loose ends, in search of a cause. She periodically fought on the side of the angels, including aiding the Justice League when she snuck into their moon-based Watchtower to help stop Prometheus from taking them down.

She even went so far as to "kill" Selina Kyle after a failed exploit in Manhattan. Slowly, she resurrected herself, coming to Batman's side during the No Man's Land year. She avoided being killed by Deathstroke and went into hiding, emerging sometime later as the protector of Gotham's East End. She was its defender, and woe to any cop, cape, or villain who tried to cross her there. She continued her burglaries, as much for the thrill as for the money. She found herself fighting just as often against Batman as she did alongside him. As a result, they reignited their long-simmering romance.

As they got increasingly involved with each other, the bandaged Hush was manipulating the city's criminals in an all-out assault on the hero. She fought beside Batman, deepening the bond, until finally he brought her to the Batcave, where he shared his secret identity. Hush wound up spoiling the relationship, putting an end to the romance for a time.

45. KISSING TALIA

It was love at first sight. When Dr. Ebenezer Darrk split from Ra's al Ghul's League of Assassins, he kidnapped the Demon Head's youngest daughter. Batman intervened and heroically rescued her, and she returned to tell her father about this Dark Knight. Intrigued, Ra's investigated and determined that Batman would be ideal as a mate for Talia and as his successor.

The entire Dr. Darrk incident was considered a test for Batman, gauging his suitability to assume control of the League. Ra's had Robin kidnapped, then introduced himself to Batman in the Batcave, nothing that his own daughter was taken in the same manner. Batman's investigation and rescue of the pair convinced Ra's that Batman was a suitable heir, but the Dark Knight rejected the offer.

From the beginning, Talia found herself drawn to Batman despite their differing view of the world. His outright rejection of her father's offer, and subsequent efforts to dismantle the League, only seemed to encourage her own independence. When Batman and Ra's dueled in the desert, Batman was struck by a scorpion, and as he lay dying under the blazing sun, Talia slipped him the antidote. After defeating her father, Batman grabbed her in a passionate embrace, then dragged her father away.

She continued to vie for Batman's affection through time, with Ra's kidnapping the hero and performing a wedding ceremony, giving them a unique bond that later resulted in Batman fathering their son, Damian.

Of all the women Batman has loved, Talia is likely second to Selina Kyle, even though they exist in opposite worlds. When it appeared Batman and Selina would wed, Talia even approved of the pairing. After raising Damian, Talia left the ten-year-old with his father only as a ploy to distract him from her building the Leviathan network, which would prove to be a global threat.

46. SILVER ST. CLOUD

It was a chance meeting when Bruce Wayne met event planner Silver St. Cloud. Captivated by her beauty and platinum hair, Wayne began to date her. All along, Silver was paying close attention to her boyfriend, and as she stared at his jawline, she came to realize that Wayne was also Batman, whom she had encountered on more than one occasion. When Wayne sought treatment for radiation poisoning, he was kidnapped by professor Hugo Strange, who impersonated him for days. Silver was the one to find and free Wayne after Strange had tried to end their relationship.

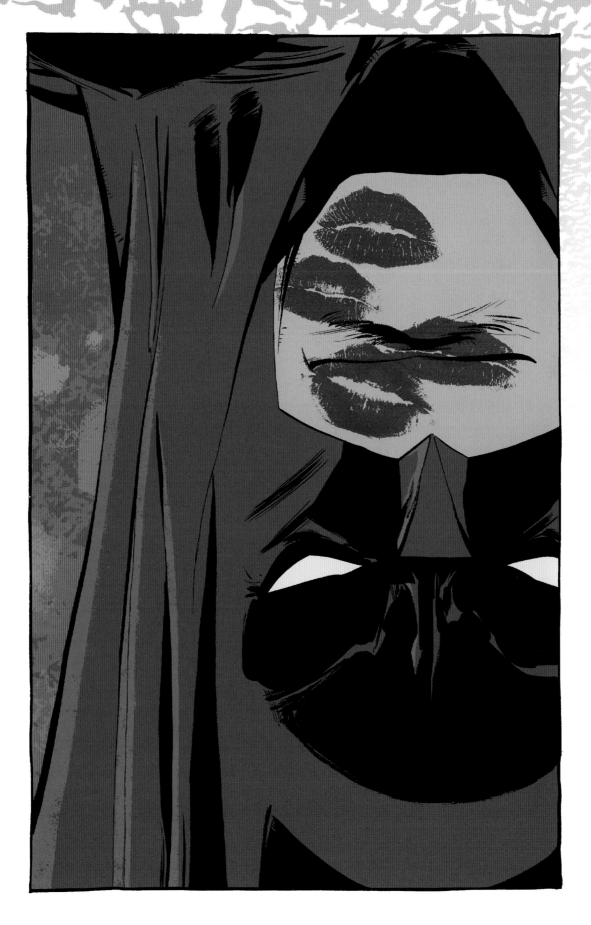

Batman had no clue what to do with the woman his alter ego had fallen in love with. That resolved itself when she watched Batman battle the Joker and realized that this was not a life she could be a part of. Reluctantly, she ended the relationship and moved from Gotham City.

In time, she returned with her fiancée, Evan Gregory, a gubernatorial candidate. Of course, she was embroiled in Batman's life once more, giving her conflicting emotions until she chose to remain with her fiancée. Unfortunately, the Joker decided to become interested in politics, which resulted in Gregory's dismemberment and subsequent death.

Wayne and St. Cloud rekindled their romance as she came to accept why Batman needed to exist. Unfortunately, the relationship continued to endanger her life, until she was stabbed by the criminal Onomatopoeia.

47. KILLING VESPER FAIRCHILD

Vesper Fairchild made her name first as a journalist and then as a radio personality. Hired to helm Gotham's WKGC radio program *Siren of the Night,* she quickly established herself as a popular broadcaster. Her popularity led to many public appearances, so it was inevitable that she would encounter Bruce

Wayne and his caped alter ego. Wayne and Fairchild began dating, and a serious romance was underway.

The green-eyed, auburn-haired woman sensed there was something Wayne was not sharing with her, however, and she began to study him as an investigative subject. When the earthquake that devastated Gotham derailed her work, she soon left Wayne and the city.

When she became determined to uncover Batman's secret identity, she returned to Gotham, resuming her relationship with Wayne. She had hoped he'd be a good source of information, but he warned her away from the story. Her questioning earned her the enmity of Wayne's new bodyguard, Sasha Bordeaux. Wayne then contrived to break off the relationship for good.

By then, Bordeaux had learned her charge's secret and was coerced into donning a costume and adventuring with him at night to fulfill her duty. One evening, a month after Wayne ended things with Fairchild, they returned to the manor to find Fairchild's corpse, with all evidence pointing to Wayne having committed the murder.

Wayne had been framed by David Cain, father of Cassandra, and during the mission to clear his name, Wayne found Vesper's research and realized she'd uncovered his secret but kept it to herself.

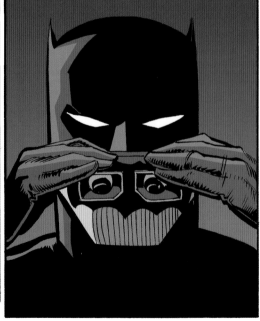

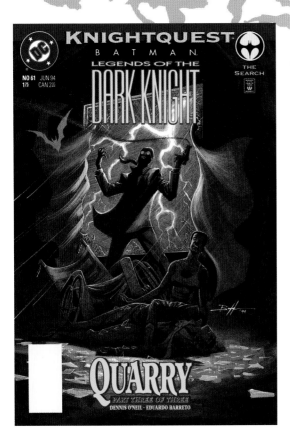

48. SHONDRA HEALS THE BAT

Tim Drake's father, Jack, had suffered injuries in Africa so he hired Shondra Kinsolving, a physiotherapist, to work with him. At much the same time, Bane's gambit was working and leaving Bruce Wayne physically and emotionally exhausted. Wayne asked Kinsolving to work with him as well when he suffered what was called a horrific accident. The reality was that Bane had broken Batman's back, and Wayne was desperate to be healed to resume his crime-fighting career.

In time, Shondra and Wayne fell for each other, but her half brother, Benedict Asplin, reappeared in her life. Apparently, they were born with a psychic link that grew with proximity. He arrived to fully activate her mental powers, assuming the identity of Mister Asp and spiriting his sibling away. Taking her south, he forced her to exercise her newfound powers by wiping out an entire island village.

Wayne donned leg braces and disguised himself as Sir Hemmingford Gray, tracking Mister Asp and Shondra. The final confrontation took place in Santa Prisca, Bane's birthplace, where Gray and Asp battled. The psychic toll was too much for Shondra, whose mind began to shut down, reducing her intellect to that of a child.

She did manage, though, to use her powers one final time, completely healing Bruce Wayne's back. After winning back the mantle of the bat, Wayne had Shondra placed with a foster family that could care for her.

49. FIRST MEETINGS WITH SUPERMAN

Batman, Robin, and Superman first shared a cover in 1940, welcoming readers to the second issue of *New York World's Fair Comics*. The image was an indelible, happy one, and when the book was made an ongoing title, as *World's Finest Comics,* the three shared the cover for much of its 323-issue run.

But when did they first meet? The first story outlining that was reserved for *Superman* #76 in 1952; however, they actually shared an adventure together long before that classic tale. In 1941's *All-Star Comics* #7, the Justice Society of America was informed by their chairman Green Lantern that immediate financial aid was needed for the children orphaned by the escalating European conflict. Hawkman suggested each member raise $100,000, and so began an adventure.

Johnny Thunder boasted that he could raise three times that amount, but when he and his magical Thunderbolt attempted this, it proved fruitless, actually losing him whatever he raised. Returning to the headquarters in shame, Johnny wondered how to explain his utter failure, when the Thunderbolt arrived with honorary members Batman, Superman, and Flash (back then, if you had your own quarterly title, you were granted honorary status to shine the spotlight on other characters in the stable), each bearing $100,000.

Batman only made three appearances with the JSA back then, much like Superman, each of them also appearing together with the team in a 1941 Hop Harrigan text story and 1947's *All-Star Comics* #36. However, when page counts were reduced, it was decided to team the Man of Steel and Dynamic

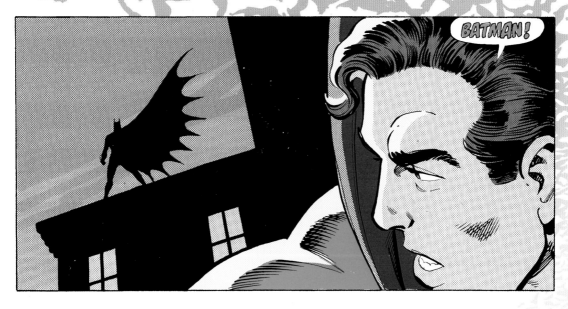

Duo rather than cut a feature in *World's Finest*. For decades, their shared adventures thrilled readers.

In the post–Crisis on Infinite Earths reality, the two met shortly after Superman began operating in Metropolis. On the trail of the teen criminal Magpie, Batman was interrupted by Superman, and they begin working together. At the end of the case, Batman suspects they might have been friends in another time. The first meeting has been retold since then in *Superman/Batman Secret Files and Origins 2003* and *Superman/Batman Annual* #1. The current version of this classic meeting, in the Prime Earth continuity, was depicted in *Batman/Superman* #1.

Still, one of the more ingenious and noble battles occurred when Batman had a rough patch and decided to give up being a hero. Superman wanted to help his friend and contrived a crisis in the bottle city of Kandor. The two reduced their sizes and entered the last Kryptonian city to fight the fake menace, leading to the cover image of the two knights fighting it out. Once Batman regained his confidence, it was time to go home and resume his battle against evil. The idea of them fighting with weapons and shields was so good, though, that the idea was repeated some five years later in *World's Finest Comics* #185.

50. BATMAN VERSUS SUPERMAN

As often as the two heroes have been close friends and allies, circumstances always seem to contrive to put them at odds. In some two dozen (or more) confrontations, one or the other or both have been coerced into the fight, such as when Maxwell Lord psychically forced Superman to nearly kill Batman. They have fought each other's multiverse counterparts. They have misunderstood each other's motivations, such as the New 52 reality when Superman first encountered Batman, with the latter holding a Mother Box, leading to the erroneous conclusion that Batman was colluding with Apokolips.

51. SUPERMAN VERSUS BATMAN

It was the super-hero story that captured the mass media's attention. Frank Miller, high off his success at Marvel Comics with *Daredevil*, was lured over to DC Comics, where he produced his original future ninja story, *Rōnin*. He followed that up with a brilliant what-if tale, imagining a fifty-five-year-old Bruce Wayne having retired his alter ego. Gotham had been overrun by a teen gang called the Mutants. He gave up his role after Jason Todd, the second Robin, died in action (foreshadowing his actual in-continuity death), and turned to alcohol while trying to rehabilitate Harvey Dent. Fate had other plans, and soon a fresh crime wave and a bat

crashing through a window indicated it was time to get back to work.

He was older and slower, relying more on mechanical methods of instilling fear in others. Seriously injured, he was rescued by young Carrie Kelley, who earlier had been saved by the returned Batman. She decided to become his new Robin, like it or not.

Dispatched by the president, Superman, more recently an undercover operative in a world without super heroes, tried to dissuade Batman from engaging with the crime wave. He was called away before the conversation could end, but Batman realized his friend was now an impediment to the job.

The mission overseas went awry, and an electromagnetic pulse rendered most Western Hemisphere electronics inoperative, while a massive dust cloud kept the sun's radiation from powering the Kryptonian. Returning to Gotham, Batman, wearing gloves laced with synthetic kryptonite, and Superman square off in Crime Alley for a final brawl. Batman seemingly dies of a heart attack during the battle, a ruse to go underground and continue his fight from the shadows, where he's at his best.

This battle proved the inspiration for the fight seen in the film *Batman v Superman: Dawn of Justice*.

52. CLUB OF HEROES

It was always curious why there were no adventures of costumed heroes in other countries. In the 1950s, that matter was addressed in a few stories, starting with a 1951 adventure where Batman and Robin met their English counterparts, the Knight and Squire. In 1955's "Batman of All Nations," readers were introduced to Argentina's El Gaucho, Rome's Legionary, France's Musketeer, and Australia's the Ranger. In their second adventure, they inducted Superman into the group, becoming the Club of Heroes.

They were not seen again until Grant Morrison took over *Batman*, and then in the post–Infinite Crisis reality, millionaire John Mayhew invited all of them, save Superman, to form the group. He underwrote their Metropolis-based

headquarters, hoping they would exchange ideas and keep the world safer. Batman quit after one meeting while Chief Man-of-Bats, a Native American, joined. With the Dark Knight gone, the team fell apart, embittering Mayhew.

Mayhew later began working with opponents of the club's membership, and the traitorous Wingman, and lured the heroes to his Caribbean mansion, where he began killing them one by one. The Ranger and Legionary died before Batman could intervene and expose Mayhew's scheme. It turned out that Mayhew was also exploring the notions of good and evil with the Black Glove organization, which would remain a threat.

53. RESIGNING FROM THE JLA

At different times, the Justice League of America worked with and without international government sanction. Still, the membership was respectful of not interfering in the internal affairs of nations or getting involved in political disputes wherever possible.

Then came the day Wayne Enterprises' Lucius Fox was kidnapped by Markovian revolutionaries. Batman felt he needed the League's help in rescuing his friend, but the team refused to get involved. An angry Caped Crusader said, "I've heard the cries of the dying . . . and the mourning . . . the victims of crime and injustice. . . . I swore I'd do everything in my

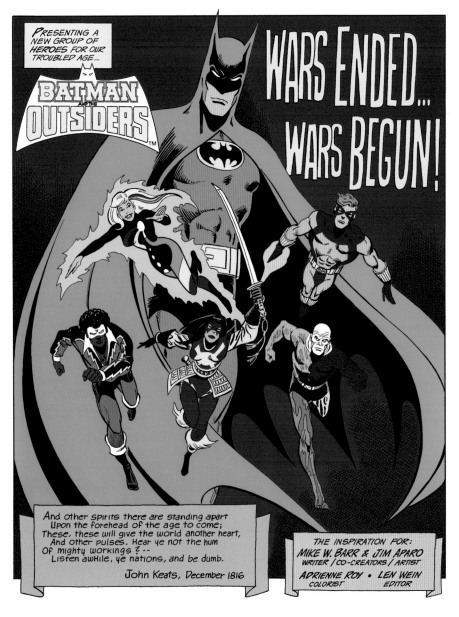

PRESENTING A NEW GROUP OF HEROES FOR OUR TROUBLED AGE...

BATMAN AND THE OUTSIDERS™

WARS ENDED... WARS BEGUN!

And other spirits there are standing apart
Upon the forehead of the age to come;
These, these will give the world another heart,
And other pulses. Hear ye not the hum
Of mighty workings?--
Listen awhile, ye nations, and be dumb.

John Keats, December 1816

THE INSPIRATION FOR:
MIKE W. BARR & JIM APARO
WRITER / CO-CREATORS / ARTIST
ADRIENNE ROY • LEN WEIN
COLORIST EDITOR

power to avenge those deaths . . . to protect innocent lives . . . and if I fail to keep that promise . . . my entire life is a lie!" With that, he stormed away from the satellite headquarters and went out on his own. In the country of Markovia, Batman found himself allied with Black Lightning, Metamorpho, Katana, and the young woman Halo. In time they were joined by Prince Brion and the super-powered Geo-Force, and the Outsiders were born.

Batman has left his various teams since. He has quit the JLA several times, been thrown out at least once, left the Club of Heroes, and even left his own Outsiders. He's formed his own rogue version of the Justice League, always aware there are problems in need of a squadron of heroes, but has refused to compromise. His hard-nosed approach to leadership has rubbed many the wrong way, as has his exacting training regimens. Most, though, will agree the world has been made a safer place thanks to these efforts.

54. ONE PUNCH

Batman does not suffer fools, gladly or otherwise. In the wake of mankind questioning the motivations of Earth's legends, it was clear there needed to be a Justice League. In the aftermath of a battle with Apokolips, the new team formed under Batman's guidance, including Black Canary, Blue Beetle, Captain Marvel, Doctor Fate, Green Lantern Guy Gardner, Martian Manhunter, and Mister Miracle. Their glad-handing financier, Maxwell Lord, also invited the female Doctor Light to join the team without checking, angering the chairman. The Dark Knight intended for the new configuration to spend time out of the limelight, getting to know one another and training to be a smooth tactical unit. Destiny and the machinations of Lord made that pretty much impossible, forcing them into action around the world. And before they could really train, Lord forced Booster Gold onto the team.

All along, Gardner argued that he should be in charge, having not only the requisite skills but superior power to Batman. Tensions between them grew, to the point where Gardner challenged his

teammate to a fight. With one punch from Batman, Gardner was laid low, much to the team's amusement.

It was also the single best-remembered moment from the early run of this incarnation of the team.

55. TRUSTING THE OUTSIDERS

Batman had been operating with his Outsiders for a while, getting to know and trust them as individuals and a team. Since trust didn't come easily, he revealed little about himself to the team, until he was exposed to poison in Japan. Suffering back in Gotham City, he was taken to Gotham Central Hospital and the team was told he needed to stay active, letting his body fight the poison. Uncertain how to best accomplish this, the team decided to seek Bruce Wayne's advice. Arriving at Wayne Manor, Alfred greeted the colorful characters with shock and, to save Batman's life, revealed his secret to the team.

UH-OH.

They then took him to Crime Alley, where the memories of his parents' slaying proved a powerful motivation to keep moving and stay alive. In disguise, the Outsiders reenacted the robbery, and it worked, keeping Batman moving. But the feverish hero took to the streets and continued his fight against crime while still battling the poison.

Finally, he had recovered enough to return to Wayne Manor and sleep off the remainder. When he awoke, he was apprised of what had occurred and realized he *could* trust the team. He revealed his identity, and the others feigned their surprise.

56. SWAMP THING

Swamp Thing was Earth's plant elemental, guardian of the Green, the life force of all native plant life. As a result, he avoided cities whenever possible, though his work required the occasional visit. Therefore, he and Batman had met before, but there came a time when they were in opposition to each other.

Abigail Cable, Swamp Thing's human lover, had been caught on film engaged in sexual activity with the being. This resulted in her being jailed in Gotham, awaiting extradition for sex crimes, and Swamp Thing was having none of it. He exerted his will and the city became a true concrete jungle, overgrown with vines and plants. The Bat-Signal lit up the night sky, and soon Commissioner Gordon was asking the Gotham Guardian to speak to Swamp Thing.

Batman soon came to realize how powerful Swamp Thing truly was. The plant elemental made it clear that he was leaving with Abby, or Gotham would be erased from the Eastern seaboard. It was apparent that the Dark Knight could not prevent this, so he appealed to Mayor Skowcroft to get Abby pardoned—and quickly. He noted that if the law found sexual congress between Swamp Thing and Abby illegal, what about Earth's other champions, from Metamorpho to the Thanagarian Hawkman or Kryptonian Superman? Persuasive arguments indeed.

At dawn, the federal pardon was issued and Abby freed. Batman warned Swamp Thing that should he attack the city again, Batman would find a way to kill him. Swamp Thing nodded and said he believed that to be true.

"--AND THAT INSTANT WAS ALL THAT HE *NEEDED!*"

WAIT-- COME BACK!!

"BUT HE WAS ALREADY *GONE,* SWALLOWED BY THE *SHADOWS* WHICH SEEMED TO *SPAWN* HIM..."

FOR WEEKS, I'VE TRIED TO *HUNT HIM DOWN,* AND NOW HE SAVES MY *LIFE--* WITHOUT EVER SAYING A *WORD!*

IN GOD'S NAME, WHAT KIND OF MAN AM I *DEALING* WITH?

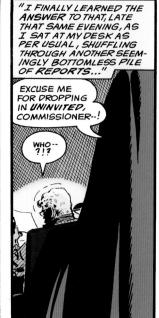

"I FINALLY LEARNED THE *ANSWER* TO THAT, LATE THAT SAME EVENING, AS I SAT AT MY DESK AS PER USUAL, SHUFFLING THROUGH ANOTHER SEEM-INGLY BOTTOMLESS PILE OF *REPORTS...*"

EXCUSE ME FOR DROPPING IN *UNINVITED,* COMMISSIONER--!

WHO--?!?

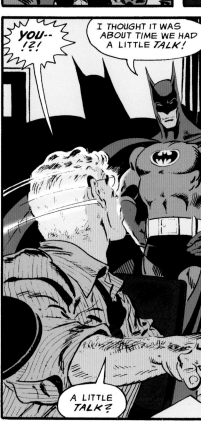

YOU--!?!

I THOUGHT IT WAS ABOUT TIME WE HAD A LITTLE *TALK!*

A LITTLE *TALK?*

MISTER, I HAVE ONLY *ONE* THING I WANT TO *SAY* TO YOU...

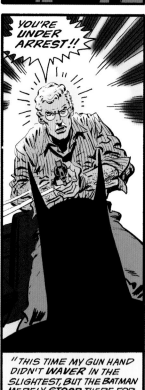

YOU'RE UNDER ARREST!!

"THIS TIME MY GUN HAND DIDN'T *WAVER* IN THE SLIGHTEST, BUT THE BATMAN MERELY *STOOD* THERE FOR A MOMENT, SILENT, DISTANT--"

The relationship between Batman and Commissioner Gordon is one of the most enduring in comics, but how they learned to trust each other took time to tell.

The Untold Legend of the Batman #3, September 1980
Writer: Len Wein *Artist:* Jim Aparo

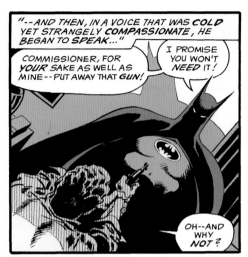

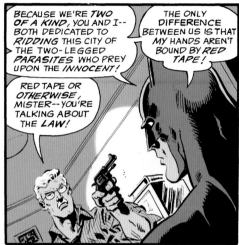

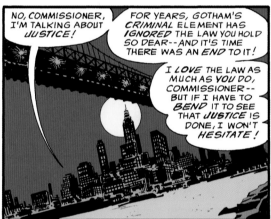

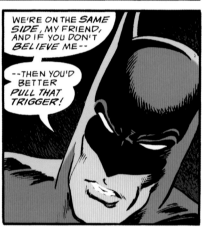

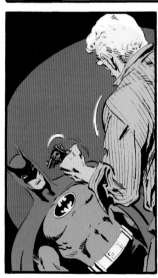

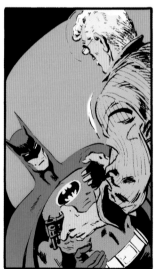

The Untold Legend of the Batman #3, September 1980
Writer: Len Wein *Artist:* Jim Aparo

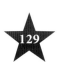

The trust between Batman and Gordon has been tested time and again, and here, Batman is ready to prove that trust with his most precious secret, but Gordon's refusal is classic.

Legends of the Dark Knight #125, January 2000
Writer: Greg Rucka *Artists:* Rich Burchett & James Hodgkins

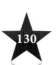

Legends of the Dark Knight #125, January 2000
Writer: Greg Rucka *Artists:* Rich Burchett & James Hodgkins

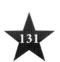

Legends of the Dark Knight #125, January 2000
Writer: Greg Rucka *Artists:* Rich Burchett & James Hodgkins

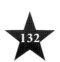

Legends of the Dark Knight #125, January 2000
Writer: Greg Rucka *Artists:* Rich Burchett & James Hodgkins

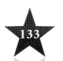

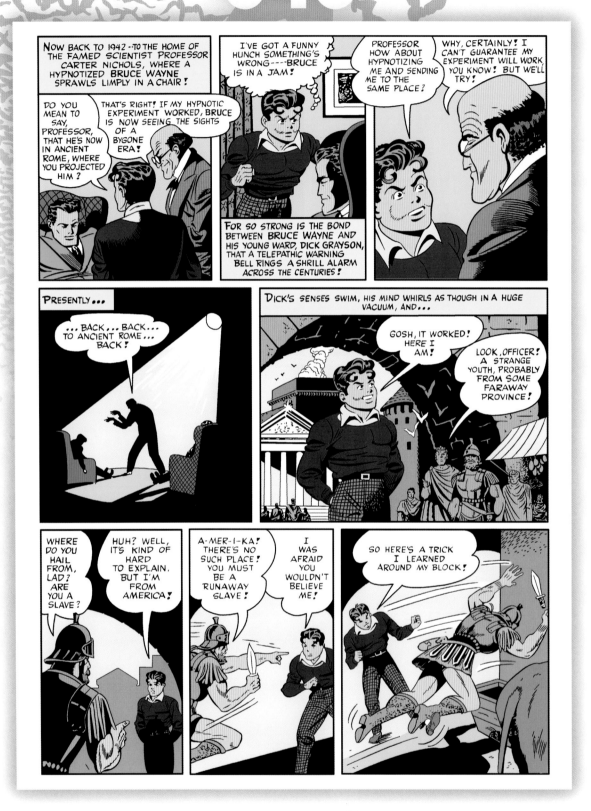

What seemed like a one-off gimmick became an enduring part of the Batman mythos for well over a decade, with Nichols becoming a trusted friend to the Dynamic Duo.

Batman #24, August 1944
Writer: Joe Samachson *Artist:* Dick Sprang

Batman #24, August 1944
Writer: Joe Samachson *Artist:* Dick Sprang

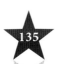

Julie Madison is leaving her fiancée, Bruce Wayne, and Gotham City behind for a successful Hollywood career. But the threat of Clayface has her first help the Batman.

Detective Comics #49, March 1941
Writer: Bill Finger *Artists:* Bob Kane, Jerry Robinson & George Roussos

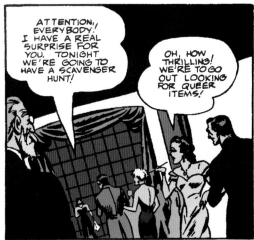
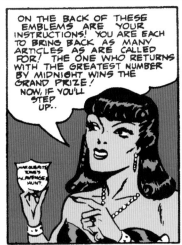
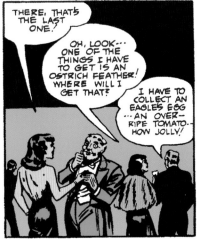
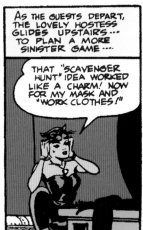
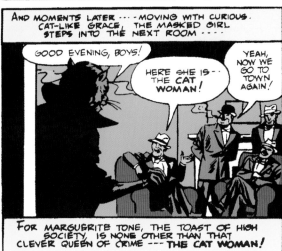
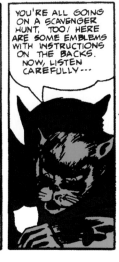
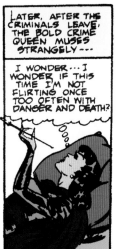

Not only does the Cat gain a mask and costume, but she finally acts on her feelings toward the Caped Crusader, beginning one of comicdom's most enduring (and frustrating) romances.

Batman #10, May 1942
Writer: Jack Schiff *Artists:* Fred Ray, Jerry Robinson & George Roussos

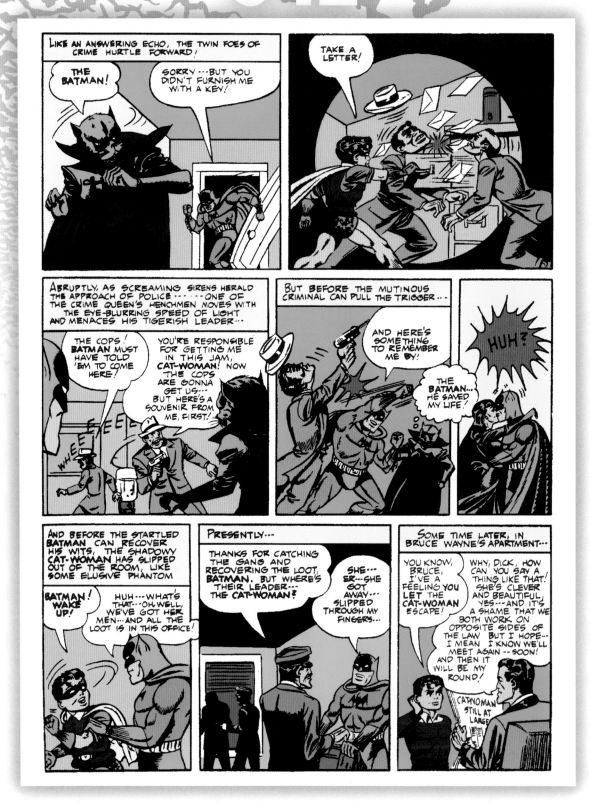

Batman #10, May 1942

Writer: Jack Schiff *Artists:* Fred Ray, Jerry Robinson & George Roussos

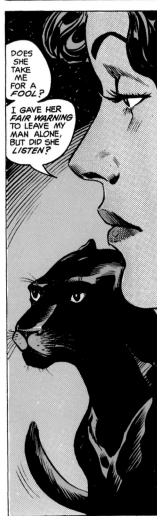

Catwoman and Bruce Wayne had been an item for a few years by now, so when Vicki Vale returns to the scene, Selina Kyle's jealousy gets the better of her.

Batman #355, January 1983
Writer: Gerry Conway *Artists:* Don Newton & Alfredo Alcala

Batman #355, January 1983
Writer: Gerry Conway *Artists:* Don Newton & Alfredo Alcala

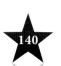

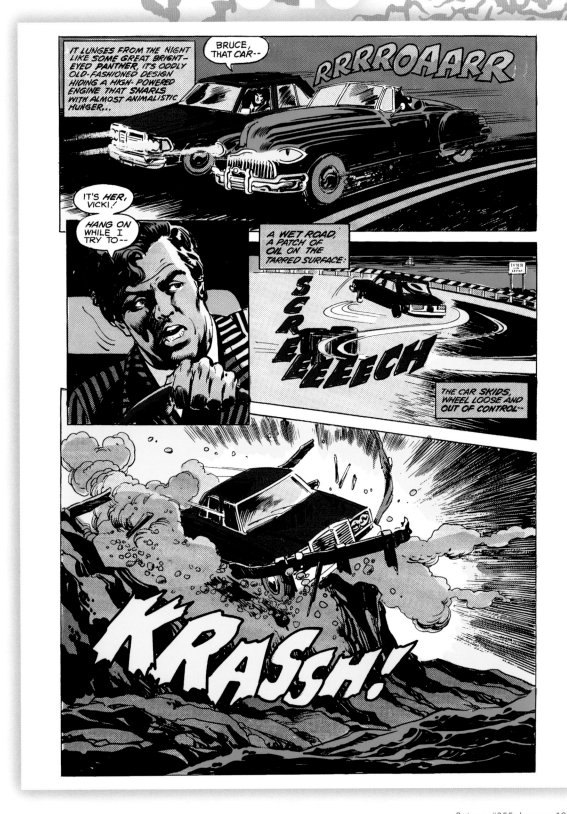

Batman #355, January 1983
Writer: Gerry Conway *Artists:* Don Newton & Alfredo Alcala

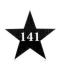

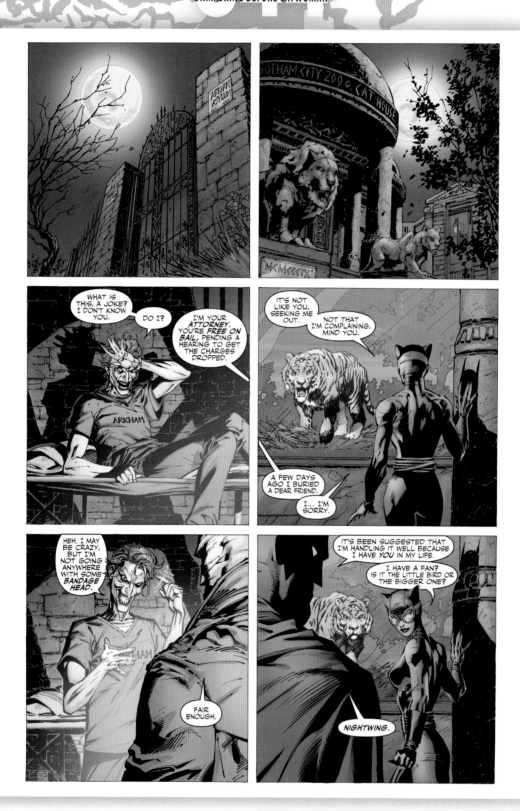

During the Hush case, Catwoman and Batman renew their partnership and torrid romance, this time to the point of his revealing his secret identity.

Batman #615, July 2003
Writer: Jeph Loeb *Artists:* Jim Lee & Scott Williams

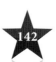

Batman #615, July 2003
Writer: Jeph Loeb *Artists:* Jim Lee & Scott Williams

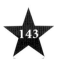

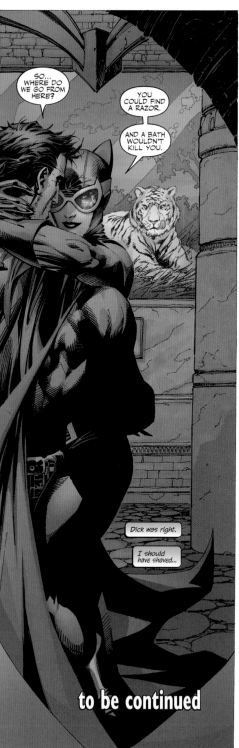

Batman #615, July 2003
Writer: Jeph Loeb *Artists:* Jim Lee & Scott Williams

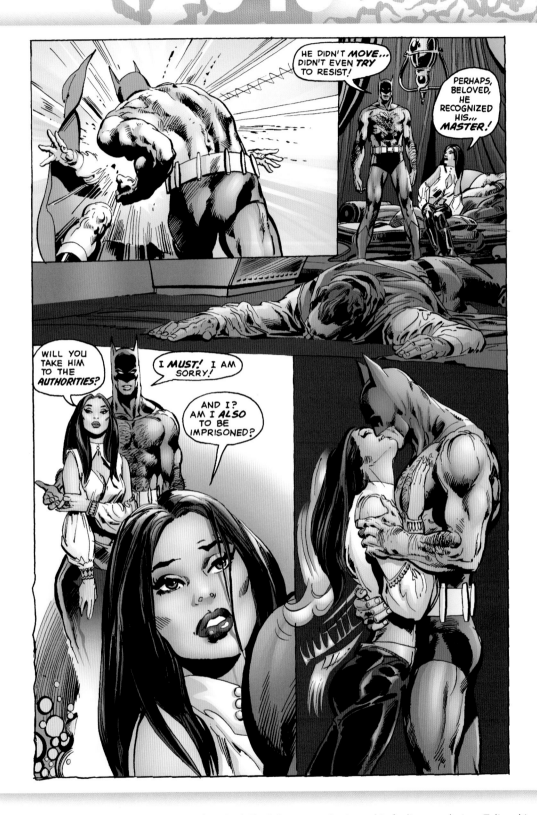

At the climax of the worldwide battle with Ra's al Ghul, Batman submits to his feelings and gives Talia a kiss to remember, a dramatic moment for the pair that will have repercussions for decades to come.

Batman #244, September 1972
Writer: Dennis O'Neil *Artists:* Neal Adams & Dick Giordano

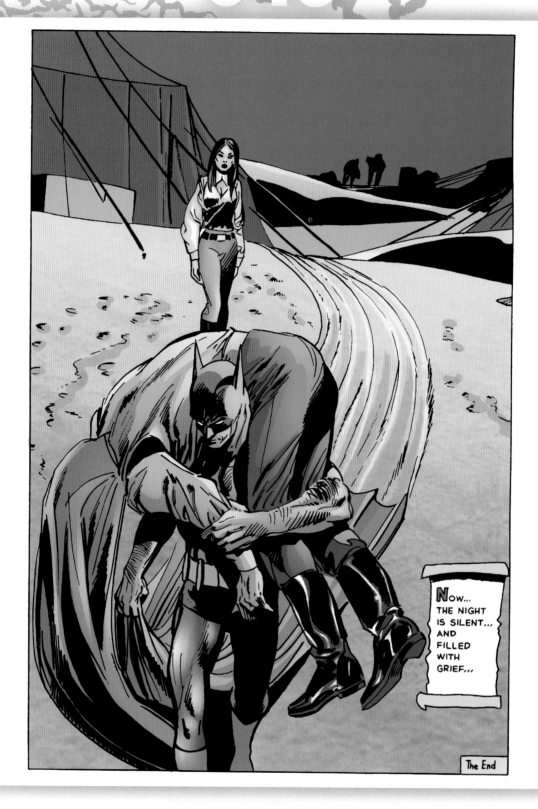

Batman #244, September 1972
Writer: Dennis O'Neil *Artists:* Neal Adams & Dick Giordano

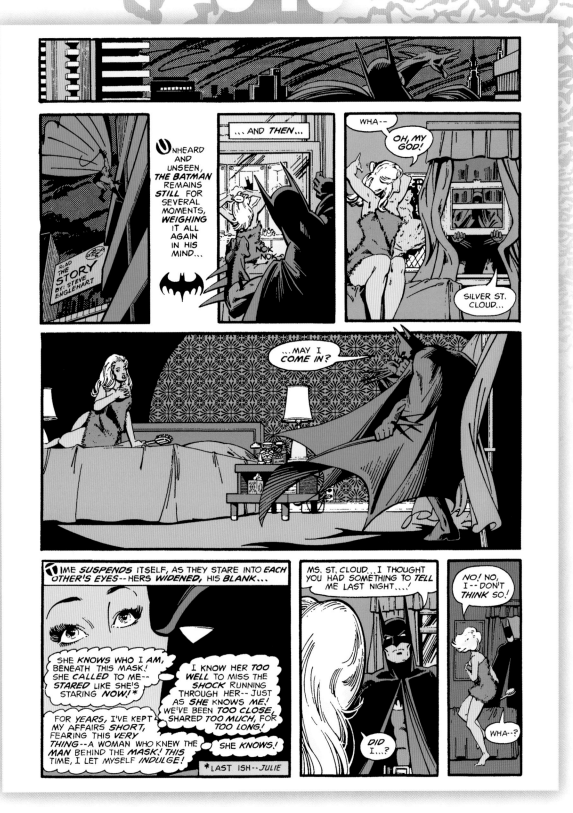

Silver St. Cloud discerned Batman's true identity, a secret she kept to herself even when confronted by the Dark Knight in her bedroom. Still, once she got caught up in his world, it was more than she could handle, and she willingly, tearfully walked away.

Detective Comics #475, February 1978
Writer: Steve Englehart *Artists:* Marshall Rogers & Terry Austin

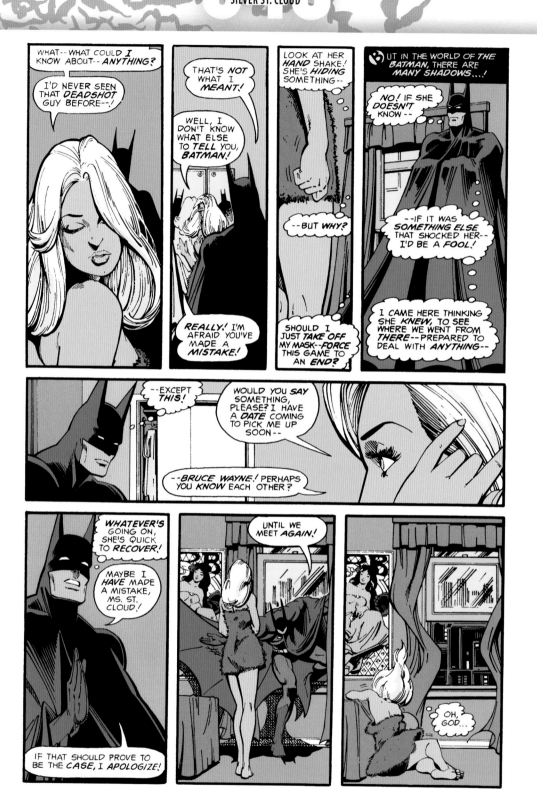

Detective Comics #475, February 1978
Writer: Steve Englehart Artists: Marshall Rogers & Terry Austin

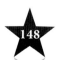

Detective Comics #476, March 1978
Writer: Steve Englehart *Artists:* Marshall Rogers & Terry Austin

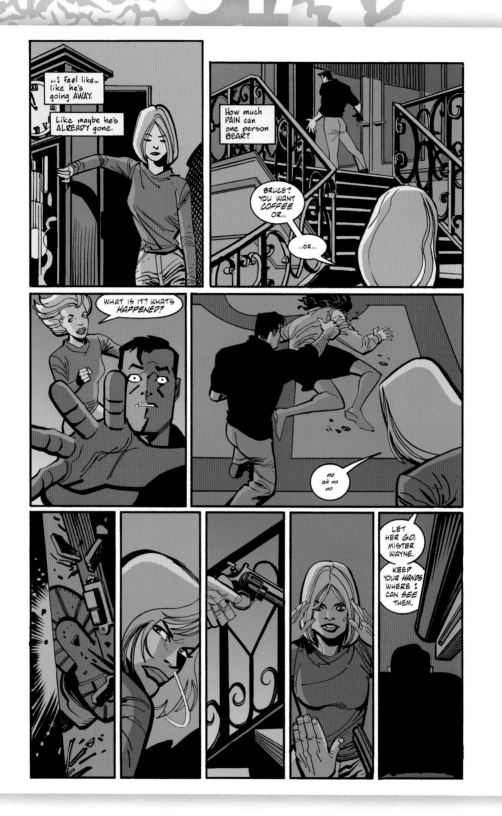

Bruce Wayne had been getting serious about radio personality Vesper Fairchild, but when her corpse is found in Wayne Manor, everything spirals out of control and makes Batman a fugitive.

Batman the 10-Cent Adventure, March 2002
Writer: Greg Rucka *Artists:* Rich Burchett & Klaus Janson

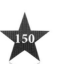

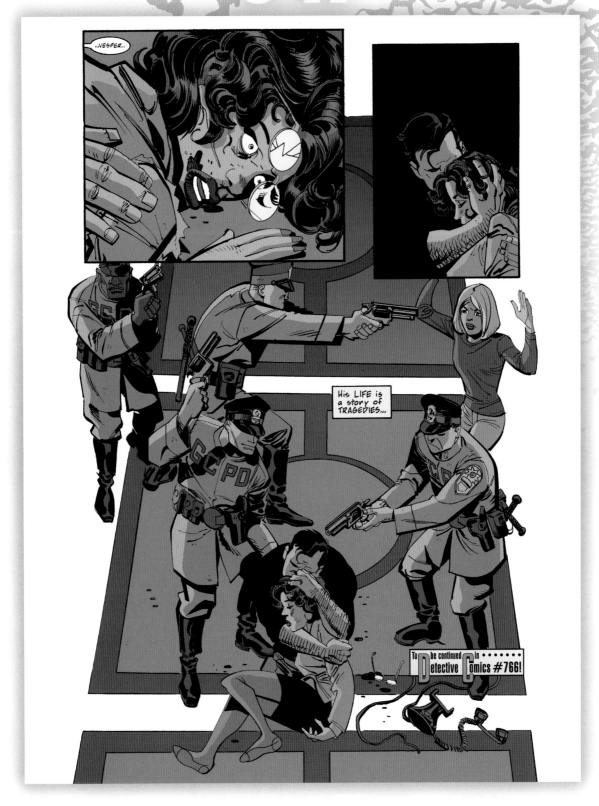

Batman the 10-Cent Adventure, March 2002
Writer: Greg Rucka *Artists:* Rich Burchett & Klaus Janson

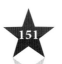

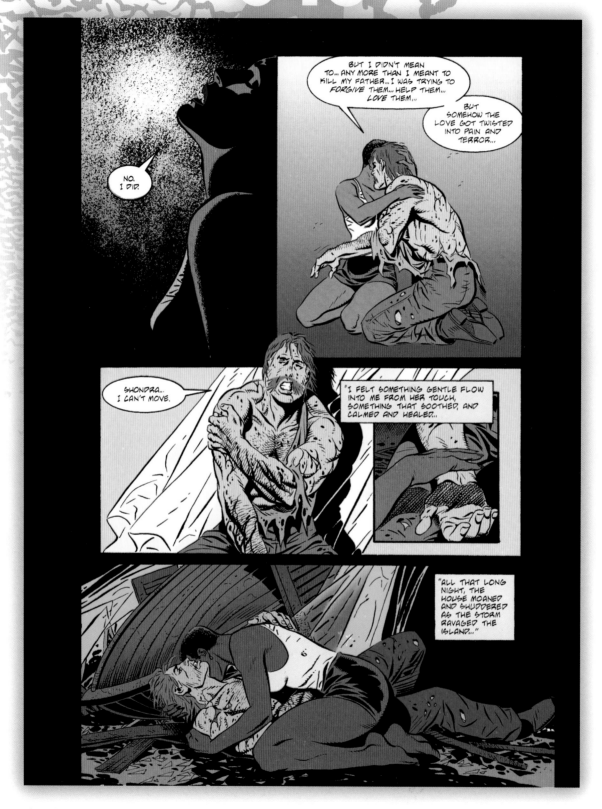

Shondra Kinsolving had a unique ability to heal people, something that proved pivotal as Bruce Wayne struggled to recover from his back being broken by Bane. It did, though, come at the cost of her sanity.

Legends of the Dark Knight #61, June 1994
Writer: Dennis O'Neil *Artist:* Eduardo Barreto

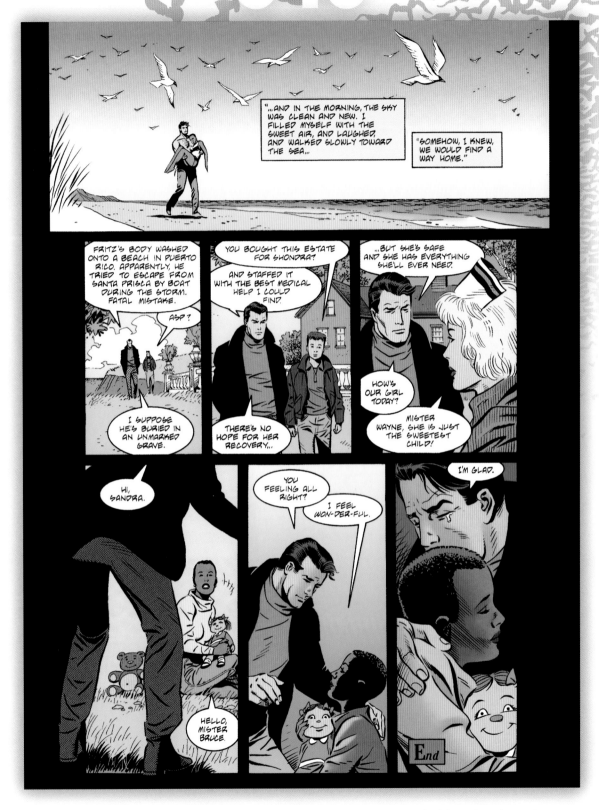

Legends of the Dark Knight #61, June 1994
Writer: Dennis O'Neil Artist: Eduardo Barreto

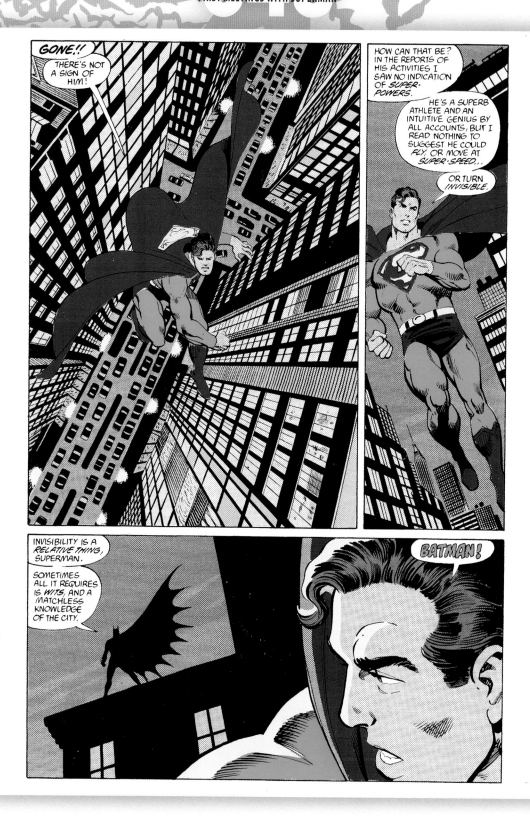

In the post-Crisis retelling, Superman and Batman are wary of each other, respecting each other's skills while having entirely different ideologies.

The Man of Steel #3, November 1986
Writer: John Byrne *Artists:* John Byrne & Dick Giordano

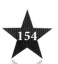

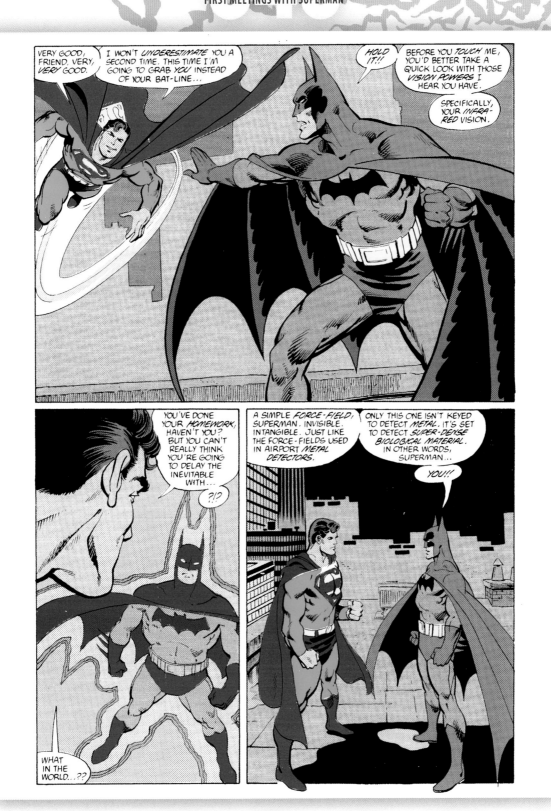

The Man of Steel #3, November 1986
Writer: John Byrne *Artists:* John Byrne & Dick Giordano

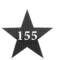

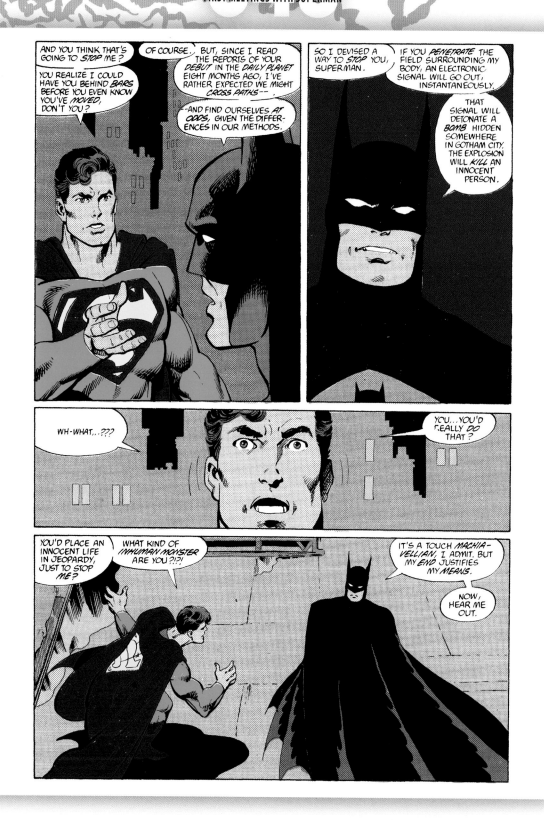

The Man of Steel #3, November 1986
Writer: John Byrne *Artists:* John Byrne & Dick Giordano

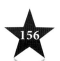

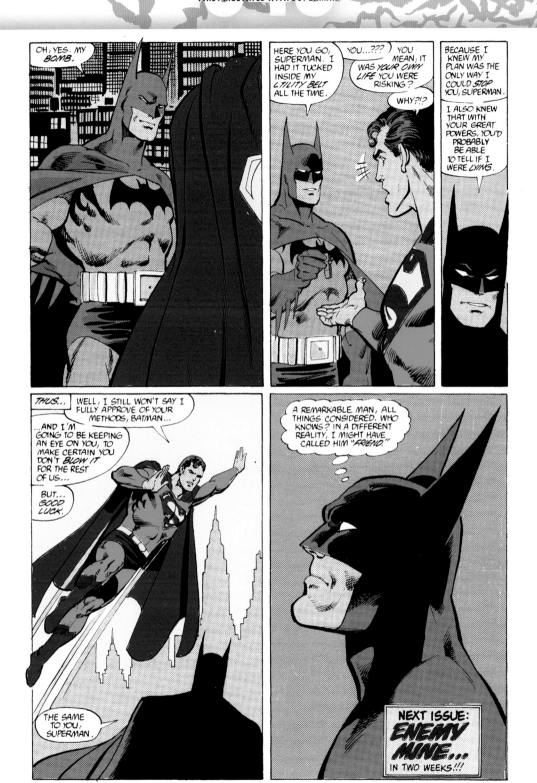

The Man of Steel #3, November 1986
Writer: John Byrne *Artists:* John Byrne & Dick Giordano

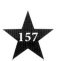

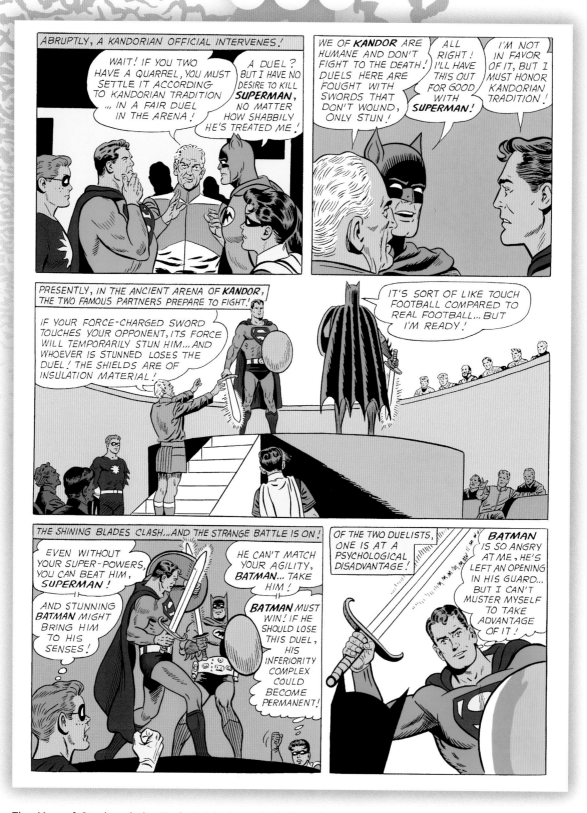

The Man of Steel and the Dark Knight have had their disagreements, but this memorable fight is a manufactured confrontation to give an injured Batman his confidence back.

World's Finest Comics #143, August 1964
Writer: Edmond Hamilton *Artists:* Sheldon Moldoff & George Klein

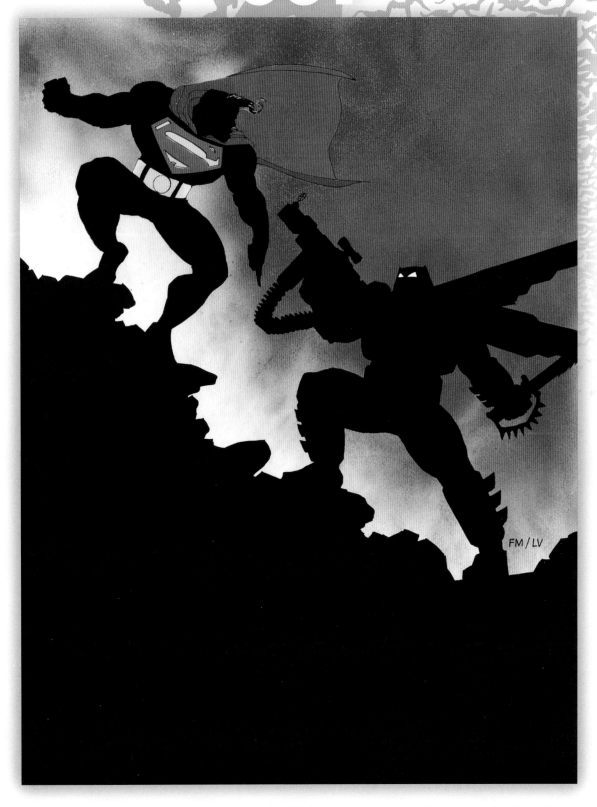

Armed with kryptonite gauntlets, Batman is ready to fight Superman, seen in this postapocalyptic world as a fascist figurehead of the American government.

Batman: The Dark Knight #4, December 1986
Artist: Frank Miller

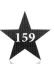

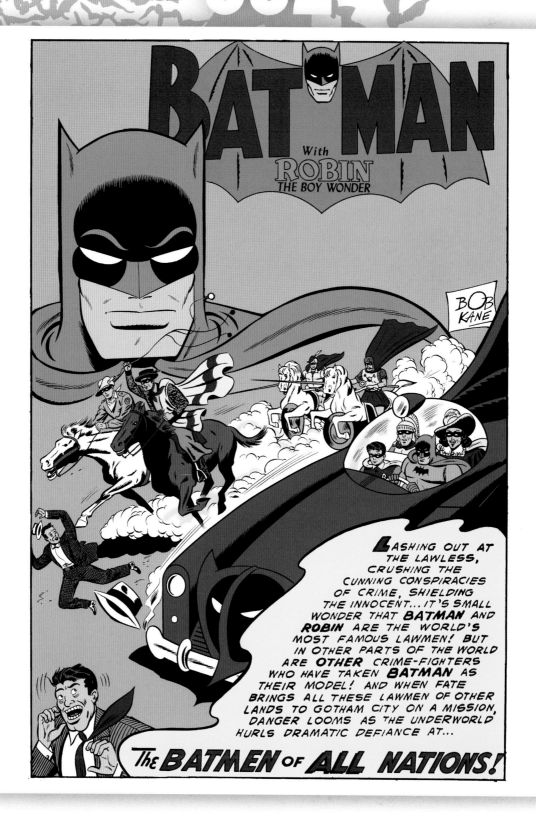

From around the world, Batman's counterparts come to Gotham City to help on an important case, a forerunner of stories told fifty years later.

Detective Comics #215, January 1955
Writer: Edmond Hamilton *Artists:* Sheldon Moldoff & Charles Paris

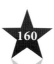

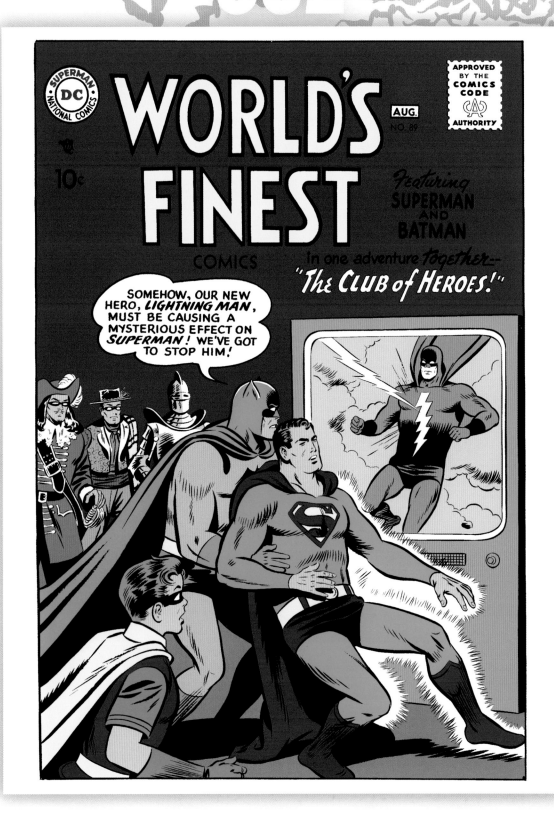

The international heroes renamed themselves the Club of Heroes so Superman could be inaugurated.

World's Finest Comics #89, August 1957
Artists: Dick Sprang & Stan Kaye

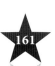

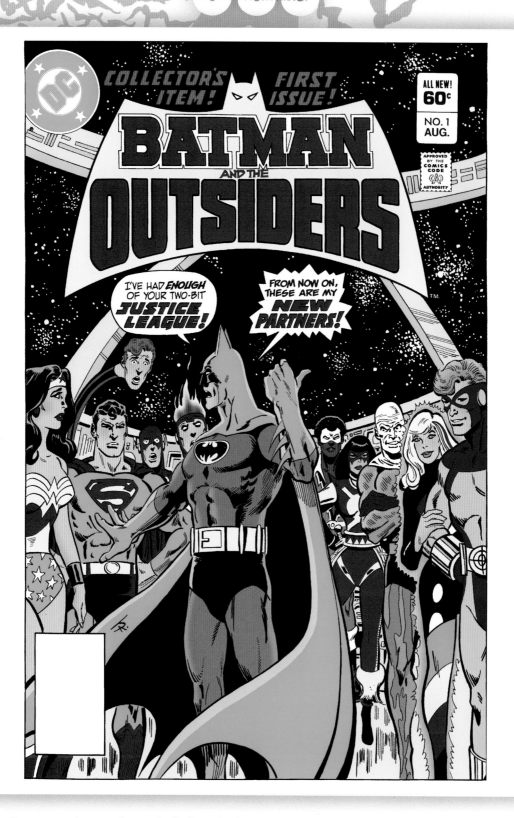

When Batman needs to work outside the lines, he finds himself in the first, and far from the last, ideological schism with his JLA teammates. This time, though, he forms a new team to aid him.

Batman and the Outsiders #1, August 1983
Artist: Jim Aparo

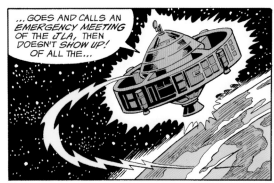

Batman and the Outsiders #1, August 1983
Writer: Mike W. Barr *Artist*: Jim Aparo

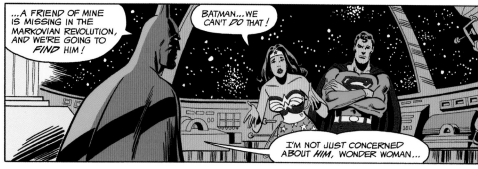

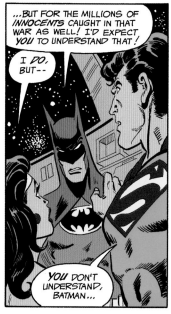

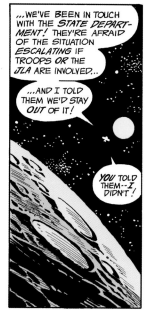

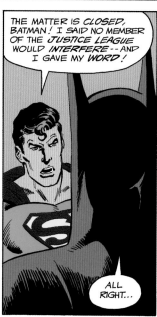

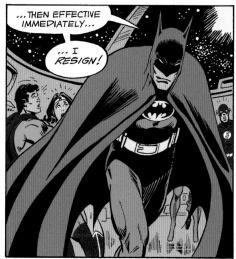

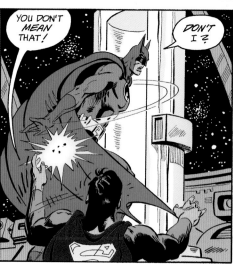

Batman and the Outsiders #1, August 1983
Writer: Mike W. Barr *Artist*: Jim Aparo

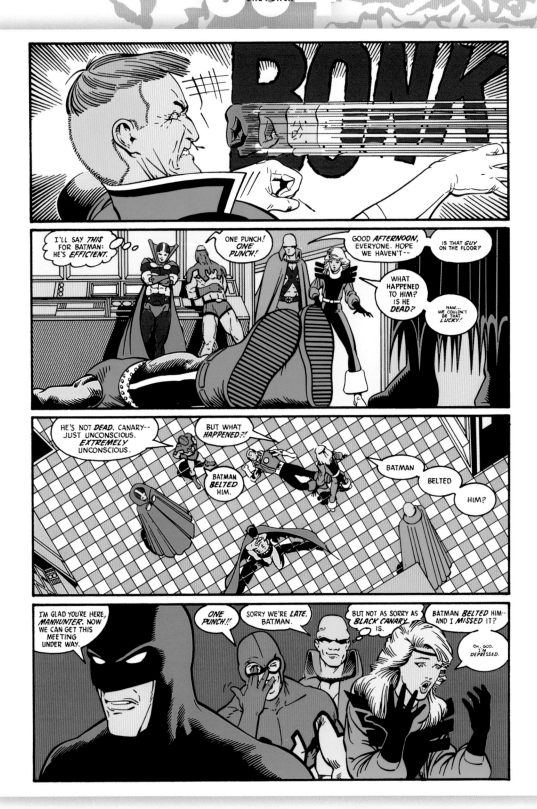

Batman sees himself as a loner, working with teams as a necessity, but he has little patience for blowhards and self-styled egotists, so he settles things in a classic manner.

Justice League #5, September 1987
Writers: Keith Giffen & J. M. DeMatteis *Artists:* Keith Giffen, Kevin Maguire & Al Gordon

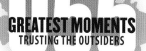

After working with his newfound teammates for a time, Batman finally decided he could trust them with his alter ego, something they had accidentally discovered on their own.

Batman and the Outsiders #13, August 1984
Writer: Mike W. Barr *Artists:* Dan Day & Pablo Marcos

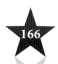

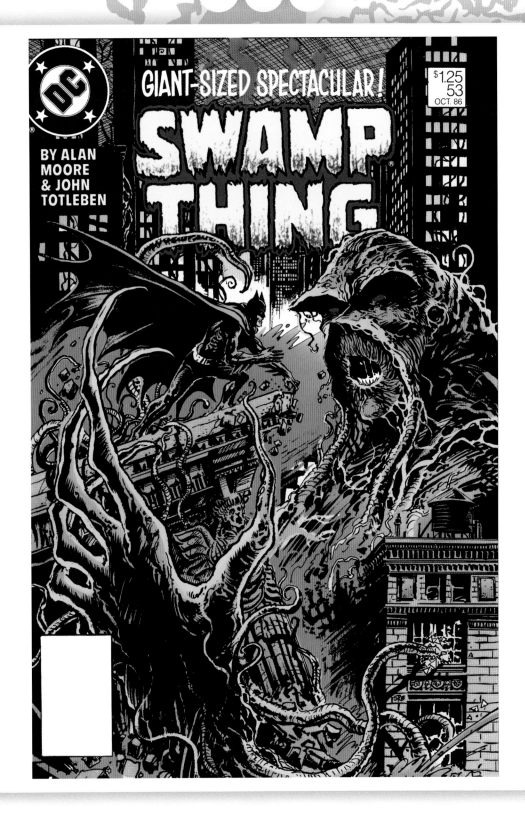

Swamp Thing had been to Gotham City before, but this visit was anything but a friendly one, earning the elemental the Dark Knight's wrath.

Swamp Thing #53, October 1986
Artist: John Totleben

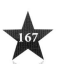

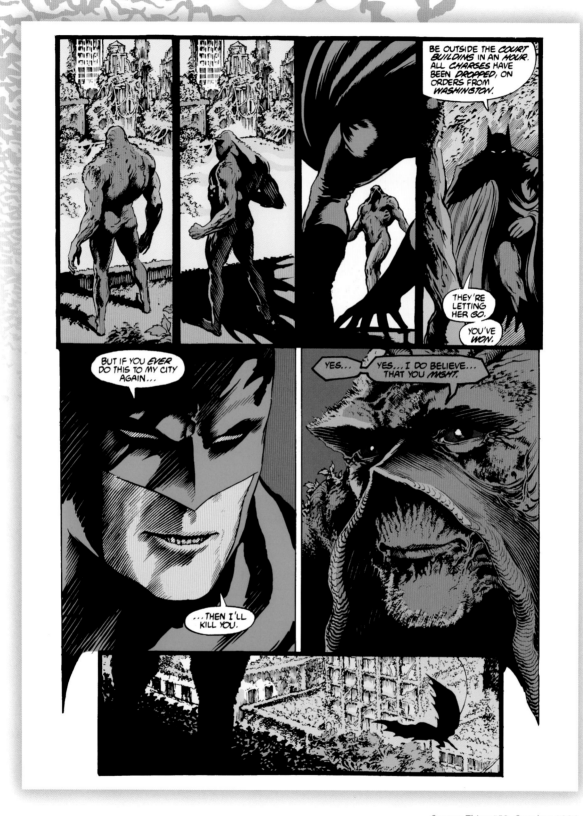

Swamp Thing #53, October 1986
Writer: Alan Moore *Artist:* John Totleben

CHAPTER 5
ENEMIES

GIVEN ITS PULP ROOTS, THE BATMAN FEATURE DEBUTING IN *DETECTIVE COMICS* SAW THE COSTUMED VIGILANTE TAKE ON YOUR STANDARD-ISSUE CRIMINALS. THERE WAS THE CHEMICAL SYNDICATE, FOLLOWED BY FRENCHY BLAKE'S JEWEL GANG AND THE MAD SCIENTIST DOCTOR DEATH. THEN CAME THE MONK, AND WE WERE FINALLY GETTING SOME FANTASTIC FOES. THINGS KICKED UP A NOTCH IN 1940 WHEN *BATMAN* #1 GAVE US NOT ONLY THE RETURN OF PROFESSOR HUGO STRANGE BUT INTRODUCED US TO THE JOKER AND CATWOMAN.

After that, writer Bill Finger and his compatriots, Gardner Fox, Don Cameron, Jack Schiff, Joseph Greene, Edmond Hamilton, and others, were constantly adding bizarre and grotesque opponents. Batman's rogues' gallery may be the most colorful and deadly of any super hero published. While often compared with Chester Gould's villains in *Dick Tracy*, it should be noted that Batman got there first.

Many opponents were colorful sorts, while others were delusional, and some were so powerful they staggered the imagination. Over time, the truly popular ones returned again and again, many making their way into live-action or animated fare. Over the years, Batman's antagonists have grown more numerous and increasingly dangerous, not only to the Dark Knight but the world at large. Organizations such as the Court of Owls and the Black Glove have directly threatened Gotham, while Earth itself is endangered by the League of Assassins and Leviathan. There remain other worldly threats, too, such as the New God Darkseid or the Batman Who Laughs, coming from the Dark Multiverse.

No wonder Batman finds himself in need of allies in his battle for justice.

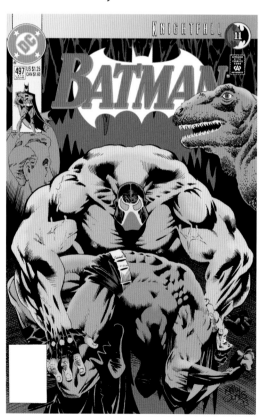

57. BATMAN KILLS THE MAD MONK

Bill Finger was never a fast writer, so shortly after Batman launched in *Detective Comics*, editor Vin Sullivan hired Gardner Fox to write several stories starting with the third installment. As a result, it is Fox who gave us Doctor Death and then the Monk, the first true super-villains of Batman's career. The latter was a vampire/werewolf hybrid from Hungary who possessed powerful hypnotic powers. Wearing a hood and full-length red robes, the Mad Monk was building an army of vampiric followers and was in Gotham when he recruited Julie Madison, Bruce Wayne's girlfriend.

Madison was lured to Europe, with Batman following in his Batgyro, a forerunner of the Batplane. The Monk sent a variety of obstacles in Batman's path, including an ape and the beautiful Dala. Tracking the Monk to his Hungarian castle, Batman melted silver candlesticks to fashion bullets, certain they would end the creature's threat and free his victims, including Madison. It was the first premeditated murder in the crime fighter's career and, quickly, one of the last.

The Monk was reinvented on Earth-1 and again after the events of the Crisis on Infinite Earths. In the latter, he was Niccolai Tepes, leader of the Brotherhood, expanding their reach to Gotham City.

58. CRASHING THE DINNER PARTY

Batman's post–Crisis on Infinite Earths origin was retold as *Batman: Year One*, running in *Batman* #404–407, written by Frank Miller and illustrated by David Mazzucchelli. The Gotham City power elite was filled with corrupt politicians and criminals, with the police department led by commissioner Gillian Loeb, who recruited lieutenant James W. Gordon from Chicago to make it appear all was under control.

What no one could count on was twenty-five-year-old Bruce Wayne, back in Gotham City after training for nearly a decade to begin his war on crime as Batman. The rookie hero found crime fighting tougher than imagined and nearly botched his first effort, taking on a gang of teen muggers. Still, he

gained confidence with each outing, until an urban legend about a bat-man began circulating through the city, reaching the commissioner and mayor.

One evening, the mayor was hosting a dinner, which included Loeb and crime family boss Carmine Falcone. Smoke grenades burst through the windows, and as the dining room was clouded, Batman appeared, a hazy shape. He announced, "Ladies. Gentlemen. You have eaten well. You've eaten Gotham's wealth. Its spirit. Your feast is nearly over. From this moment on—none of you are safe."

This was taken as a declaration of war, and Gordon was appointed to lead a task force to hunt down the dangerous vigilante. At one point, he interrogated assistant district attorney Harvey Dent, even suspecting him of being the culprit. Instead, Dent's alibi checked out, and he hid from Gordon the fact that he had been double-dealing, aiding the Batman in secret.

When Gordon first encountered the costumed man, it was to witness him saving a wino from a runaway truck. That began his reconsideration of exactly what kind of man he was dealing with.

59. THE LONG HALLOWEEN

Set shortly after the events of *Batman: Year One, The Long Halloween* was a year-plus story crafted by the team of Jeph Loeb and Tim Sale. Here, Loeb established his pattern of writing sprawling stories that tied in Batman's most infamous opponents while providing an intense character study.

They introduced the Holiday killer, who seemed to be murdering people on specific holidays, one a month. Batman allied himself with newly promoted district attorney Harvey Dent and captain James Gordon to determine who this killer was. At the same time, the Falcone and Maroni crime families had begun a gang war that threatened most of the citizens.

Maddening the Caped Crusader was the imprisoned Calendar Man, who claimed to know Holiday's identity but refused to divulge it, doling out clues and riddles instead. The case led to clashes with Scarecrow, Joker, Mad Hatter, Poison Ivy, Riddler, Solomon Grundy, and others.

In the end, Carmine Falcone's youngest son, Alberto, was revealed as the killer, attempting to win his father's approval and earn a place in the family business. What was never known by most was that Dent's wife, Gilda, also killed as Holiday, attempting to end organized crime in Gotham and keep her husband safe. Ironically, her efforts led to subsequent events that turned Dent into Two-Face.

60. SEWER CHASE

Batman was created in the vein of the great masked pulp heroes and blended brilliantly within Gotham's shadows. Over time, its darkness helped set this fictitious city apart from all others across the DC Universe. Many writers even played with the dichotomy between Batman's shadowy world and the gleaming city of tomorrow, Metropolis, where his pal Superman operated.

It wasn't until the 1970s, though, that we truly understood Batman's connection to his city. He knew criminals were a superstitious and cowardly lot, but his understanding of how their minds worked plus his intimate connection to the city gave him a superior edge.

While most people adored *Batman* #251's story for its return of the Joker, after a four-year absence, to his homicidal roots, the story is also memorable for just how dangerous an opponent Batman can be. As he hunts former associates to learn the Clown Prince of Crime's whereabouts, one of them runs. The man ducks, bobs, weaves, and finally goes into the sewer system to put distance between him and the Caped Crusader. He emerges, thinking himself safe, when a gloved hand grips his shoulder.

This was Batman. Cold, calculating, and seemingly everywhere.

61. "THE MAN IN THE RED HOOD"

The Joker was introduced in *Batman* #1 as a white-faced, green-haired murderer, possessing a venom that killed his victims, their faces left in a grinning rictus. Who he was and why he killed remained mysteries never solved. In fact, his initial story saw him killed off, but editor Whitney Ellsworth saw potential in the criminal and asked Bob Kane to spare him. He and Bill Finger whipped up a second tale, used to bookend that inaugural issue.

Since then, the Joker's pure origin has never been told. He's chaos made manifest, and no story could satisfy after the mayhem left in his wake.

In 1951, Finger decided to play with that and wrote a story in which a gang of criminals led by the unknown Red Hood Gang committed a series of robberies, attracting Batman's attention early in his career. When the Dynamic Duo pursued the criminals at the Monarch Playing Card Company, the Red Hood fell into a vat of chemicals and vanished. Opening the cold case a decade later, the Caped Crusader sifted through evidence and discovered that the toxic bath had transformed his adversary into the Monarch of Menace.

This version of the story was the closest any reality had to a definitive origin even though we never learned his name. The story has been retold in different eras, notably by Alan Moore as part of his *The Killing Joke* and Ed Brubaker in his *The Man Who Laughs*. The latter's title was a play on the Victor Hugo novel that was made into a silent film starring Conrad Veidt, whose makeup closely resembles that of the Clown Prince of Crime.

The various Batman film incarnations have used this story as a launch point with modifications, but who this man was remains one of comics' great mysteries.

62. AVENGING JASON

Jason Todd finally found a clue to his mother's whereabouts. He went globe-trotting, without Batman or his permission, and investigated the four women he suspected. In the Sahara, he finally located his birth mother, only to be shocked to learn she was working for the Joker. The Monarch of Menace was delighted to see the Boy Wonder and greeted

him with a crowbar, battering the hero until he lay unconscious. Then came an explosion, and by the time Batman arrived, it was too late. Jason was dead.

The Dark Knight hunted the Joker, only to find he had somehow been named Iran's ambassador to the United Nations, giving him diplomatic immunity and requiring Superman's intervention to prevent an international incident.

Frustrated, Batman had to bide his time, controlling his anger, until the day the Joker returned to Gotham City, as was inevitable. This finally occurred during chapter nine of the Knightfall storyline, which saw Bane unleash all of Batman's villains to wear down the hero. The Joker had partnered with the Scarecrow to abduct Mayor Krol, holding him hostage in the traffic tunnel under Gotham River. Batman, alone, approached his enemies only to get a face full of Fear Toxin. He managed to incapacitate the Scarecrow, but the gas triggered his anger over the Joker's murderous work and he savagely beat the Clown Prince of Crime, crying out Jason's name. He might have finally killed his nemesis, but the Scarecrow

managed to launch a missile, compromising the tunnel and forcing Batman to rescue the mayor and let the criminals escape.

63. JOKER TELLS BATMAN A JOKE

Brian Bolland was coming off a celebrated project, *Camelot 3000*, and was asked what he wanted to draw next. He said Batman and asked to work with writer Alan Moore. The ascendant writer was happy to comply and in 1984 delivered a 48-page script for *The Killing Joke*. This became a textbook example of how to explore the differences between hero and villain, order and chaos, Batman and the Joker.

Bolland took nearly four years to illustrate the tale, and when it was finally released, it sent shock waves throughout the fandom. First, the Joker crippled Barbara Gordon, taking the just-retired Batgirl off the playing field. He tortured Commissioner Gordon in a variety of ways, including showing him images of his daughter writhing in

pain. The tale also explored the Bill Finger quasi-origin story and added elements to explain how a man could so completely lose his grip on sanity.

It was clear that the relationship between the Dark Knight and the Clown Prince of Crime was taking center stage, so things built up to a climactic scene set at a circus (of course). After successfully avoiding the Joker's fun-house traps, Batman's opponent attempted to persuade him that their world was inherently insane and thus not worth fighting for.

After reaching and subduing his longtime nemesis, rather than beat the criminal, the Gotham Guardian tried something new: reaching out to the Joker, calmly asking him to give up his ways. "It's too late for that . . . far too late," he's told. Then the Joker tells Batman a joke, which makes the grim hero actually laugh. As the story ends, we never see what happens next. We only hear police sirens in the distance and see the steady rainfall.

64. RIDDLER AND JOKER DINE AT WAYNE MANOR

It was early in Batman's Prime Earth career, shortly after the Riddler arrived in Gotham City and triggered the Zero Year event that first brought Batman to action. Fairly quickly thereafter, the other rogues—Joker, Penguin, Mister Freeze, Clayface, Two-Face, Ventriloquist and Scarface, Solomon Grundy, Killer Croc, and Poison Ivy—were all on the scene. Then the Riddler suggested he partner with the Clown Prince of Crime, who replied by shooting him. Thus began the War of Jokes and Riddles, an event designed by the Prince of Puzzlers to get a laugh out of the Joker. It spiraled out of control, though, as the super-villains were forced to choose sides. And some five dozen people died in the month-long battle.

At one point, Bruce Wayne intervened and invited both sides to Wayne Manor for the year's most bizarre diplomatic dinner. An unamused Joker and a perfectly happy Riddler and their allies filled the dining room to break bread with Wayne. Alfred was at his best, negotiating between serving the perfect meal and avoiding being killed for the wrong word. Things did not end well, and later,

Batman was brought to the brink of killing the Riddler despite his code against killing. This formed one of his greatest regrets, and he felt he must share his shame with Selina Kyle before she said yes or no to his marriage proposal.

and editors would discuss online, in interviews, and elsewhere but not in the comics themselves. Batman exists to prevent other children from losing their parents and becoming orphans. It's a powerful moment for patient, doctor, and reader.

65. SCARECROW PSYCHOANALYZES BATMAN

Professor Jonathan Crane was a renowned psychiatrist who was constantly berated, belittled, and badgered by others, turning him into the criminal Scarecrow. His unique understanding of what people fear was applied to develop a variety of fear gases that made him a deadly opponent of the Dark Knight.

There came a confrontation, though, where the Scarecrow contrived to capture Batman to perform one of the oddest analysis sessions anywhere. Incapacitated, Batman was subjected to the latest iteration of Scarecrow's fear gas while he probed the hero's mind. The verbal exchange and mental wrestling provided readers with a fascinating glimpse into how the Caped Crusader's mind worked.

Batman truly sees himself as a hero, but one hampered by a lack of super-powers and an unending river of human suffering. He flashes back to young eight-year-old Bruce Wayne losing his parents to crime and how that forever altered his life. During their talks, Crane tries to convince the Dark Knight that Gotham City would be better without him, but his patient resists, remembering why he took up his cause.

And in what might be a first in comics, he articulates why he is Batman, something writers

66. THE PENGUIN AIDS THE BAT

The Penguin styled himself as the criminal broker of Gotham City, operating from his Iceberg Lounge, using extortion, blackmail, and barter to grease the wheels of the criminal underworld. Then Bane was imprisoned and set the wheels in motion to utterly destroy Batman. One way or another, Bane managed to coerce or convince the other criminals in the city to throw in with him so their efforts could be coordinated.

Oswald Chesterfield Cobblepot, bereft at the loss of Penny, his prized penguin, risked his well-being by surrendering to the Dark Knight. He confirmed Batman's suspicions that Bane was orchestrating the horrible events in his life. The uneasy truce led the Penguin to be taken to the Batcave, where he remained in a prison, speaking only to Alfred, and scared Bane would learn of the betrayal. This odd pairing was far from unique, as the two had traded information through the years, each turning a blind eye to the other's main occupation.

What neither realized at the time was that the canny criminal anticipated the defection and made it a part of the plan. The Penguin escaped the Batcave with his life only to run afoul of the Red Hood, the one-time Robin Jason Todd.

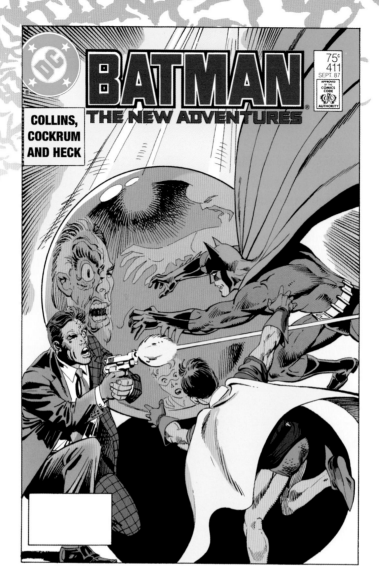

67. JASON TODD VERSUS TWO-FACE

Two-Face remained a fixture in Gotham City and ran several gangs while committing his crimes. During one such period, he killed a hireling for failing him—a man who later proved to be the father of Jason Todd, the second Robin. When the newly christened Boy Wonder found out the truth on the Batcomputer, he sought out the villain, intending to exact revenge. Wounding him further, he learned that Batman knew this fact and had yet to tell him.

The former district attorney was committing a new wave of robberies when he targeted Gotham Stadium during a doubleheader. Alone with his father's killer, Robin began to choke him, but Two-Face managed to break free and escape.

Back at the Batcave, Batman admitted to Robin that he was wrong to withhold the information, and they worked together to apprehend Two-Face for good the following evening. However, the story foreshadowed Jason's go-it-alone attitude and lack of complete trust in his mentor, setting up his eventual murder at the hands of the Joker.

68. TWO-FACE, DEFENDER OF GOTHAM

There came a day when all things seemed possible. Batman, Nightwing, and Robin had been through much and were due for a spiritual recharge. Still, their beloved Gotham City needed a protector, and Batman turned to Harvey Dent, district attorney

turned Two-Face, who had been restored to his original appearance. Looking for a fresh start after having his face, and sanity, seemingly restored by Dr. Tommy Elliot (the villainous Hush), Dent accepted Batman's offer and underwent extensive training.

Dent relished the role and earned admiration from his old friend Commissioner Gordon. Yet, no sooner did the heroes return to the city than a series of murders occurred with a modus operandi matching Two-Face, making Dent the primary suspect. When confronted by the Dark Knight, Dent's twisted persona returned, and Two-Face was reborn. This proved to be a crushing defeat for Batman, who always wanted to redeem Bruce Wayne's longtime colleague and friend.

In the Prime Earth reality, Two-Face, not Harvey Dent, worked with Batman to track down the murderer of mercenary Karl Twist. Having failed to convict Twist while he was district attorney, it was Dent, not his other self, who killed Twist, with Two-Face framing himself to protect the moral half of his persona. The pair managed to apprehend the cult leader Kobra, seeming to "correct" Harvey's lapse in judgment. In the aftermath, Two-Face faked his death and remained at large.

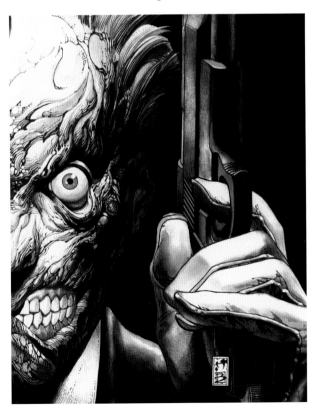

69. RIDDLER FORCES A TRACHEOTOMY

The Prince of Puzzlers was known for his keen intellect and criminal bent; psychologically compelled to solve riddles and mysteries, he used clues to challenge law enforcement. As a result, he was always one of the Dark Knight's most difficult opponents. What he generally was not was a killer.

That changed once, when he grew interested in occult rituals, including finding directions to summon the demon Barbatos, last brought to Earth by Thomas Jefferson. The Riddler needed a sacrifice so laid a series of clues to bring Batman into his trap, intending to use the hero as the offering soul. He kidnapped four innocent babies, forced Batman to kiss a hanged man through the need for CPR, and then bathed the Caped Crusader in blood at a transfusion center. This was followed by dancing with zombie robots and killing a pit bull using a silver dagger.

Then came the call that sent Batman to a location where an unbaptized babe was choking on a ping-pong ball. On the street, in the dark, with little in the way of proper tools, Batman was forced to perform an emergency tracheotomy.

Enraged, Batman wanted to find and punish the Riddler, but his efforts were stopped by Barbatos. In the end, the Riddler failed this test and was never again so callous toward human life.

It should be noted that these events occurred in the pre–Prime Earth reality and Barbatos is now an architect of the Dark Multiverse. The current incarnation of the Riddler is cold and capable of murder but does not make it a routine part of his work.

70. BRUCE WAYNE CALMS BLOCKBUSTER

A teenage Mark Desmond was very fortunate that Bruce Wayne was shipwrecked on a beach when the youth was trapped in quicksand. Wayne helped rescue Desmond, making a lasting impression. Hoping to improve his physique so he could help himself in the future, the reclusive Desmond worked on a small island where he lived with his older brother Roland.

The serum he developed worked on his endocrine glands, enlarging them and packing more mass and muscle onto his frame. In an unanticipated side effect, his anterior lobe was also enlarged, robbing him of his personality and intelligence. As a result, Mark was transformed into a brutish, hulking man, capable of mass violence.

Roland, a small-time criminal, saw ways to exploit his poor brother's condition and used him to help commit a series of robberies. When the Dynamic Duo arrived, the supersized human pummeled them soundly. Robin dubbed him Blockbuster, and the media began calling Mark by this name.

Tracing the two criminals, Batman realized they lived near where he had previously rescued Mark. Once Blockbuster was in sight, Batman unmasked and stepped into the same quicksand, triggering dim memories. Blockbuster rescued Wayne in the exact same manner, and he calmed down. However, once the heroes went after Roland, Blockbuster vanished.

He would reappear time and again, until his unfortunate death battling the Apokoliptian demon Brimstone, as part of the first Suicide Squad.

Roland altered the formula and used it on himself to become a second Blockbuster, this one retaining his intellect, making him far more dangerous.

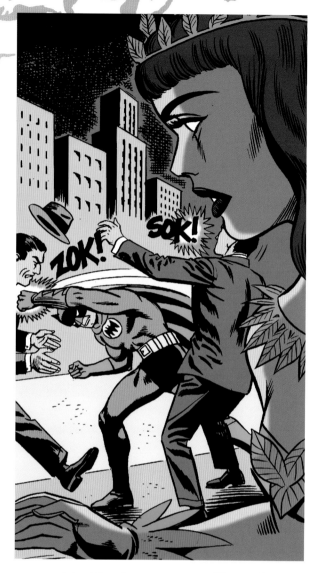

71. POISON IVY SPROUTS

Poison Ivy was the first major villain introduced during the Batmania era and immediately attracted reader attention, partly because of the intense interest in all things bat but also because she was the first significant female foe in years. About a decade after her introduction, she finally received an origin, only to have it retconned by the events of Crisis on Infinite Earths.

Pamela Lillian Isley was tied to Earth's other plant-based characters in Neil Gaiman's *Black Orchid* miniseries. There, she was a student of biochemistry, under the tutelage of Jason Woodrue, a refugee from another dimension who occasionally operated as the Floronic Man. A promising student, despite the false rumors about their having an affair, she

was used by Woodrue as an unwilling subject in an experiment. Her body chemistry was altered, making her immune to all toxins and pushing her to the brink of insanity. It also made her sterile, so she began creating plant-based life-forms and dubbed them her children.

As Poison Ivy, Isley used her brilliance to become a villain or a heroine or a protector of the earth. As a result, she spent long stretches in Arkham Asylum, often cut off from the very plant life she craved. She often fought Batman, using her various creations to ensnare him, frequently leaving him with a memorable kiss.

In time, she sought out her revenge on Woodrue, nearly destroying Gotham in the process. However, she remained protective of the city, coming

to live in the park during the No Man's Land year, ensuring that the foliage was cared for and occasionally growing food to help the poor and homeless.

Later, manipulated into working with the Riddler and Hush, Isley tried to cure herself only to wind up with her skin pigment impregnated with chlorophyll, making her appear green.

72. BRUCE WAYNE HELPS CREATE POISON IVY

Of all of Batman's foes, Pamela Isley may have undergone the most radical revisions in the Prime Earth reality. Here, she was born with a skin condition that made her exceptionally sensitive to sunlight. This, coupled with being raised in an abusive household where her father consistently beat her mother, gave young Pamela a skewed and jaundiced view of the world. After each beating, her mother would retreat to her garden and her father would apologetically gift her mother with flowers and plants to help grow her garden, teaching Pamela how people could be manipulated with nature.

While at college, she developed inventive pheromone pills and gave them away in order to track their effects on people, until the school administration learned of it and had her expelled. The order was rescinded by the dean, who had fallen under her chemical thrall. Not only did she graduate summa cum laude, but the dean arranged a prestigious internship for her at Wayne Enterprises. There, her research into accelerated plant growth was stolen by the Riddler during the Zero Year events, and he used it to turn a powerless Gotham into an overgrown jungle.

Once the newly arrived Batman saved the city from the Riddler, Isley went back to work and used her drugs to earn a meeting with Wayne. There, she proposed a plan that would eliminate his advertising division in favor of her pheromones being used to manipulate the buying public. Wayne argued that it robbed people of free choice and was ethically opposed to it, firing her on the spot. Gathering her things in a hurry, she accidentally doused herself with a serum that permeated her skin and altered her body chemistry, making her

immune to poisons while giving her a connection to The Green, so she was able to control plant life.

The somewhat deranged woman became Poison Ivy, who worked to protect the world from mankind as both a villain and occasional heroine. She formed few attachments other than a romantic relationship with Harley Quinn, who asked her to check herself into the metahuman mental health facility known as Sanctuary. During the *Heroes in Crisis* miniseries, Ivy was killed, only to be reborn as a sentient plant-based life-form.

73. MAN-BAT

Detective Comics was nearing its landmark 400th issue, and editor Julie Schwartz and writer Frank Robbins were creating a brand-new opponent for the occasion. Schwartz suggested inverting Batman's name to create a man-bat. Artist Neal Adams was hanging out in the offices and helped plot the initial story and then agreed to draw it. He or Robbins illustrated the new character's first few appearances, establishing the tone. Man-Bat was a hit with readers, even earning his own short-lived series, and he's been a fixture in comics ever since.

What has changed over time is Kirk Langstrom himself. In a 1989 account, he was a young boy who once was lost in a cave for six hours, and when rescued, he talked of leaving his "friends," the bats, behind. He grew obsessed with bats, becoming a zoologist and nocturnal mammal expert at the Gotham Natural History Museum, as in the 1970s origin. As a side project, he worked with secretions

from bat glands to develop a serum to amplify a human's sensory capabilities. He experimented on himself with disastrous results, as his body changed shape and he began exhibiting bat characteristics.

In time, Batman found this threat and subdued him, eventually determining what had happened. Langstrom later married his longtime love, Francine Lee, who inevitably became She-Bat, and when they had children, both worried what the serum had done to their genes. Sure enough, Rebecca's life was endangered by her parents' folly, requiring intervention from the Man of Steel to help find a cure.

Man-Bat has fought more often than not as a champion of justice, but his mind has been constantly affected by the serum. Talia al Ghul took advantage of this, forcing Langstrom to create an army of Man-Bats as part of her campaign to seize control of Leviathan.

Much of his history has been altered in the Prime Earth reality, with Langstrom now a hero, working as a member of Justice League Dark.

74. CONFRONTING RA'S

The villains created during the New Look era, apart from Poison Ivy, were never terribly memorable to readers. When Julie Schwartz took Batman back to his gothic roots, he made Denny O'Neil his primary writer, and every Thursday the two would meet and plot stories. After they fell into a groove that reset the status quo, Schwartz decided it was time for a new major villain to be introduced. He'd done some

research and offered O'Neil a name: Ra's al Ghul, Arabic for "head of the ghoul" or Demon's Head.

O'Neil went to work, creating a global threat masterminded by this new foe. He had just completed a story where Batman rescued an attractive damsel in distress and decided to roll her into the tale. Readers first met Ra's, designed and illustrated by Neal Adams, in *Batman* #232. Here we learned the seemingly immortal Ra's headed a shadowy League of Assassins and wanted Batman for a son-in-law and an heir to his empire. When Batman refused both offers, an enmity developed that played out for the next two years, culminating in issue #244's desert battle.

A shirtless Dark Knight and Ra's fought with swords until a scorpion stung the hero, leaving him collapsed and dying. Ra's walked off, unaware that Talia's farewell kiss contained an antidote.

The image of the hero painfully rising under the harsh sun was followed by his angry entrance into Ra's tent. Stunned, Ra's realized he had met his match. While Ra's was dragged off to face justice, it was merely the opening gambit between the two, a battle of wits and wills that has carried on in comics, animation, and live action ever since.

75. SENSEI VERSUS RA'S

After defeating Ra's al Ghul, Batman made it his mission to dismantle as much of the League of Assassins as possible. The League may have been founded by Ra's, but he allowed others to run it, starting with Dr. Ebenezer Darrk, who proved disloyal and was dismissed. The League then fell to the ancient martial arts master known only as the Sensei. He, too, proved disloyal, which sparked a war between Ra's and the Sensei for control of the League.

The struggle was unknown by Batman until their fight reached Gotham City. Acting on an anonymous tip, he arrived at Kane's Kolossal Karnival, run by Kathy Kane, once the Earth-1 Batwoman. The Sensei's agents were aided by a brainwashed Bronze Tiger, now serving the Sensei, who battled Batman, preventing him from stopping the others from killing Kane. Ra's revealed himself as the informant,

explaining to Talia that he needed Batman to help him wrest the League from the Sensei before he lost total control of the organization.

Ra's didn't foresee Kane's death, but it served his purposes, as Batman tracked the Sensei and helped put an end to the League in its current configuration. Sensei was in the process of creating small earthquakes as part of his latest scheme, but Ra's interfered, and the two ancients fought. Both Ra's and Sensei died in the climactic battle, a result of the triggered earthquake, although Ra's was once more resurrected by bathing in a Lazarus Pit. The Sensei was less fortunate.

While Ra's and the Sensei both exist in the Prime Earth realty, this war, if it ever happened, did not involve Kathy Kane.

76. BAT-MURDERER

For a brief period, editor Julie Schwartz was asked to cede *Detective Comics* to incoming editor Archie Goodwin. When Goodwin departed, Schwartz got the title back and made his return a memorable one, as the cover to issue #444 shows Batman shooting his lover, Talia, in the back. So began the "Bat-Murderer" serial, which was epic for its day. Running five issues and totaling 66 pages, it was one of Batman's longest sustained stories to date. Written by incoming Bat scribe Len Wein, the first three chapters were drawn by Jim Aparo, while the final two installments were from Ernie Chan (at the time signing himself as Ernie Chua) and Dick Giordano.

With the Caped Crusader seen shooting Talia in front of a gaping public, Commissioner Gordon had no choice but to order Batman's arrest. As the manhunt began, Ra's al Ghul showed up shot, implicating that Batman was now on a killing spree. While on the hunt for clues to clear his name, Batman had to fight and eventually ally himself with the mercurial vigilante the Creeper. There was even a distraction when Batman had to deal with a threat from the newly arrived criminal Sterling Silversmith.

The finale took place inside a circus, where trick mirrors played games with Batman's mind until a circus performer revealed herself to be Talia, very much alive. This proved to be another ploy of Ra's to discredit Batman as a hero, forcing him to accept a place with the League of Assassins. Instead, Batman and Creeper fought the League as the big top burned. In the end, all but Ra's fled to safety. Turning Talia and the murder weapon over to Gordon, Batman prepared to leave but Gordon gestured with the gun, which fired at the hero, proving it had been gimmicked by Ra's to fire on its own, the proof needed to clear Batman's good name.

77. KGBEAST

Anatoli Knyazev was selected by a secret division of the USSR's KGB called the Hammer to be trained as the world's deadliest assassin. In the waning years of the USSR, the Hammer had grown so powerful that it was even feared by the Soviet Union's Central Committee.

Knyazev became more than proficient with martial arts and mastered a wide variety of weapons. Known then as the KGBeast, he set out on assignment and was credited with a body count surpassing one hundred, including nine CIA agents. His name was feared, and his presence struck terror in any setting.

The Hammer's leader decided to send KGBeast to America, to commit a killing spree with the ultimate goal of assassinating the president of the United States, all designed to foil implementation

of the Strategic Defense Initiative. Being an unsanctioned action, it was also the leader's final act of "patriotism," and he shot himself rather than watch his division be eliminated.

There was a two-week period where key participants in the SDI program would be in Gotham City, so KGBeast headed there. Despite the GCPD's best efforts, and Batman's personal intervention, seven of the nine targets were eliminated. Batman focused solely on apprehending the killer before a senator and the president could be killed to complete the assignment. Batman nearly caught him, but the killer cut off his own hand rather than risk capture.

Batman tracked the Russian to the sewers, and the KGBeast offered to battle the vigilante. Instead, Batman locked him inside a chamber and let the police handle the matter. Unfortunately, they arrived to find the chamber empty.

The two men would battle each other time and again in all subsequent realities. On Prime Earth, Bane hired the KGBeast to shoot Nightwing, only managing to seriously wound the hero.

78. DEACON BLACKFIRE

Many have tried to coerce, befuddle, battle, entice, and kill the Dark Knight. Few have taken on the task of trying to mentally break the hero, and the first to succeed at this was an unlikely candidate.

Joseph Blackfire was a deacon who grew distraught at the rising tide of criminals and dangers to Gotham City's populace. Having worked with the indigent, Blackfire saw in them an army to be trained, to help them rise up and have their plight taken seriously. Beginning with the homeless who huddled in the city's sewer system, he used his charisma and honeyed words to energize them, and so began a citizen uprising.

Blackfire's efforts proved more successful than ever imagined, as his army took the streets and chased away the criminal element, sending them to the now-abandoned sewers. With his success, the power went to his head and he narrowed his worldview. With his people now in control, Gotham City essentially cut itself off from

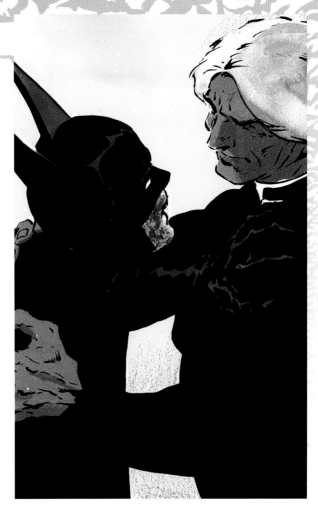

the United States (foreshadowing the government returning the favor some time later).

Batman had seen enough and intervened, only to be captured by Deacon's forces. The Gotham Guardian was subjected to various techniques to break down his mental discipline. Finally, adding pharmacological drugs to his work, Blackfire wore away at Batman's mind. He eventually succeeded where the more colorful rogues' gallery had failed. Batman was now brainwashed to serve Blackfire.

Robin finally located his partner, and together they fought their way through Blackfire's men. Batman quickly overcame Blackfire's control and used a modified Batmobile to help take back the city from Blackfire's acolytes. In a final confrontation, the Deacon's mental discipline was nowhere near as strong as Batman's, and he crumbled, begging for death. His followers had turned on him, and they granted him his wish.

When Bane released all the criminals in Blackgate Prison and Arkham Asylum, Zsasz was among them and he made his way to a girls' college, taking the students hostage. Awaiting the Dark Knight, he was rewarded, and during their confrontation he boasted of how similar the two men were.

Already mentally exhausted from recapturing the criminals and dealing with their heinous acts, Batman reacted violently to the comparison. Here, he savagely pummeled Zsasz, and police intervention was required to keep the Dark Knight from killing Zsasz.

The two men would continue to meet and fight, with Zsasz's body running out of places to memorialize each victim.

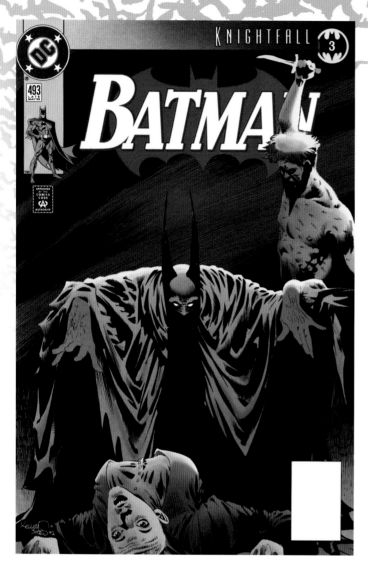

79. MISTER ZSASZ

Of all the characters created by the team of Alan Grant and Norm Breyfogle, the most enduring is Mister Zsasz.

Victor Zsasz lost his parents at age twenty-five, emotionally crippling him. He engaged in risky behavior, eventually losing all his money to the Penguin before concluding that life was meaningless. He began a killing spree to "liberate" people from this pointless existence.

To keep track, the increasingly insane Zsasz began notching each kill onto his skin, transforming his body into a grotesque tote board. Batman eventually captured Zsasz, remanding him to Arkham Asylum.

80. ADDICTED TO VENOM

Venom was a drug derived from the unique substance Miraclo, developed by Rex "Tick-Tock" Tyler at Bannerman Chemical. When it was initially created in the 1940s, Miraclo was used to give Tyler an hour's super-strength, speed, and agility, allowing him to fight crime as Hourman.

Years later, the basics for Miraclo were used to create Venom on the island of Santa Prisca. It was an addictive substance that provided the user with enhanced skills and abilities but with reduced mental and emotional control.

The man known as Bane, a criminal who grew up in the Santa Prisca prison, began using a new version of the genetically engineered steroid. He carried a supply strapped to him with intravenous tubing snaking down both arms. The constant supply kept him a raging behemoth. After several years of being addicted to it, Bane eventually weaned himself from Venom and began destroying the drug manufacturers and suppliers to keep the drug away from the world.

When Batman encountered Venom, he tried to keep it out of Gotham City, but he was injected with a high dosage. It took the Dark Knight a solid month's isolation in the Batcave to overcome its addictive properties.

81. BATMAN BEATS BANE

Bane came to Gotham City to prove he was a better man than Batman, starting by releasing the criminals in Blackgate Prison and Arkham Asylum to mentally and physically tax the Gotham Guardian. Then he battled the weary hero in the Batcave, snapping Batman's back over his knee.

The mantle of the bat was passed on to Jean-Paul Valley, who switched from being the Avenging Azrael to the second Batman. One of his acts was to track down and beat Bane in revenge.

Bruce Wayne eventually was healed and retrieved his alter ego from Valley, but by then Bane was no longer a factor. Still, a part of Batman's mind wanted his own turn at exacting vengeance and awaited the opportunity. That presented itself when time was too precious to waste. Batman was aware that Ra's al Ghul was attempting to release a new version of the Ebola Gulf-A virus in Gotham City, eventually learning that it was intended to be released at the opening of a brand-new casino.

As Batman investigated the new facility, he found himself face-to-face with Bane, then-allied with Ra's. The two men fought violently throughout the kitchen, both men escaping a gas explosion that destroyed the casino. The fight, though, was not yet extinguished, just relocated to adjacent Gotham Bay. There, Bane gained the upper hand, nearly drowning Batman.

"So much pain . . . so long ago . . . just like yesterday . . . the night my parents died . . . the last night I knew fear. . . . An even uglier emotion than fear wells up in me . . . rage," thought Batman. Channeling that emotion, he managed to beat the Venom-fueled Bane, leaving him battered and broken on the dock.

82. HARLEY QUINN MEETS BATMAN

Her story is one of the most repeated of any character: how Harley Quinn was created for *Batman: The Animated Series* by Paul Dini and Bruce Timm, a one-off foil for the Joker. Between their work and the voice performance of Arleen Sorkin, Quinn captivated the Joker's heart but, more important, those of the viewers. She quickly began reappearing on the series while Dini and Timm produced 1994's one-shot comic, *The Batman Adventures: Mad Love*, to explore her origins. That, too, resonated with readers, earning it both Eisner and Harvey Awards.

It was therefore inevitable that Harley Quinn would make an appearance in the core continuity, although it didn't happen until 1999. She arrived at a time when Gotham City was a No Man's Land, cut off from the United States and divided into territories. Readers first saw her inside a rocket that landed in Poison Ivy's path. Recognizing the costumed woman inside as Arkham Asylum psychiatrist Harleen

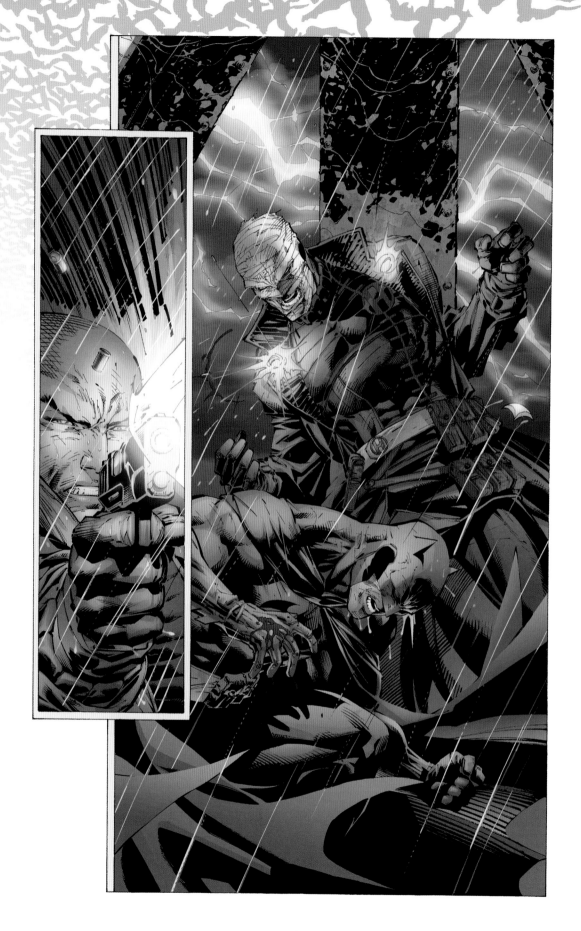

Quinzel, Ivy took her to Robinson Park and healed her, sparking the beginnings of a romance. Quinzel, though, was in love with the Joker and sought to work with him, hence the red and black costume.

Harley Quinn emerged as one of DC's most popular characters, sustaining a growing number of comic series where she has been a hero, villain, and crazy woman. She battled, bested, belittled, and bussed Batman over the course of her comics career.

83. HARLEY LOVES BRUCE WAYNE

Bruce Wayne periodically must make public appearances to maintain the notion that he is an active playboy millionaire as well as head of Wayne Enterprise. In most cases, he makes the requisite appearance, is seen, photographed, and fawned over, and then vanishes without people noticing. One time, though, he agrees to auction off a date in support of an animal shelter.

Harley Quinn, busy with her own menagerie, learns of the auction and approves, especially when she gets a good look at Wayne. Smitten, she decides she must win the date; however, she doesn't have a million-plus dollars on hand, which was the auction estimate. As a result, she begins committing crimes, robbing businessmen partly responsible for the 2008 fiscal meltdown, deciding their ill-gotten gains should go to a better cause.

With exactly $1,000,100 to spend, Harley makes that her top bid and quickly strangles her bidding rival before the offer can be bested. A villain called the Carp arrives to rob the cash for himself before Harley and her bemused date can leave. The Carp winds up making off with the money *and* Wayne, requiring Harley to get help from Poison Ivy to rescue both.

In the end, Wayne and Harley have their date, and he's impressed by her selfless acts of charity and gives her a warm kiss.

Later, Batman surprises Harley with a visit to thank her for rescuing Wayne. She asks to see how good a kisser the Dark Knight is and, surprisingly, he obliges. Harley sends him off with the suggestion that he take lessons from Wayne.

84. HUSH HAUNTS BATMAN

Bruce Wayne and Tommy Elliot were childhood playmates, although the latter hated his parents. He somehow managed to weaken the brakes on the family car in an attempt to kill them, inherit their fortune, and be happy. Instead, his father died, but Bruce's father, Thomas, used his surgical skills to save Tommy's mother. Hatred burned through Tommy, and he silently vowed revenge against Bruce for his father's efforts. When the Waynes were gunned down, Tommy was secretly pleased.

His mother finally succumbed to cancer and he obtained the desired inheritance, using it to fund his medical school training, after which he became a world-class surgeon. Years later, the Riddler came to him, dying of cancer. As they grew to know each other, the Riddler, who had deduced who Batman was, realized his doctor hated Wayne. Together, they laid out a complex scheme that would slowly but surely take down the hero.

For months, various foes battled the Dark Knight even as he rekindled his romance with Catwoman and witnessed Two-Face successfully restored to Harvey Dent by Elliot. When Batman was seriously hurt, Elliot was summoned to treat Wayne, and he implanted a tracking chip in the hero's skull, allowing Elliot to up the torment.

With Batman physically and emotionally worn, the bandaged Hush appeared, guns at the ready, prepared to kill his nemesis. The arrival of James Gordon and Harvey Dent was just distraction enough to allow Batman to prevail, and Hush vanished.

He has since returned to torment his childhood friend.

85. CLUB OF VILLAINS

Dr. Simon Hurt was born centuries ago as Thomas Wayne, who worshipped the bat-god Barbatos. He summoned, instead, the Hyper-Adapter, a creature of Darkseid's that had been tasked with overseeing Batman's journey through history after being seemingly killed by the Omega Sanction. Wayne was somehow granted an extended life,

leading him to an 18th-Century encounter with the immortal Vandal Savage where each sought ways to prolong their lives.

In the modern day, he changed his name to Simon Hurt. He positioned himself to be instrumental in a series of sensory deprivation experiments that Batman agreed to conduct on behalf of NASA. At the same time, Hurt worked with the GCPD to train three replacement Batmans, ultimately arranging for them to fight, and hopefully kill, Batman, only to lose.

Hurt then targeted Batman's Club of Heroes by taking their arch foes and forming the Club of Villains. This included Charlie Caligula, El Sombrero, King Kraken, Pierrot Lunaire, Scorpiana, and Swagman. From this group he forged the cult known as the Black Glove, with their first task being the framing of Martha Wayne for a crime, besmirching her stellar reputation. This put Batman on Hurt's trail, and the battle of the Dark Knight versus the Black Glove was a fierce one.

On more than one occasion, and in differing realities, Hurt has seemingly been killed, only to return later.

86. THE RETURN OF BRUCE WAYNE

During the events of the Final Crisis, Batman got the drop on Darkseid and attempted to fire a killing blow. When that didn't work, it was the New God's turn, and the twin Omega blasts seemingly destroyed the hero but actually sent him hurtling through time, to the dawn of mankind. An amnesiac Bruce Wayne had to use his wits and superior skills to survive in various hostile environments. After being nearly killed by a tribe of Neanderthals, Wayne escaped by jumping over a waterfall, to awaken in Puritan America.

Taking the name Mordecai, Wayne came to live in the village of Gotham, joining a posse of witch hunters. He was soon catapulted to the 18th Century, where the pirate Blackbeard mistook the man for the famed Black Pirate. From there he found himself in the 19th-Century Western frontier, confronting Vandal Savage and unknowingly his ancestor Thomas Wayne (soon to emerge as Dr. Simon Hurt).

His next jaunt saw him in Gotham City, days after his parents' death. A friend of his mother's hired Bruce to investigate if Thomas had hired the

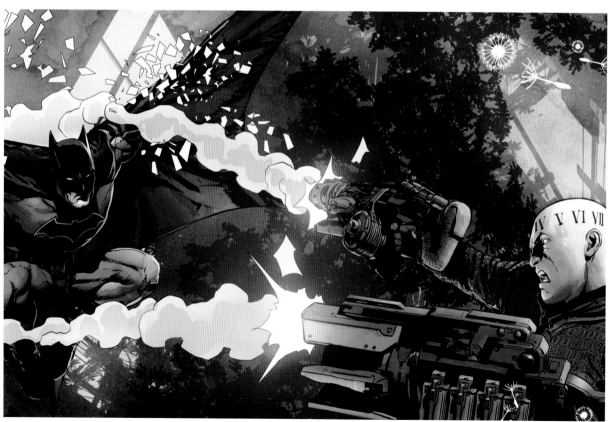

BATMAN: 100 GREATEST MOMENTS

killer to target only Martha, but the friend proved to be a member of Hurt's Black Glove organization.

Throughout all this, the bat motif followed him, as did ancestors of the Neanderthal tribe that worshipped a bat-god Barbatos. Wayne had to survive each encounter, his mind working on the clues presented to him, but his memory remained locked away from his consciousness. At the final stop, Vanishing Point, the end of time itself, Wayne recovered more memories and learned that Darkseid sent him on this journey so his body could absorb chronal energies that would be unleashed on his return to the 21st Century, destroying reality.

At the same time, Rip Hunter, a Time Master, had led a coterie of Justice Leaguers on the search for Wayne and, when they learned of the danger, found Wayne and let his body die, with the energy dissipating, before reviving him. When resuscitated, Wayne regained his complete memories, donned the cape and cowl waiting for him, and immediately returned to work.

87. STEERING A PLANE FROM OUTSIDE

Tom King was the lucky writer to follow the acclaimed run on *Batman* by Scott Snyder. He set out to craft an 85-issue arc that would redefine the classic villains for a new millennium while at the same time exploring what it means to be Batman.

That started with a new *Batman* #1 in 2016 that had as its set piece Batman trying to save a jetliner full of passengers from crashing into Gotham City. From atop the plane.

"That's the whole point of #1, that he goes through some[thing] that's going to affect him over the entire next year," King told IGN. "I think we wanted to start this with classic, confident Batman. This is Gordon on the roof and Alfred in the cave. This is a guy who knows his mission and knows it well. He's not mourning anyone. He's not looking at his parents, he's saying, 'I have all the tools I need to accomplish this mission.' That's where he is on page one. And then by the end, he's had an experience that almost challenges that directly. And that's going to affect him going forward."

He also told Comic Book Resources, "He's out there with his wits and his will and his family and his obsession. I want to look at how he gets close to that madness."

King and Snyder have plotted together, along with other writers, charting the course of the 21st-Century DC Universe, and regardless of event, Batman is intimately involved, usually at ground zero. He's not only trying to stop Bane but also train a cadre of heroes, deal with his Dark Multiverse counterparts, figure out who stole five years from everyone's lives, and contain the unimaginable energies unleased across the universe when the Source Wall was breached.

King's run is also described as the ultimate love story between Batman and Catwoman, never losing sight of the heart of the man under the cowl.

88. UNLEASHING THE DARK MULTIVERSE

"Stop me if you've heard this one . . . worlds will live, worlds will die . . . but imagine if your every fear, each bad decision, gave birth to a malformed world of nightmare. A world that shouldn't exist. And desperate as it fights to survive in the light of the true multiverse far above . . . these worlds are doomed to rot apart, and die, because they are wrong at their core. Welcome to the Dark Multiverse. Home to stories that should never be . . . It's all one big cosmic joke, except no one on this side is laughing . . . well, almost no one . . ."

—The Batman Who Laughs

Soon after the birth of the universe, the Monitor, Anti-Monitor, and Forger were all born. Worlds were fashioned from the cosmic metal, and those that survived were the Orrery of Worlds, while unstable worlds were returned to the forge to be re-formed. The Forger's assistant was the Great Dragon, who ultimately rebelled after countless eons of toil and took the name Barbatos.

He pierced the veil between realities and tapped the Court of Owls to engineer Batman's creation, then used his nightmares as templates for Dark Multiverse incarnations. Using that twisted reality's unique metals—Nth metal, Promethium,

Dionesium, Electrum, and Batmanium—Batman was brought to the worlds that never should be, while Barbatos came to Prime Earth.

The unanticipated alliance of Batman and the Joker helped take down Barbatos, who was then chained to the depths of the Dark Multiverse with 10th Metal chains. However, the rescue efforts to free Batman did result in a breach of the Source Wall, beginning fundamental changes to reality.

89. BECOMING THE BATMAN WHO LAUGHS

The Dark Multiverse is filled with failed parallel worlds, each with their own version of Batman. Most were eradicated, but several, including the Batman Who Laughs, survived and threatened all life on Prime Earth. He had been a pawn of the Legion of Doom before gaining his freedom and making his way back to Gotham City.

This twisted combination of Batman and the Joker is seen as both a physical and transcendental threat to the Joker. In his own warped way, the Joker

wanted to help Batman but did so by dosing the hero with a face full of Joker toxin before attempting his own suicide. The toxin infiltrated Batman's bloodstream, and even megadoses of the antidote managed only to slow, not stop, the changes to Batman's sanity.

Batman and Alfred managed to save the Clown Prince of Crime's life, preventing what Batman was convinced was a world-threatening version of the toxin in the criminal's heart from being released should it stop beating.

Feeling he was running out of time, Batman made a fateful decision, stopping the treatment and embracing the toxin in his system. As his sanity ebbed, he crudely forged a replica of the spiked metal headband that his dark-mirror self wore. He effectively allowed himself to become his worst nightmare in order to fight the true threat, not knowing if there was a cure to his condition or if he'd survive the battle.

Donning the headband, the hero became the villain as a result of his archnemesis's heroic act. The topsy-turvy mission played out in spring 2019, launching the company's Year of the Villain event.

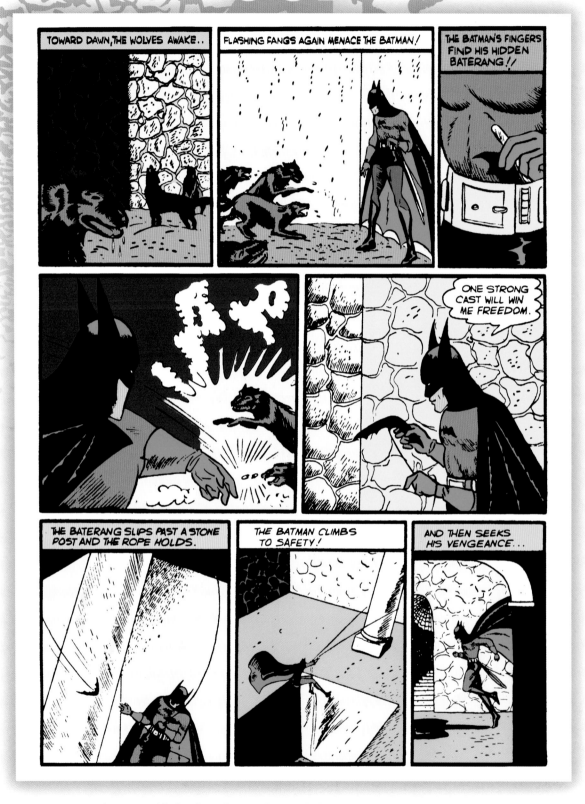

Guest writer Gardner Fox added truly gothic touches, with the hooded monk as a vampire endangering Julie Madison, and forcing Batman to use a pistol for the first time.

Detective Comics #32, October 1939
Writer: Gardner Fox *Artists:* Bob Kane & Sheldon Moldoff

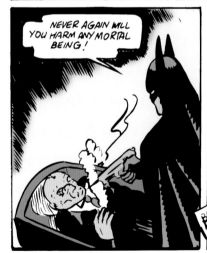

Detective Comics #32, October 1939
Writer: Gardner Fox *Artists:* Bob Kane & Sheldon Moldoff

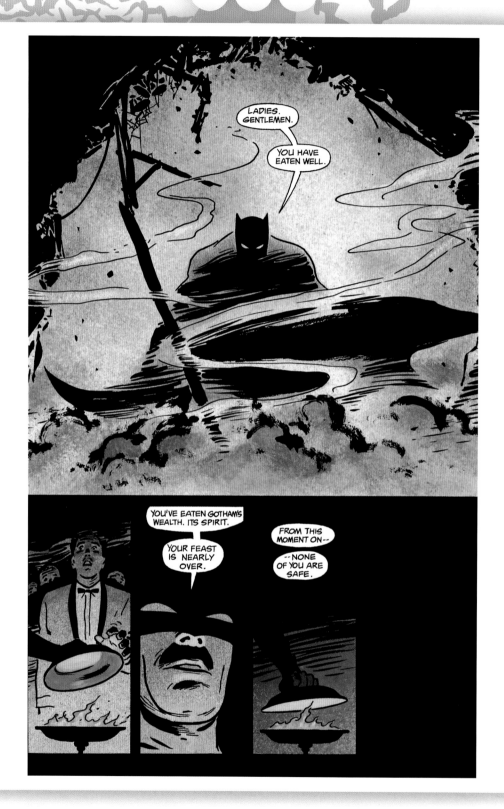

Serving notice on the corrupt Gotham criminal elite, Batman crashes their dinner party, instilling the very fear he wanted with his costume and manner.

Batman #405, March 1987
Writer: Frank Miller *Artist:* David Mazzucchelli

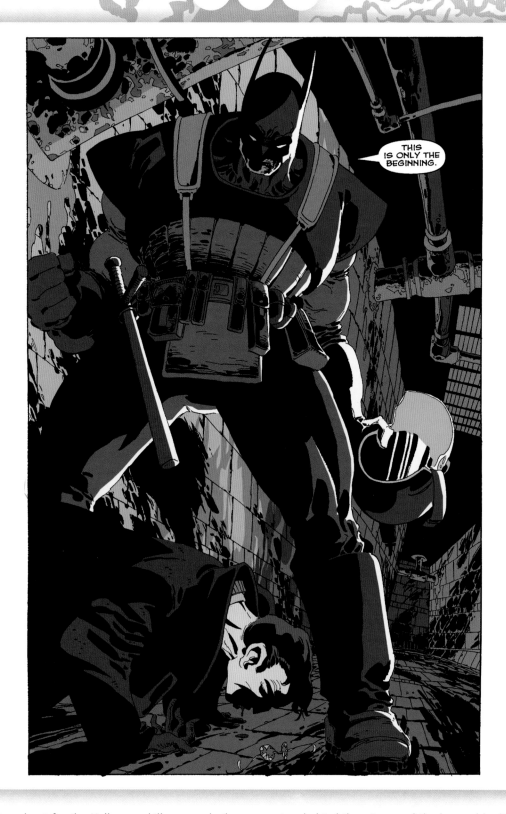

The long hunt for the Halloween killers reveals there were two behind the crime, and the honorable district attorney, Harvey Dent, is forever scarred by the events.

Batman: The Long Halloween #13, December 1997
Writer: Jeph Loeb *Artist:* Tim Sale

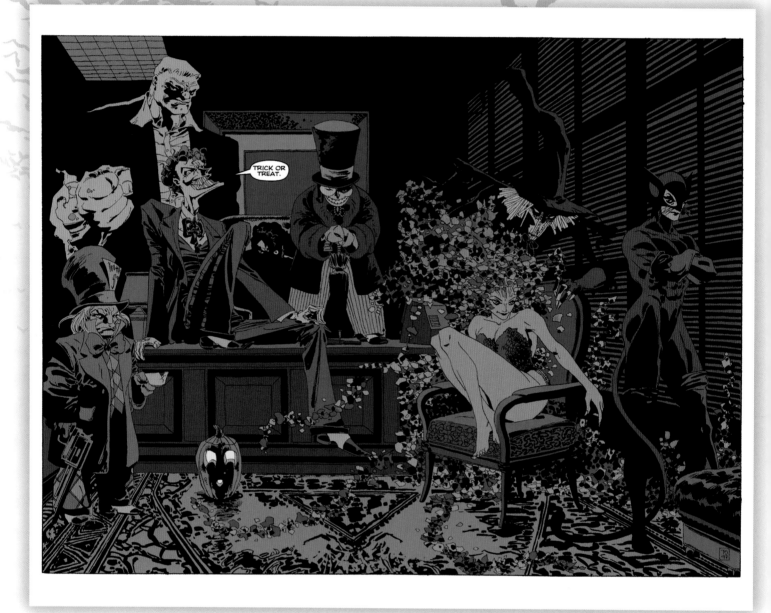

Batman: The Long Halloween #13, December 1997
Writer: Jeph Loeb *Artist:* Tim Sale

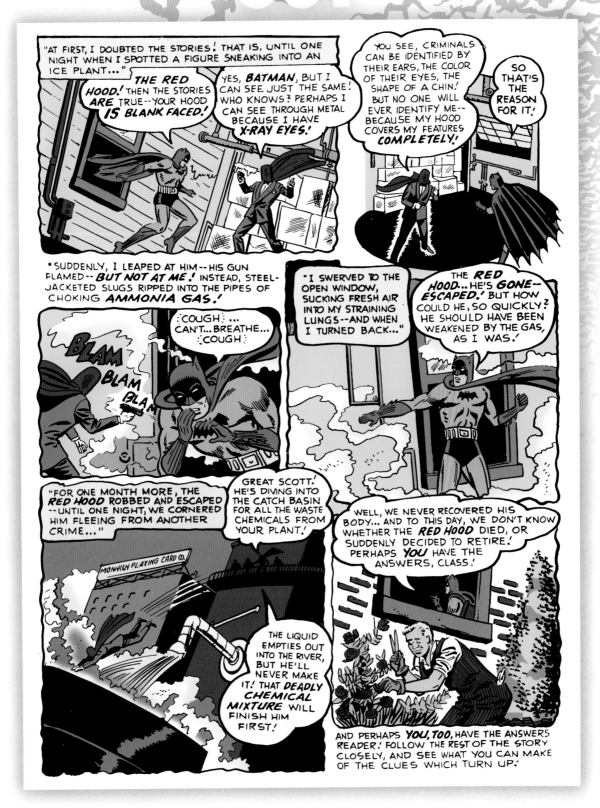

Detective Comics #168, February 1951
Writer: Bill Finger *Artists:* Lew Sayre Schwartz, Win Mortimer & George Roussos

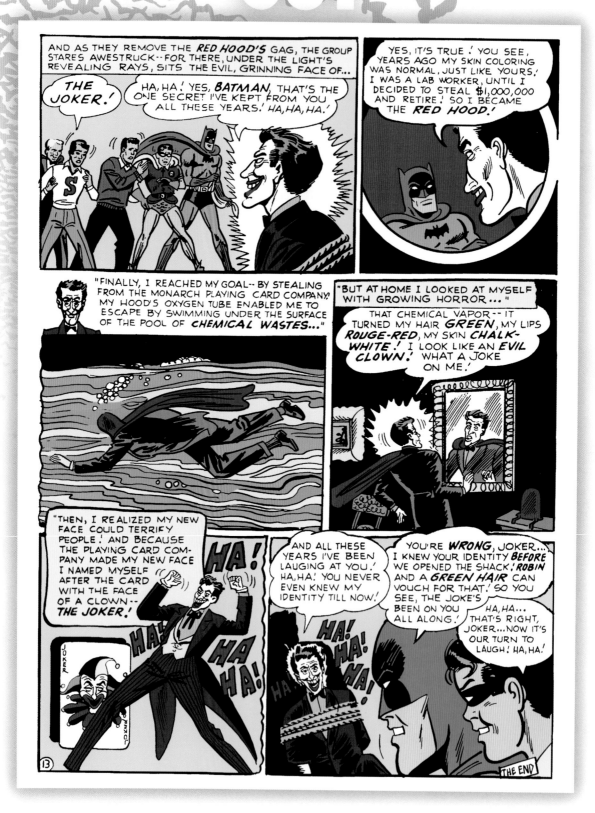

Detective Comics #168, February 1951
Writer: Bill Finger Artists: Lew Sayre Schwartz, Win Mortimer & George Roussos

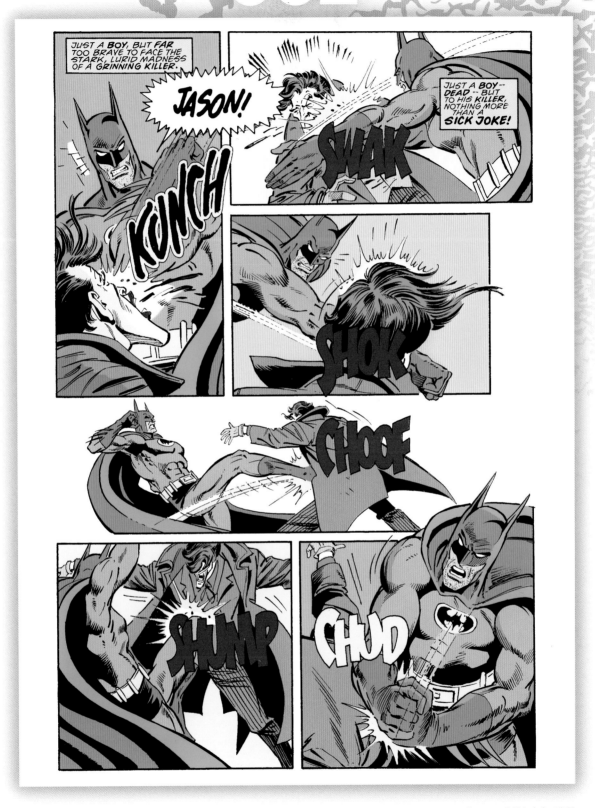

Batman #496, July 1993
Writer: Doug Moench *Artists:* Jim Aparo & Josef Rubinstein

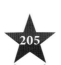

Batman #496, July 1993
Writer: Doug Moench *Artists:* Jim Aparo & Josef Rubinstein

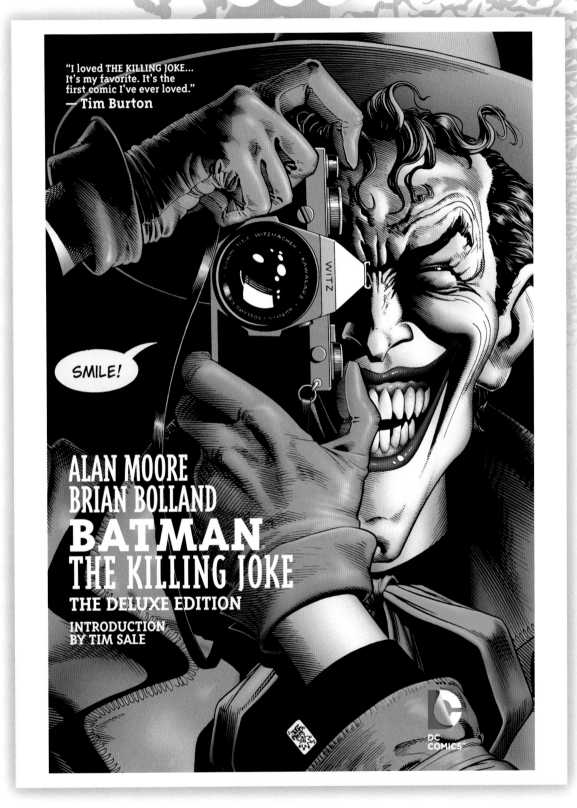

The unique relationship between the Batman and the Joker is crystalized in this sequence at the conclusion of their most recent confrontation.

Batman: The Killing Joke, May 1988
Artist: Brian Bolland

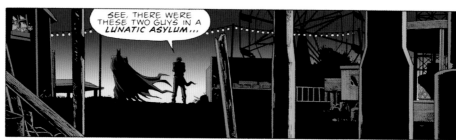

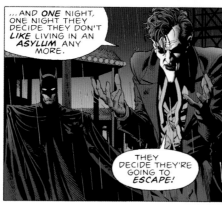

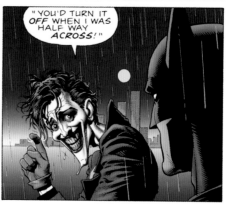

Batman: The Killing Joke, May 1988
Writer: Alan Moore *Artist:* Brian Bolland

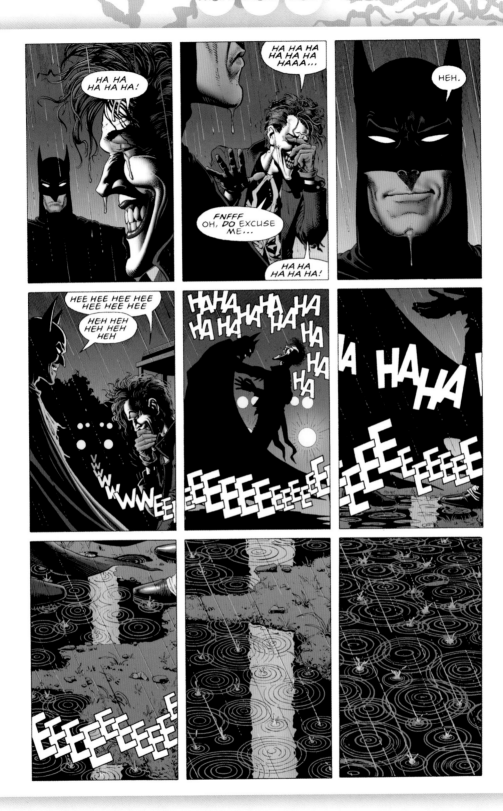

Batman: The Killing Joke, May 1988
Writer: Alan Moore *Artist:* Brian Bolland

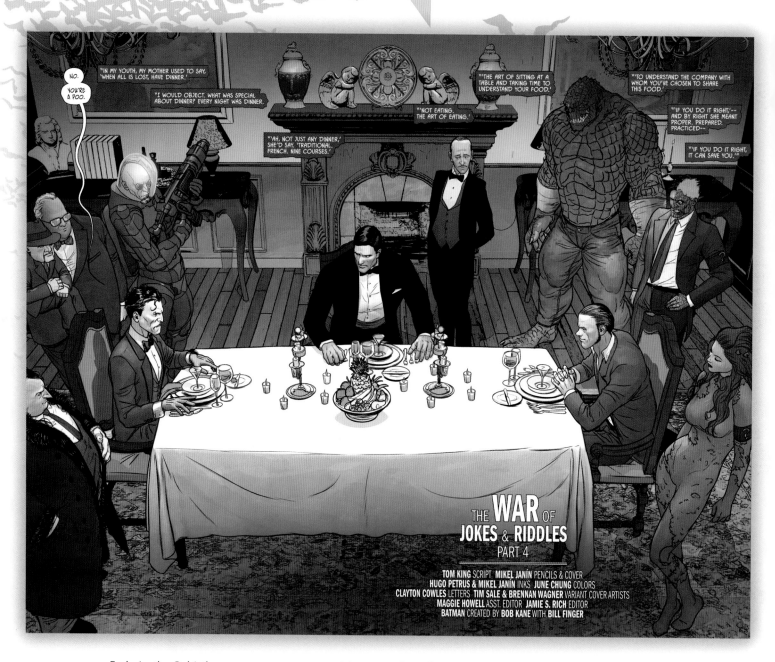

THE **WAR** OF **JOKES** & **RIDDLES** PART 4

TOM KING SCRIPT **MIKEL JANÍN** PENCILS & COVER
HUGO PETRUS & **MIKEL JANÍN** INKS **JUNE CHUNG** COLORS
CLAYTON COWLES LETTERS **TIM SALE** & **BRENNAN WAGNER** VARIANT COVER ARTISTS
MAGGIE HOWELL ASST. EDITOR **JAMIE S. RICH** EDITOR
BATMAN CREATED BY **BOB KANE** WITH **BILL FINGER**

Early in the Rebirth era, a gang war erupted between the Joker and Riddler, with other rogues forced to choose sides. Bruce Wayne attempted to negotiate a peace with a dinner, serving tension as the main course.

Batman #29, October 2017
Writer: Tom King *Artists:* Mikel Janin & Hugo Petrus

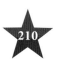

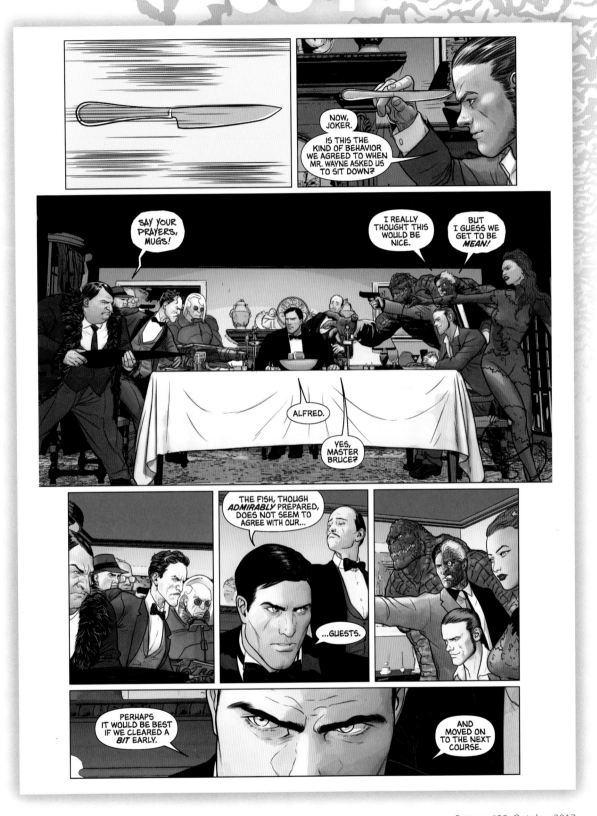

Batman #29, October 2017
Writer: Tom King Artists: Mikel Janin & Hugo Petrus

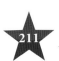

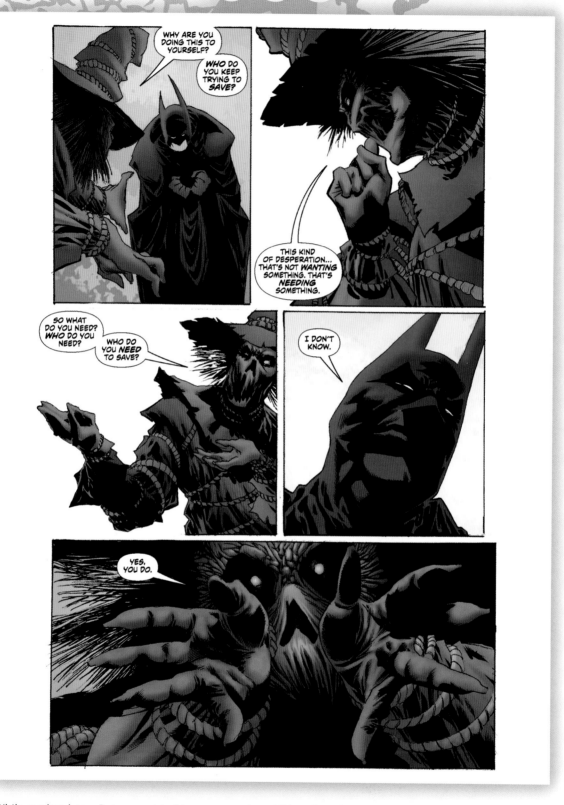

While readers knew Batman existed to prevent other children from being orphaned, he never admitted it to anyone, until he was forcibly psychoanalyzed by the Scarecrow.

Batman: Kings of Fear #4, January 2019
Writer: Scott Peterson *Artist:* Kelley Jones

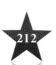

Batman: Kings of Fear #4, January 2019
Writer: Scott Peterson *Artist:* Kelley Jones

Batman: Kings of Fear #4, January 2019
Writer: Scott Peterson Artist: Kelley Jones

214

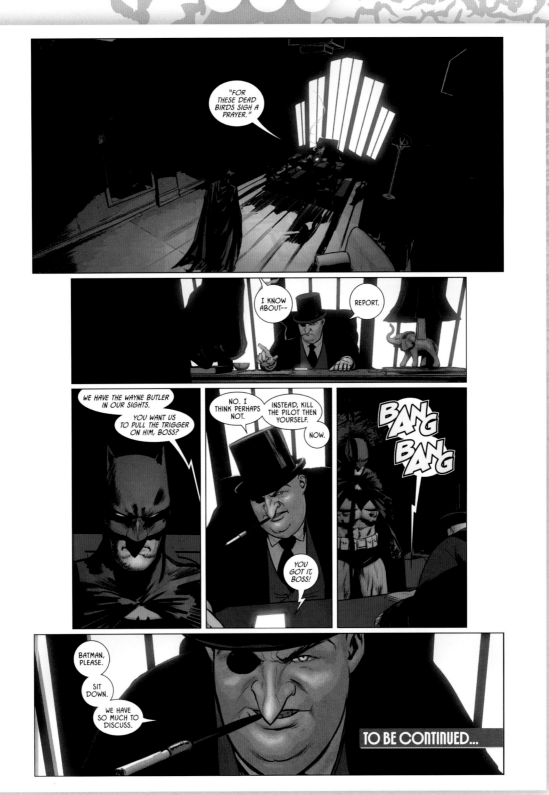

Bane had every criminal working with him to undermine Batman—until the Penguin broke ranks and aided the Dark Knight at the risk of his life.

Batman #58, January 2019
Writer: Tom King *Artist:* Mikel Janin

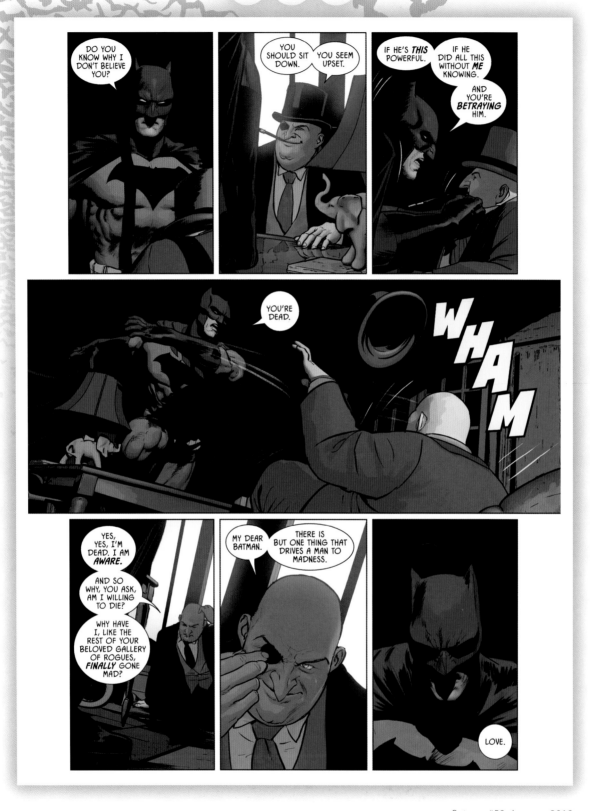

Batman #59, January 2019
Writer: Tom King Artist: Mikel Janin

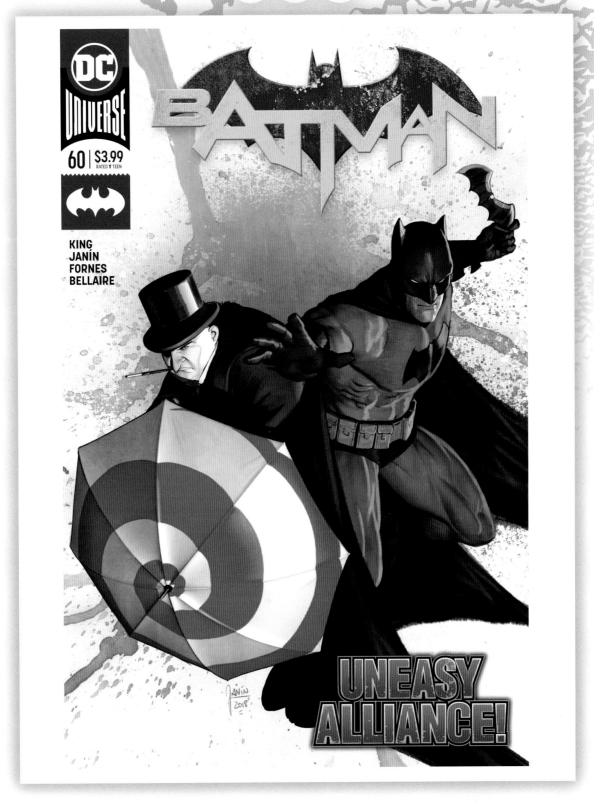

Batman #60, February 2019
Artist: Mikel Janin

After learning that Two-Face was responsible for his father's death, an underprepared Jason Todd sought him out to exact revenge.

Batman #411, September 1987
Writer: Max Allan Collins *Artists:* Dave Cockrum & Don Heck

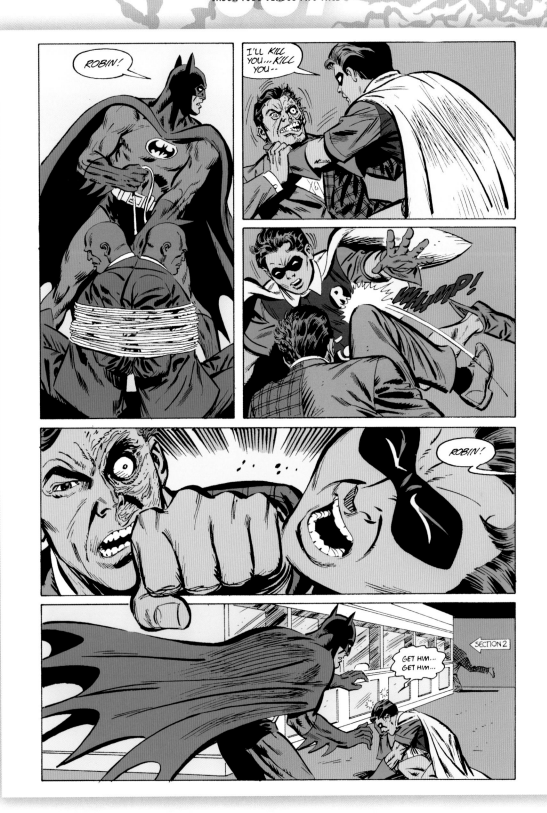

Batman #411, September 1987
Writer: Max Allan Collins *Artists:* Dave Cockrum & Don Heck

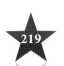

When Batman, Nightwing, and Robin went out of town on a spiritual retreat, Gotham's protection was left in the hands of the seemingly reformed Harvey Dent.

Batman #653, July 2006
Writer: James Robinson *Artists:* Don Kramer & Wayne Faucher

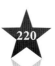

Batman #653, July 2006
Writer: James Robinson *Artists:* Don Kramer & Wayne Faucher

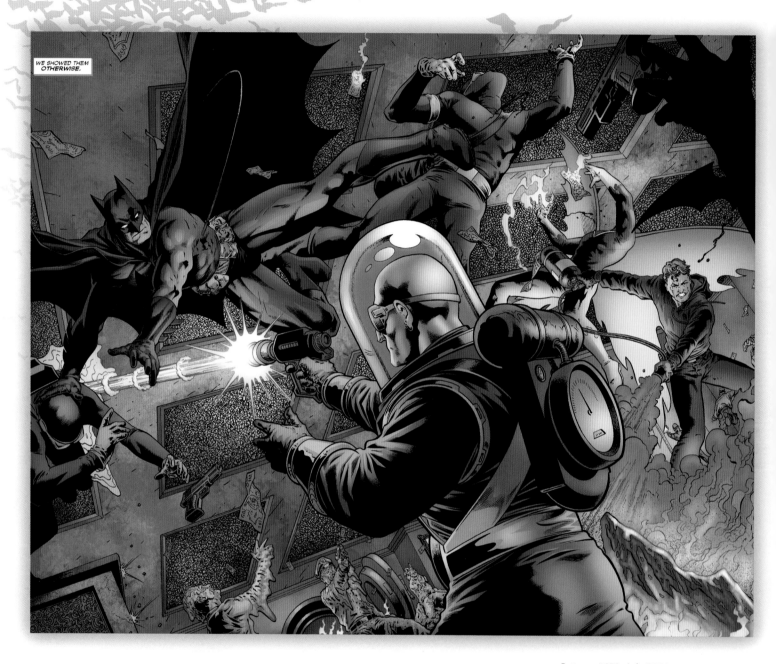

Batman #653, July 2006
Writer: James Robinson *Artists:* Don Kramer & Wayne Faucher

DARK KNIGHT, DARK CITY PART III

PETER MILLIGAN *writer* • KIERON DWYER *pencils* • DENNIS JANKE *inks* • JOHN COSTANZA *letters* • ADRIENNE ROY *colors* • DAN RASPLER *assoc. editor* • DENNY O'NEIL *editor* • BOB KANE *creator*

THE KNIFE SHOULD BE *SHARPER* AND *FINER*. A *SCALPEL*, NOT THIS *BUTCHER'S* KNIFE...

IT SHOULD BE *CLEANER*, TOO. *STERILIZED*...

So Batman takes a deep breath . . .

BUT IT'S ALL I'VE GOT...

AND *I'M* ALL *YOU'VE* GOT...

And slits the little cherub's throat . . .

The Riddler had never stooped this low, endangering an infant's life all in his scheme to best the Gotham Guardian, forcing the hero to perform a hasty tracheotomy.

Batman #454, September 1990
Writer: Peter Milligan Artists: Kieron Dwyer & Dennis Janke

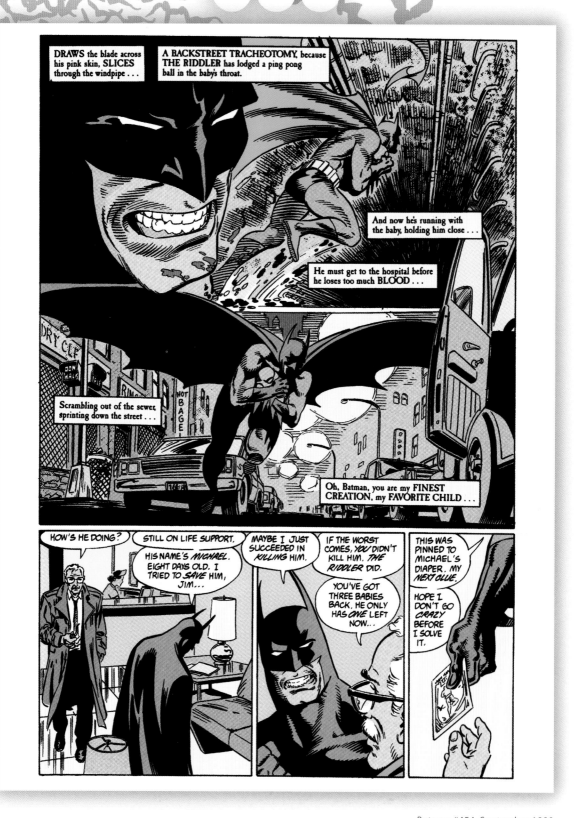

Batman #454, September 1990
Writer: Peter Milligan *Artists:* Kieron Dwyer & Dennis Janke

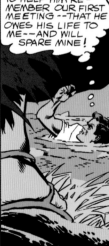

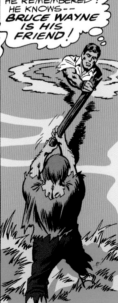

In an odd twist, the brutish Blockbuster only trusted Bruce Wayne, forcing the Caped Crusader to reveal his secret identity to protect Gotham's citizens.

Detective Comics #345, November 1965
Writer: Gardner Fox *Artists:* Carmine Infantino & Joe Giella

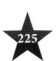

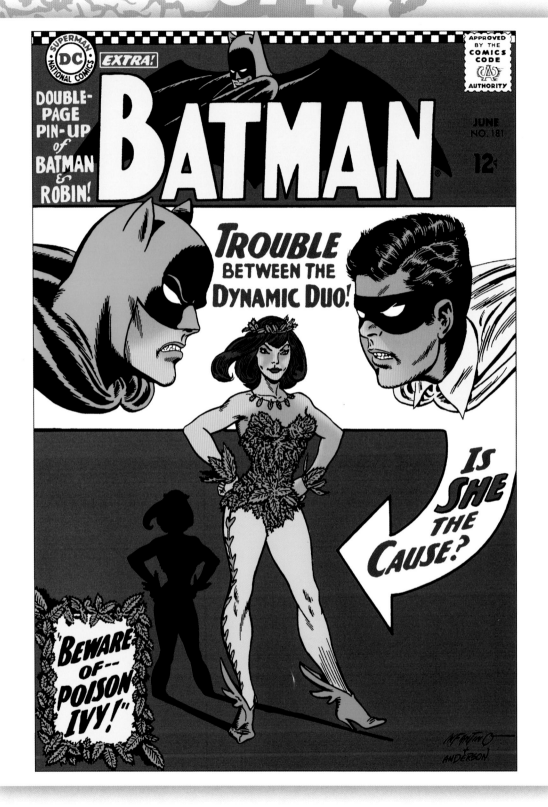

The first major female foe of the Silver Age arrived at the dawn of Batmania and has rooted herself in the mythos ever since.

Batman #181, June 1966
Artists: Carmine Infantino & Murphy Anderson

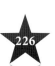

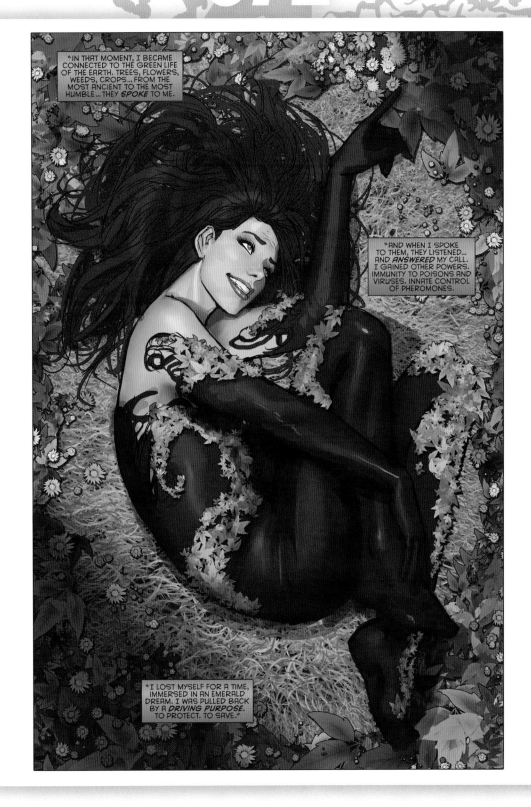

In the Rebirth reality, Bruce Wayne fired Pamela Isley from Wayne Enterprises, setting the embittered woman on a course that turned her into ecoterrorist Poison Ivy.

Secret Origins #10, April 2015
Writer: Christy Marx *Artist:* Stjepan Sejic

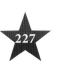

Secret Origins #10, April 2015
Writer: Christy Marx Artist: Stjepan Sejic

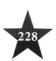

GREATEST MOMENTS
BRUCE WAYNE HELPS CREATE POISON IVY

Secret Origins #10, April 2015
Writer: Christy Marx *Artist:* Stjepan Sejic

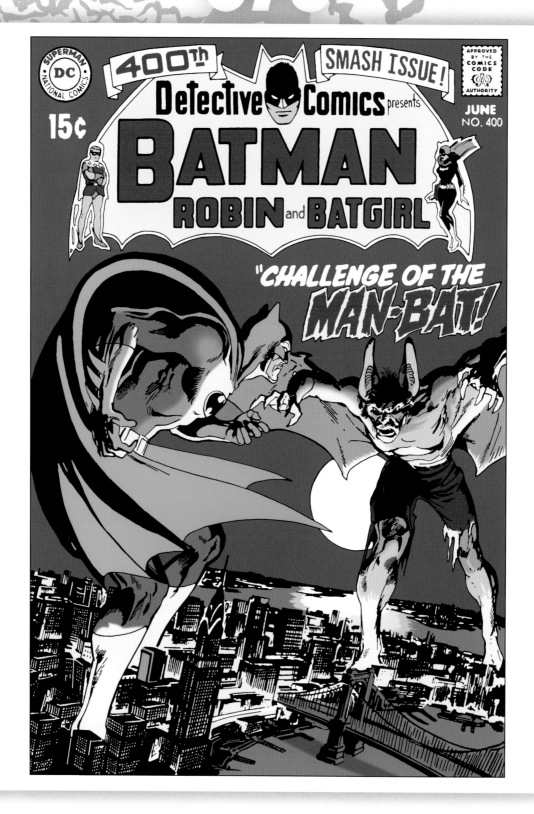

Kirk Langstrom merely tried to help the handicapped but instead doomed himself to an unimagined life as the Man-Bat, a member of the supporting cast ever since.

Detective Comics #400, June 1970
Artist: Neal Adams

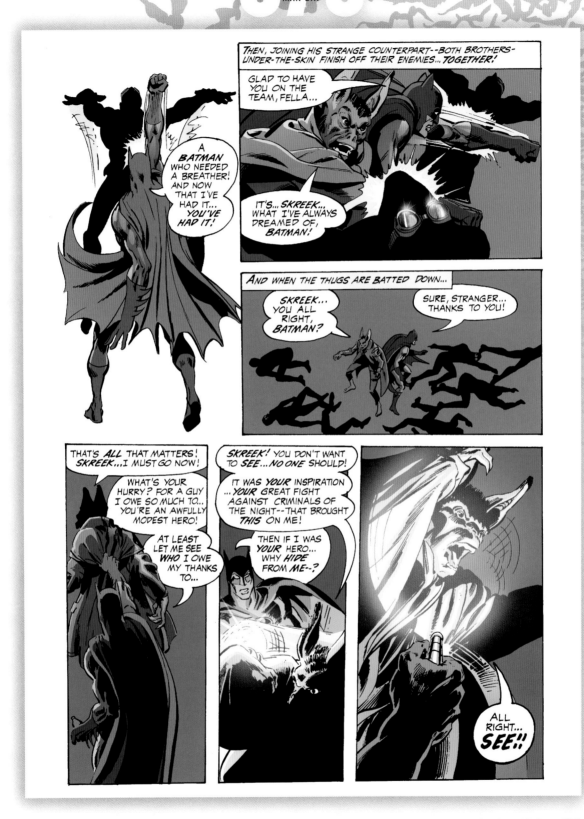

Detective Comics #400, June 1970
Writer: Frank Robbins Artists: Neal Adams & Dick Giordano

Detective Comics #400, June 1970
Writer: Frank Robbins *Artists:* Neal Adams & Dick Giordano

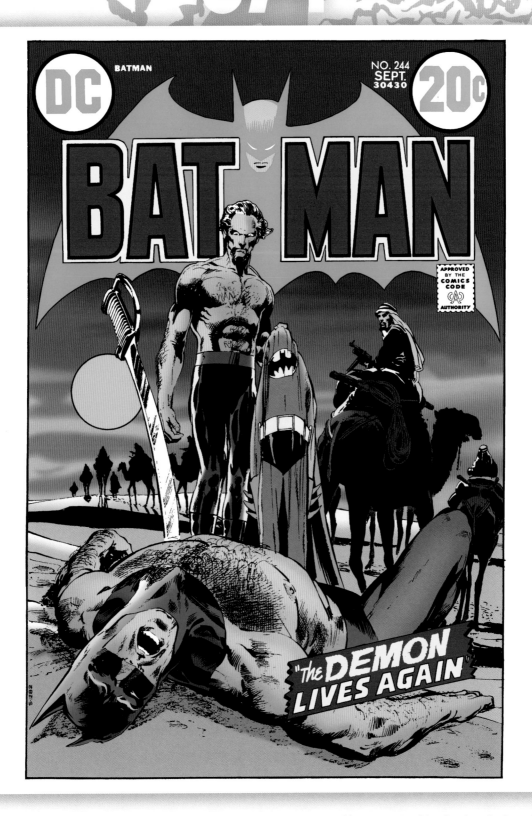

The climactic battle between Ra's al Ghul and Batman was interrupted by a scorpion bite, leaving the hero for dead. This moment proves death is merely an obstacle to justice.

Batman #244, September 1972
Artists: Neal Adams & Dick Giordano

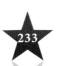

Batman #244, September 1972
Writer: Dennis O'Neil *Artists:* Neal Adams & Dick Giordano

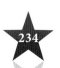

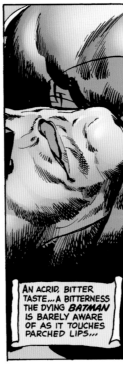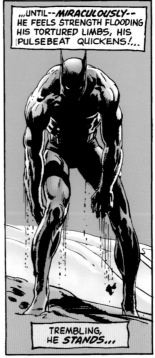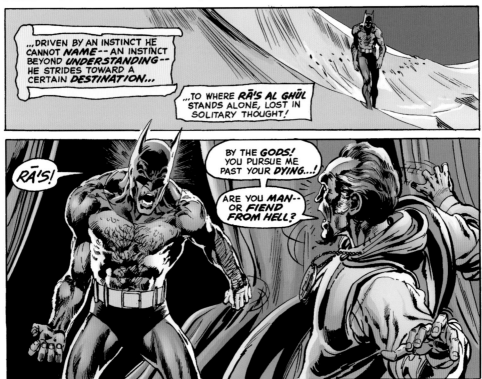

Batman #244, September 1972
Writer: Dennis O'Neil *Artists:* Neal Adams & Dick Giordano

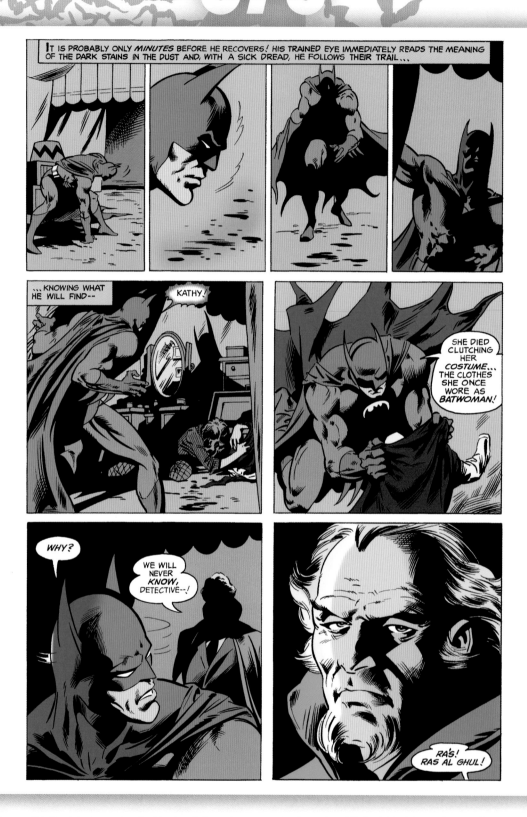

Batman didn't ask to be embroiled in the civil war between the Sensei and Ra's al Ghul, but when Kathy Kane was murdered as collateral damage, he became determined to shut it down for good.

Detective Comics #485, September 1979
Writer: Dennis O'Neil *Artists:* Don Newton & Dan Adkins

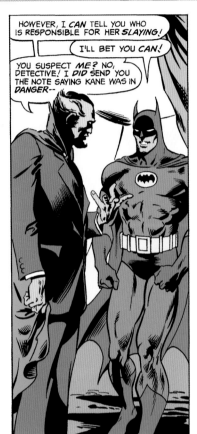

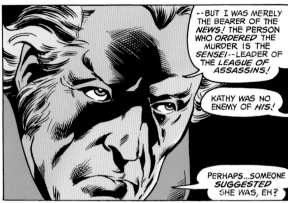

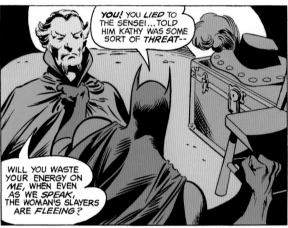

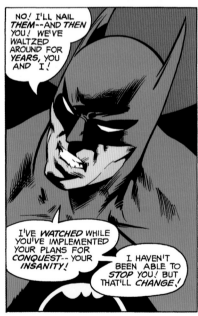

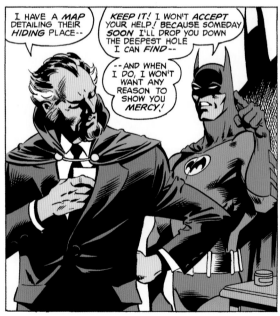

Detective Comics #485, September 1979
Writer: Dennis O'Neil *Artists:* Don Newton & Dan Adkins

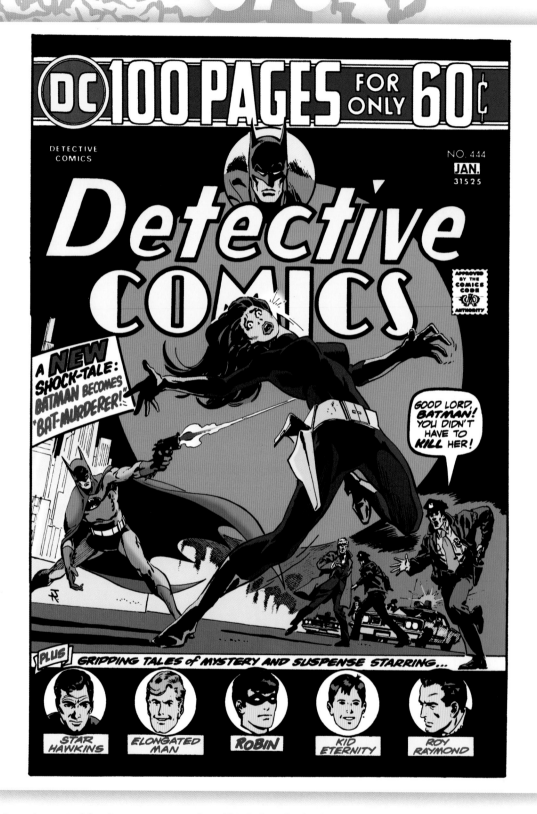

Batman is wanted for the apparent murder of his beloved Talia, but not everything is as it seems, and he is hunted while searching for the truth.

Detective Comics #444, January 1975
Artist: Jim Aparo

Detective Comics #445, March 1975
Artist: Jim Aparo

Detective Comics #448, June 1975
Artist: Jim Aparo

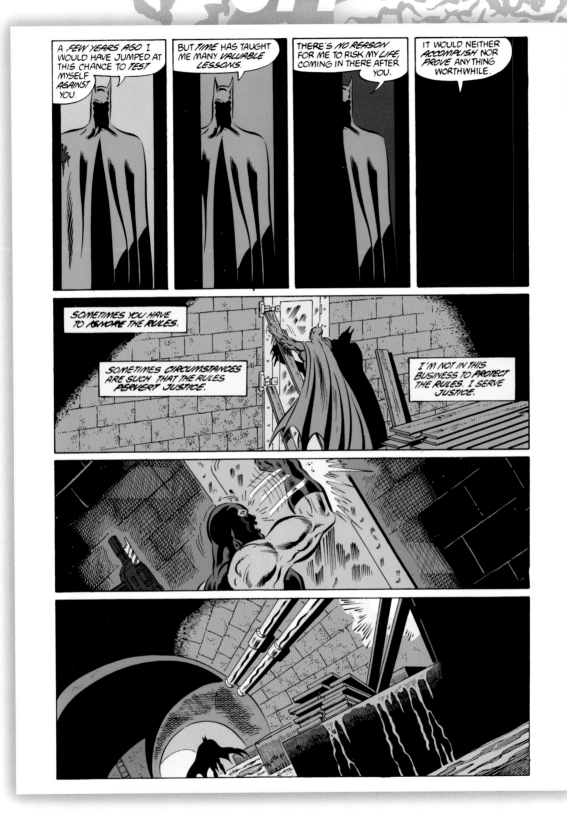

A brand-new threat has arrived in Gotham, although, despite his cybernetic armaments, the mercenary proves unable to best the Batman.

Batman #420, June 1988
Writer: Jim Starlin *Artists:* Jim Aparo & Mike DeCarlo

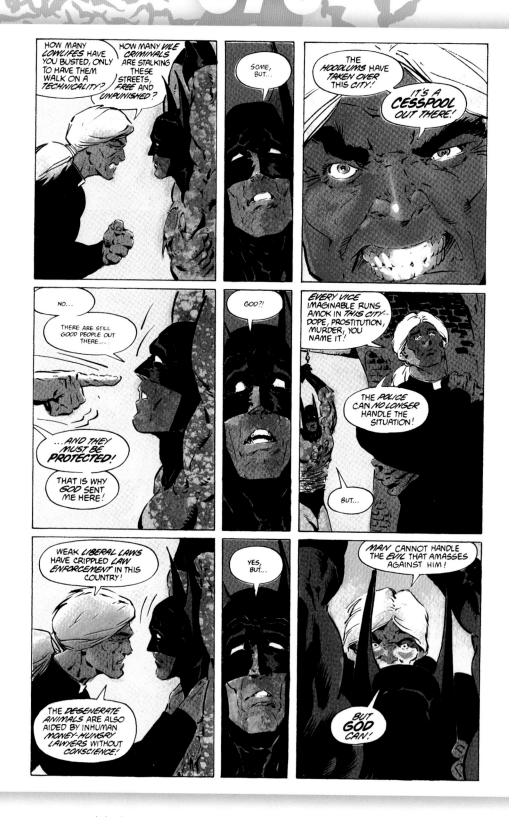

In an attempt to control the hearts and minds of Gotham's citizens, Deacon Blackfire first captures and tortures Batman, actually breaking his will—a very rare feat.

Batman: The Cult #1, September 1988
Writer: Jim Starlin *Artist:* Bernie Wrightson

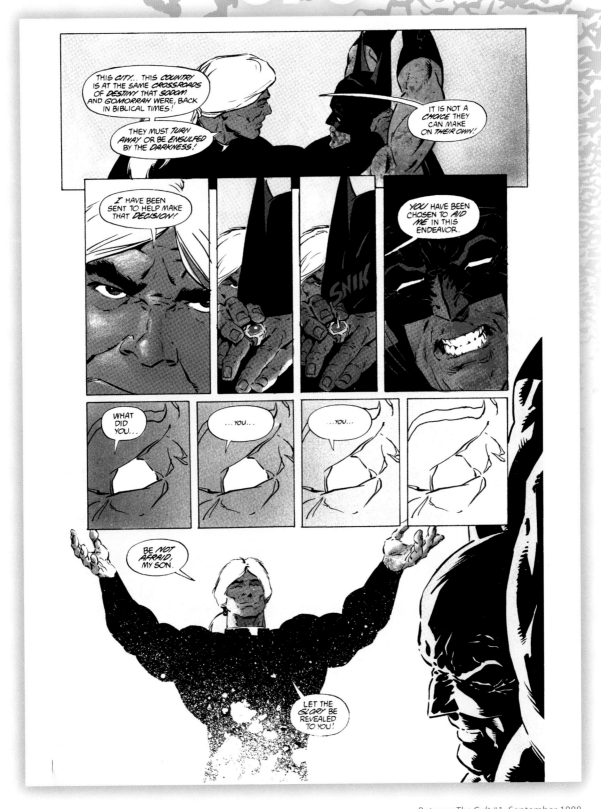

Batman: The Cult #1, September 1988
Writer: Jim Starlin *Artist:* Bernie Wrightson

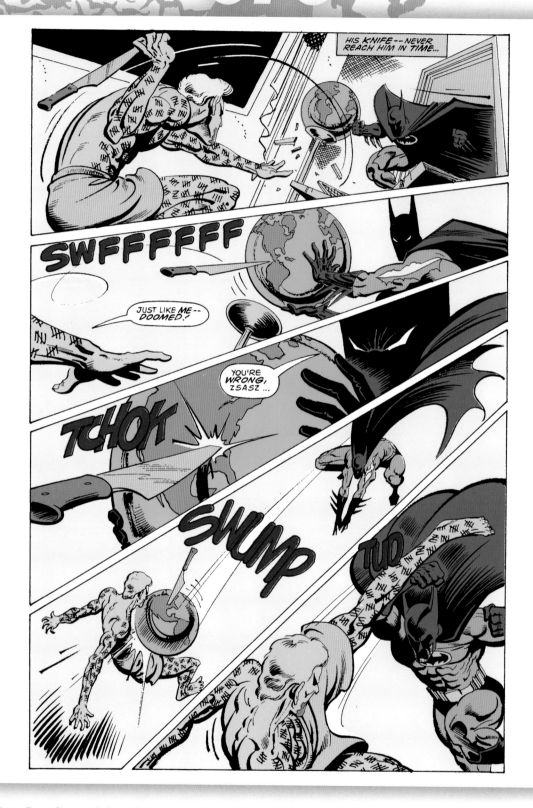

Mister Zsasz lives to kill, tracking each victim on his body, but here, he has pushed the Dark Knight too far, earning himself a vicious beatdown.

Batman #493, May 1993
Writer: Doug Moench *Artist:* Norm Breyfogle

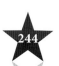

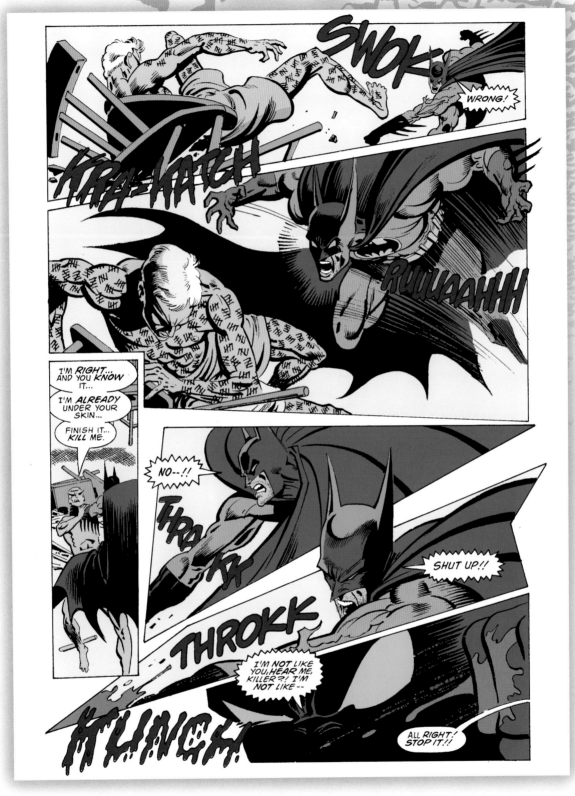

Batman #493, May 1993
Writer: Doug Moench *Artist:* Norm Breyfogle

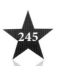

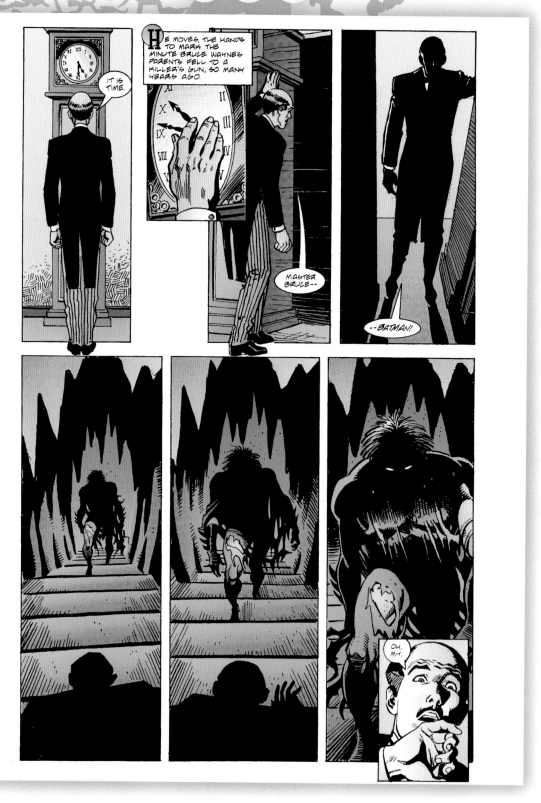

Batman endured a grueling period fighting the addiction to Venom, proving to all that his mind was superior to any other human's. While it was agonizing, he endured and emerged the better for the experience.

Legends of the Dark Knight #20, May 1991
Writer: Dennis O'Neil *Artists:* Russell Braun, Trevor Von Eeden & José Luis García-López

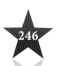

Legends of the Dark Knight #20, May 1991
Writer: Dennis O'Neil *Artists:* Russell Braun, Trevor Von Eeden & José Luis García-López

In his first confrontation since the brutal Bane broke his back, Batman is more than ready to return the favor in this epic battle.

Detective Comics #701, September 1996
Writer: Chuck Dixon *Artists:* Graham Nolan & Scott Hanna

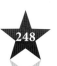

Detective Comics #701, September 1996
Writer: Chuck Dixon Artists: Graham Nolan & Scott Hanna

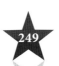

She was so popular on the animated series that it was only a matter of time before Harley Quinn made it to the core comics continuity, a deadly addition to Batman's rogues' gallery.

Batman: Harley Quinn, October 1999
Writer: Paul Dini *Artists:* Yvel Guichet & Aaron Sowd

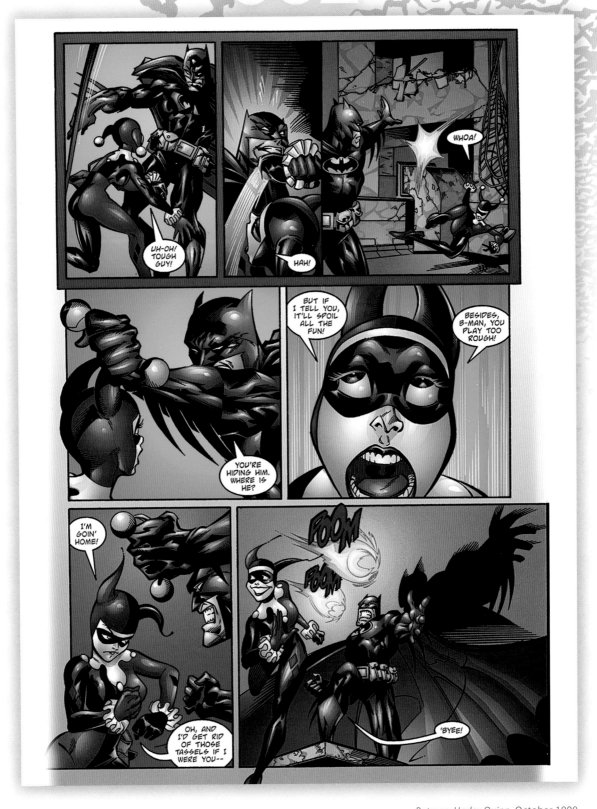

Batman: Harley Quinn, October 1999
Writer: Paul Dini *Artists:* Yvel Guichet & Aaron Sowd

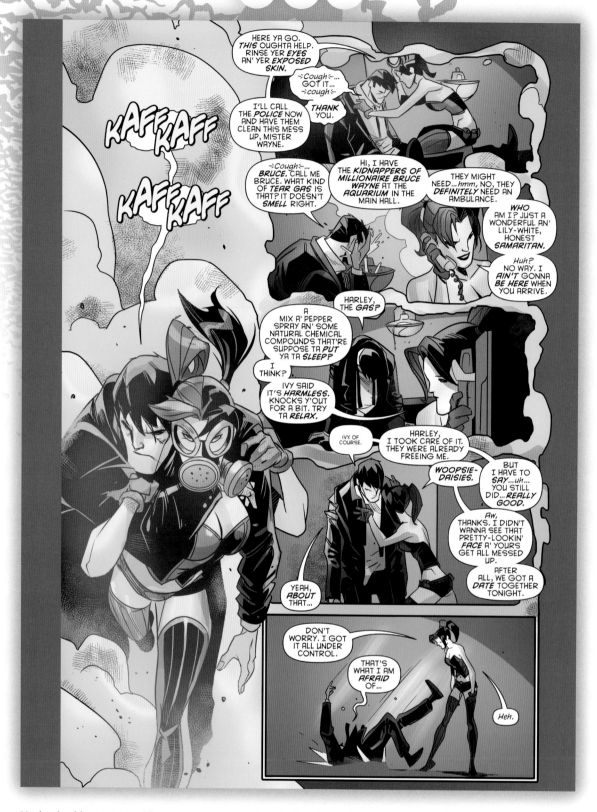

Harley had her eyes and heart set on millionaire playboy Bruce Wayne, but their date didn't go as planned so she returned to crime, only to be stopped by Batman. Still, everyone gets kissed.

Harley Quinn Valentine's Day Special, April 2015
Writers: Amanda Conner & Jimmy Palmiotti *Artist:* John Timms

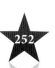

Harley Quinn Valentine's Day Special, April 2015
Writers: Amanda Conner & Jimmy Palmiotti *Artist:* John Timms

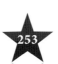

Harley Quinn Valentine's Day Special, April 2015
Writers: Amanda Conner & Jimmy Palmiotti *Artist:* John Timms

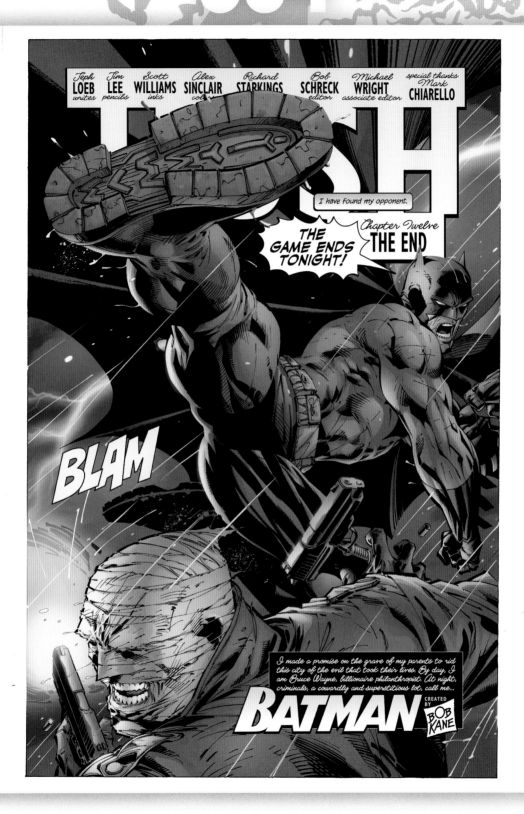

After being hounded for weeks by the bandaged Hush, the two men finally face off just prior to all the secrets spilling out.

Batman #619, November 2003
Writer: Jeph Loeb *Artists:* Jim Lee & Scott Williams

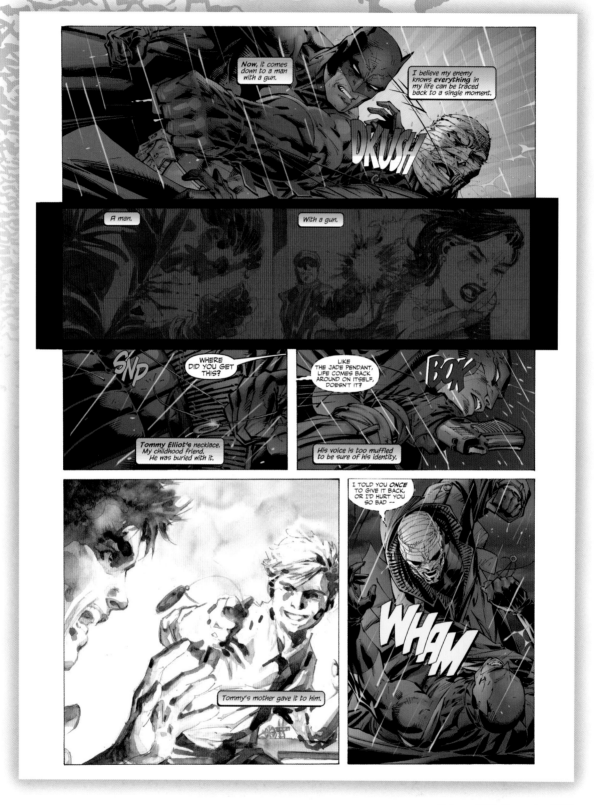

Batman #619, November 2003
Writer: Jeph Loeb *Artists:* Jim Lee & Scott Williams

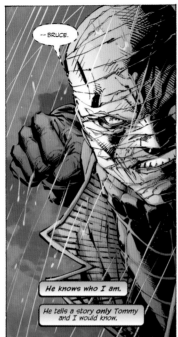

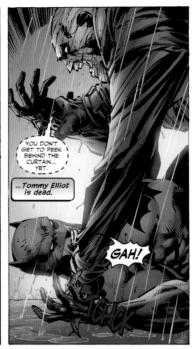

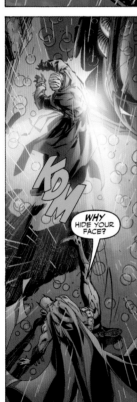

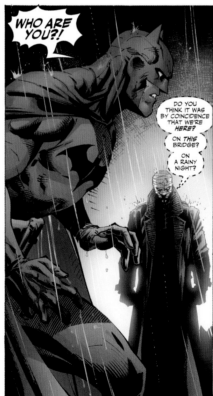

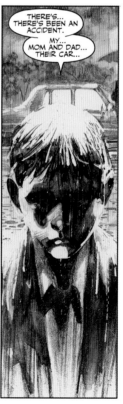

Batman #619, November 2003
Writer: Jeph Loeb *Artists:* Jim Lee & Scott Williams

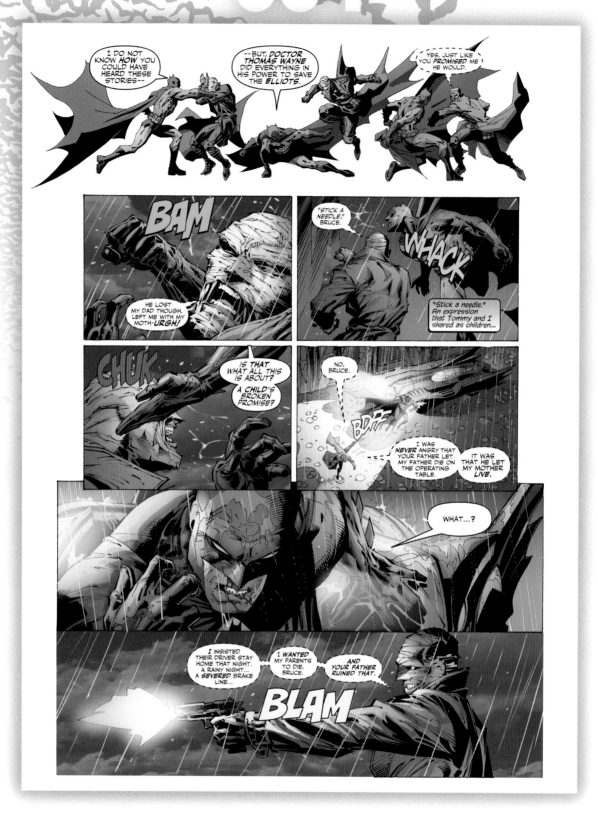

Batman #619, November 2003
Writer: Jeph Loeb *Artists:* Jim Lee & Scott Williams

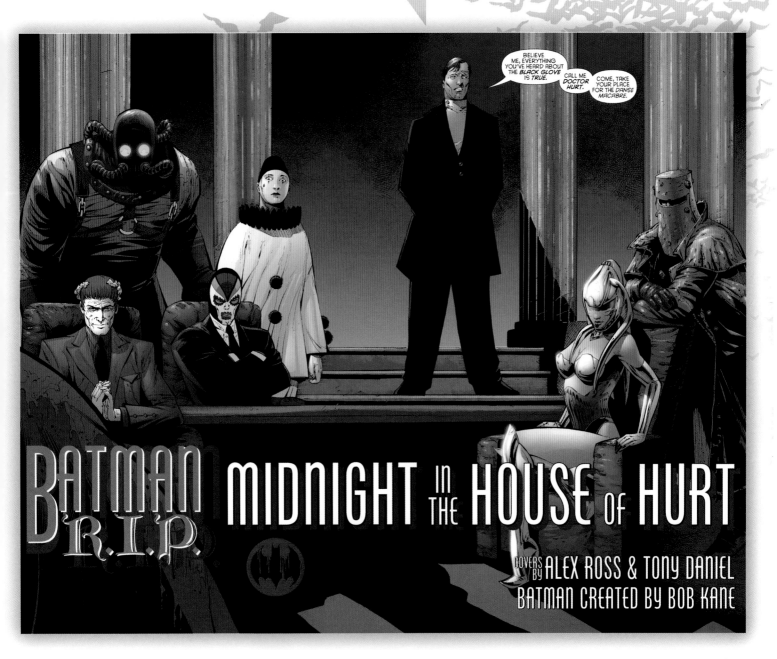

After forming the Black Glove to take down Batman, Doctor Hurt realizes he needs more help and creates the Club of Villains to counter the Dark Knight's Club of Heroes.

Batman #676, June 2008
Writer: Grant Morrison *Artists:* Tony Daniel & Sandu Florea

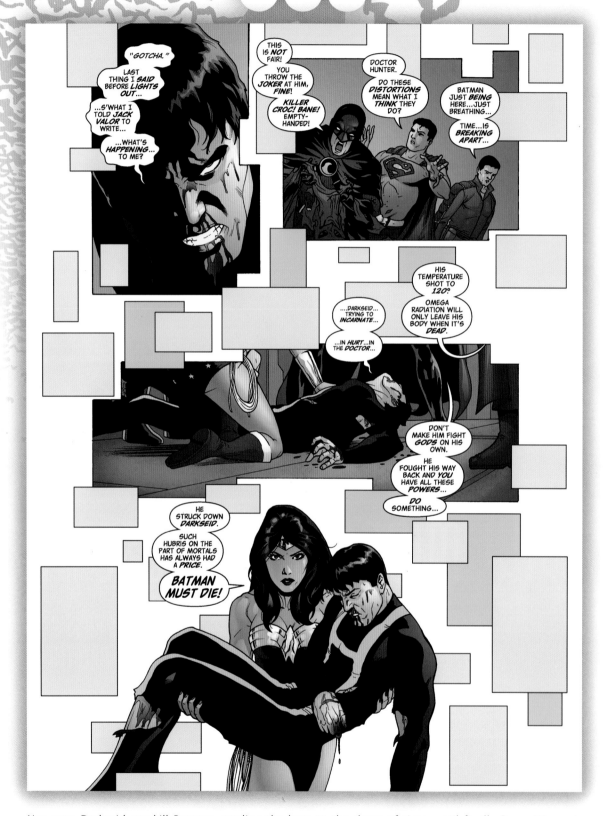

Not even Darkseid can kill Batman, sending the hero to the dawn of time, until finally Bruce Wayne is brought back to the present. True to form, he goes right back to work.

Batman: The Return of Bruce Wayne #6, December 2010
Writer: Grant Morrison *Artist:* Lee Garbett

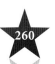

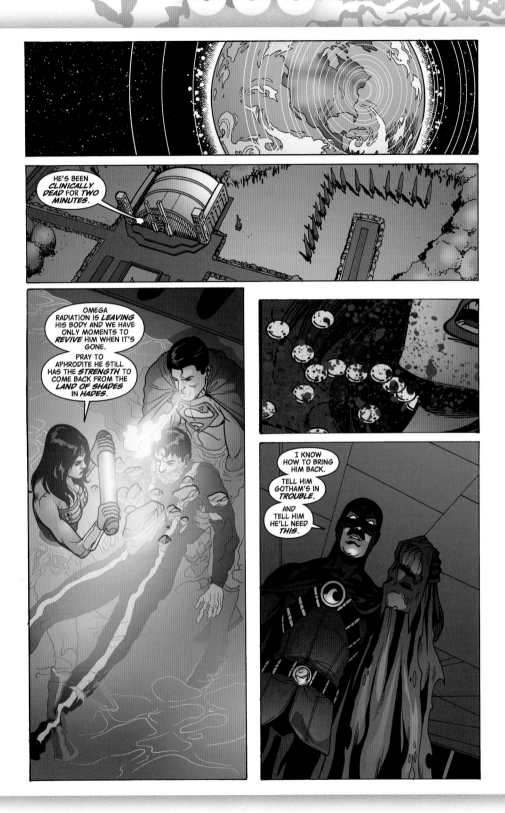

Batman: The Return of Bruce Wayne #6, December 2010
Writer: Grant Morrison *Artists:* Pere Perez & Lee Garbett

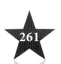

Batman: The Return of Bruce Wayne #6, December 2010
Writer: Grant Morrison Artists: Lee Garbett & Alejandro Sicat

Not every criminal event involves a person, such as this moment when an airliner is sabotaged and somehow the Batman has to stop it from crashing into Gotham—from the outside.

Batman #1, September 2016
Writer: Tom King *Artists:* David Finch & Matt Banning

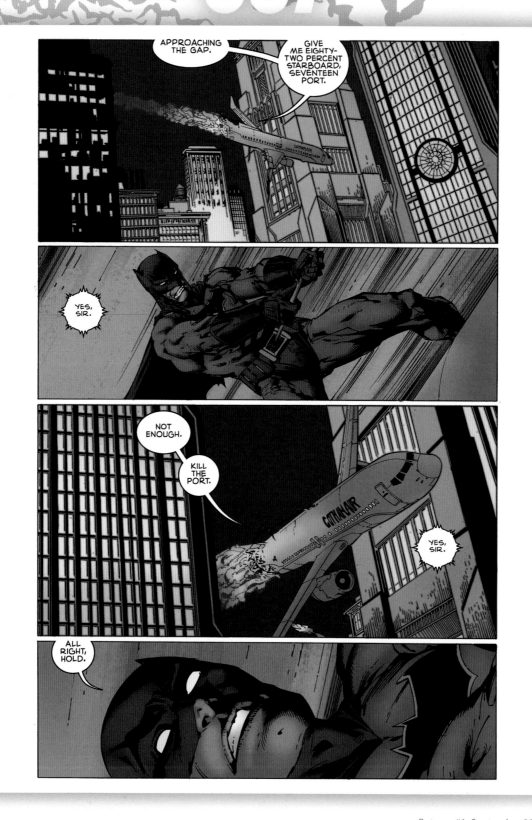

Batman #1, September 2016
Writer: Tom King *Artists:* David Finch & Matt Banning

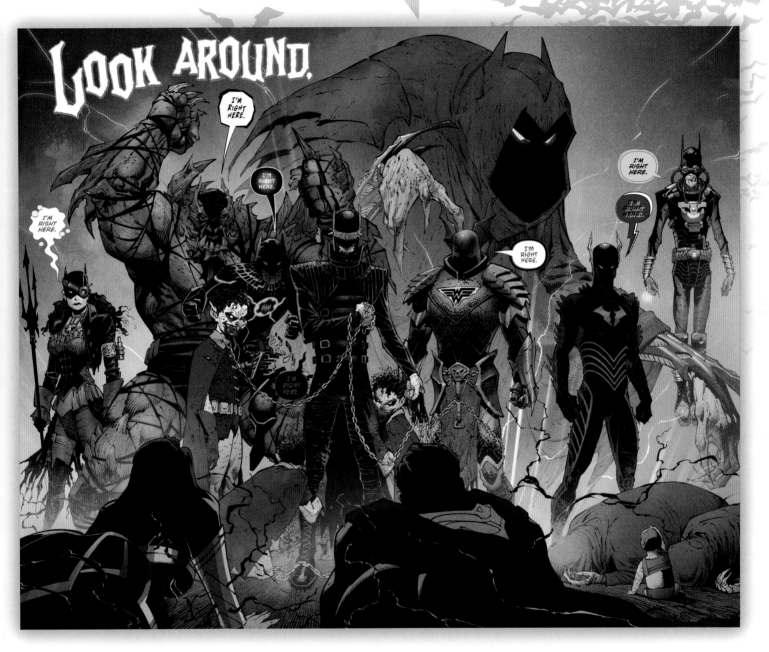

The Dark Multiverse is made of parallel worlds that never should have survived but did, each with their twisted version of Batman. The Nth metal breached the barrier and brought fresh nightmares to Prime Earth.

Dark Knights Metal #2, July 2017
Writer: Scott Snyder *Artists:* Greg Capullo & Jonathan Glapion

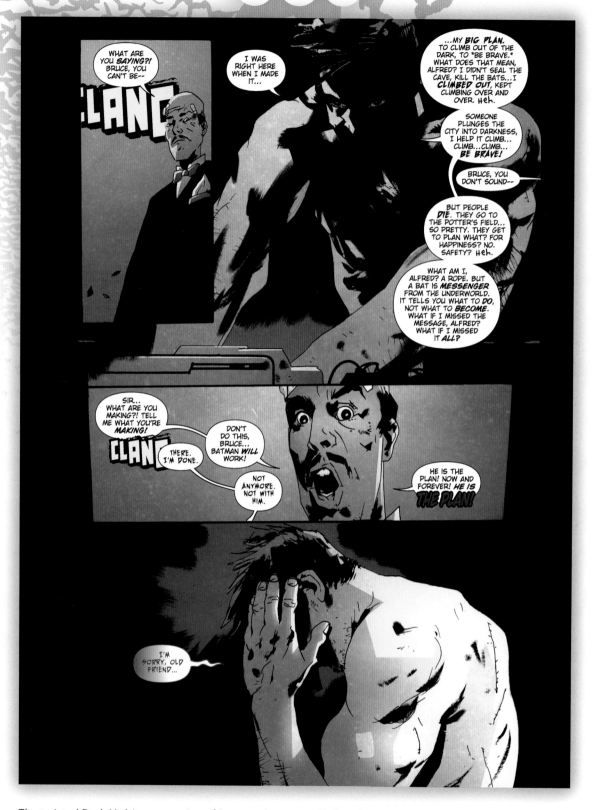

The twisted Dark Multiverse version of Batman threatens all of Gotham City, and the Prime Dark Knight sees little choice but to succumb to madness in order to stop him.

The Batman Who Laughs #3, April 2019
Writer: Scott Snyder *Artist:* Jock

The Batman Who Laughs #3, April 2019
Writer: Scott Snyder Artist: Jock

CHAPTER 6
OUT OF THIS WORLD

DC COMICS NEEDED TO CLEAN UP ITS ALREADY SQUEAKY-CLEAN ACT, TO STAY OUT OF THE ANTI-COMICS HYSTERIA WHIPPED UP IN THE LATE 1940S AND EARLY 1950S. AS PUBLISHERS FORMED THE COMICS MAGAZINE ASSOCIATION OF AMERICA AND ESTABLISHED THE COMICS CODE AUTHORITY, BATMAN'S COLORFUL ROGUES WERE QUICKLY SHUFFLED OFFSTAGE EXCEPT FOR THE JOKER.

Editor Jack Schiff increasingly pitched Batman against more common criminals and then took a cue from the 1950s' interest in science fiction. Batman suffered numerous transformations as well as numerous costume variations for the sake of specific stories. Then aliens came to Gotham or brought the Dynamic Duo to strange new worlds. Not many of these stories are truly memorable, but a few were done well enough to resonate with readers, some of whom went on to write comics.

In more modern times, some of those events were woven into the current continuity, keeping their essence if not all the details.

Similarly, contemporary creators began to explore what-if scenarios, beginning with Frank Miller's look at a fifty-five-year-old Bruce Wayne. Others explored different eras and places, all of which needed a creature of the night. Many of these have become beloved, award-winning tales.

a bit of a mystery. Batman's ancestor, Dr. Simon Hurt, captured him and, using past psychological trauma as a weapon, broke the hero's mind. But this was Grant Morrison's Batman, and the Scottish writer established that Batman was the single most prepared crime fighter in comics. He had learned from the past and prepared a backup personality to be triggered by the phrase "Zur-En-Arrh." This was young Bruce mishearing his father's comment on the night he died, "The sad thing is they'd probably throw someone like Zorro in Arkham."

The reconditioned Batman of Zur-En-Arrh was dangerously psychotic and out of control. He used a representation of the Fifth-Dimensional imp Bat-Mite to symbolize the last bits of his normal mind. In this form, he took down Hurt and his Black Glove cult, but the Joker got the best of him, burying him alive. There, his mind began to heal and his normal self regained dominance. Literally reborn from the earth, Batman was back to work.

90. BATMAN OF ZUR-EN-ARRH

Tlano was a scientist on the distant world of Zur-En-Arrh who discovered and studied Earth, fascinated by the Caped Crusader. He donned his own outfit, becoming the Batman of his world. When it was invaded by alien robots, Tlano summoned the real Batman for assistance. It was a fairly typical 1950s story, largely forgotten.

In the 2000s, the phrase Zur-En-Arrh began appearing across Gotham City. The graffiti showed up on walls or crime scenes and created

91. "ROBIN DIES AT DAWN"

The dramatic cover seared itself into the minds of readers when it arrived in 1963, just months before the New Look's arrival. The pose certainly proved influential to artist George Pérez, who used it for the cover of *Crisis on Infinite Earths* #7, as Superman held the corpse of his cousin Supergirl.

The story's first act was a hallucination induced when Batman experimented with a sensory deprivation tank. The trauma of Robin's death in

the fantasy had a profound effect on the Caped Crusader, who struggled with flashbacks once he was back in the real world. The idea of Batman losing Robin and being mentally incapacitated by the loss was a theme that would play out when the second Robin, Jason Todd, was killed, twenty years later.

Interestingly, the first story in the issue was a Robin versus Ant-Man story, and the cover feature explained where the hero was. Connecting the two was a rarity in its day, adding to the issue's overall luster.

Grant Morrison borrowed this story to form the core for his run on *Batman* and established that the doctor overseeing the experiment was his long-lived ancestor masquerading as Dr. Simon Hurt. Batman had agreed to the experiment to better understand the Joker's twisted psyche.

Later, in *Grayson* #5, Dick Grayson recounts the story's events as a dream he once had.

92. MARTIAN ATTACK

Batman and the Justice League were inextricably linked, and when the JLA re-formed at one point, it was proved how much they needed him. A new group arrived, calling themselves the Hyperclan, who were out to replace the heroes in the hearts and minds of the general public.

In short order, they destroyed the League's satellite headquarters and killed Metamorpho. They also unleashed a disease that incapacitated fire-based metahumans such as Firehawk. Then, using their powerful psychic abilities, they made most of mankind begin to see the JLA as the enemy.

Batman, ever observant, saw that something was suspicious about these heroes who'd just shown up out of nowhere. They believed he perished in the crash of the Batplane and put him out of their minds. To them, he was a human and not worthy of worry. Of course, this was the World's Greatest Detective, and he put together enough clues to expose them as disguised White Martians.

The White Martians had visited Earth millennia earlier and experimented on the humans they found and learned of the metagene. Since then, they had been wary of man's place in the cosmic order and over time had tried to control or destroy that destiny. In this case, they were captured by the World's Greatest Super Heroes. The Martian Manhunter and Aquaman combined their telepathic abilities to alter the Hyperclan's memories, making them believe they were ordinary humans. Scattered around the globe, they resumed manufactured lives, under constant League surveillance.

93. DARKSEID: "GOTCHA"

Ages of gods have their natural spans, and as one age of gods ends, so begins the next age. The worlds New Genesis and Apokolips, with their attendant New Gods, represent the Fourth World. But within this era, the cycle of death and rebirth continues with great frequency. During one such cycle, known as the Final Crisis, Darkseid sought to use his most recent "death" to create a singularity

at the heart of creation, and the end result was all of space-time being drawn into it.

Firing a radion bullet through time, Darkseid finally killed his son Orion, prompting an investigation by Batman and Green Lantern. When the Dark Knight realized that Hal Jordan's fellow Green Lantern Kraken was actually a disguised Granny Goodness, he was teleported to the government's Command D, a biochemical facility underneath Blüdhaven.

As the depth of the problem became known, Alan Scott, the first Green Lantern, activated Article X, summoning the world's super heroes to rally as one. As the heroes fought Darkseid and his minions, with more of the universe increasingly endangered, Batman escaped confinement and retrieved the radion bullet. Stalking Darkseid, he loaded a rifle and took aim. The New God asked him to step out of the shadows and Batman did, saying, "Gotcha," and fired. While the bullet struck Darkseid, giving him a mortal wound, he unleashed the Omega Sanction, putting one final gambit into play. Batman was struck and seemingly killed, only to be hurtled through time, absorbing chronal energies to eventually wipe out reality.

94. BATMAN: A NEW GOD

One of Batman's greatest weapons in his fight against crime is his vast arsenal of intelligence. At one point, when Darkseid and the Anti-Monitor from Earth-3 came to blows, Batman was given access to the New God Metron's Mobius Chair. Stuck in place, Batman went from being the Caped Crusader to the God of Knowledge. Using the chair, he returned to Gotham, where he could now access the minds of its citizens, and began prophylactically preventing crimes. The problem was, though, that preventing a crime also prohibited Commissioner Gordon from following protocol. No crime, no evidence, no trial, no verdict. It put the allies at odds with each other.

He also used the chair to finally learn of his parents' killer, filing away the name Joe Chill for further use. He then asked it to tell him the Joker's real name, hoping to solve another nagging mystery.

But as Batman told Hal Jordan, rather than revealing one name, the chair told him there were three Jokers, launching a mystery that remains unresolved.

It took a great deal of effort, but Jordan helped Batman free himself from the chair, which was then taken by the Crime Syndicate's Owlman and Grid. With Metron in tow, they traveled to the moon, where a mysterious force killed them, leaving the chair empty. That turned out to be Dr. Manhattan from a parallel universe, who had come to Prime Earth and had already stolen five years from the heroes for reasons unexplained.

Batman regretted losing access to all that knowledge but preferred having his physical freedom, along with the ability to use his natural skills to solve crimes.

95. BATMAN'S DEATH

The first multiverse was a series of countless parallel realities that remained largely ignorant of one another until the Earth-1 Flash accidentally achieved the precise vibrational frequency that enabled him to materialize on Earth-2. This enabled the Flash of Two Worlds to team up, opening the doorway for further interaction between the worlds.

The heroes of Earth-2 emerged earlier, operating together at the Justice Society of America and All-Star Squadron. Most aged slowly thanks to an interaction with a being called Ian Karkull, but age they did. When the House Un-American Activities Committee asked the heroes to unmask to prove their patriotism in the 1950s, JSA chairman Hawkman refused and the age of heroes ended. During this period, Batman and Catwoman admitted their love for each other, hung up their capes, and married. They had a daughter, Helena, and were happy for a time.

A criminal coerced Selina Kyle to resume her costumed identity one more time, which resulted in both her death and Helena becoming the Huntress to avenge her. She then joined the JSA, while Wayne succeeded James Gordon as Gotham's police commissioner.

When petty criminal Bill Jensen accidentally gained powers, Wayne was forced to resume his Batman persona one final time. Both men died in the confrontation, although countless lives were saved in the process.

Batman and Commissioner Wayne were mourned by a grateful Gotham City, while the heroes of multiple worlds mourned the passing of the first Caped Crusader.

96. "TO KILL A LEGEND"

In the beginning was the pitch.

"Paul Levitz, a friend from comics fandom, had just become editor of the Batman titles when we had dinner together in L.A. in 1980," writer Alan Brennert told Comic Book Resources. "I'd been writing TV for two years, but still read the occasional comic book, and I floated an idea for a Batman story—what if Batman travels to a parallel world where Thomas and Martha Wayne are about to be murdered, and he has the chance to save them?—which Paul liked. I offered to give it to one of his Batman writers, but he asked me to write it myself, and though I hadn't written a comic script since . . . ten years before, I said, sure. Paul liked the script, and I assumed it would turn up as a fill-in issue of *Batman* or *Detective Comics*. I never dreamed it would become the lead story in *Detective* #500. Or that it would be reprinted in that year's *Best of DC* digest, and later in *The Greatest Batman Stories Ever Told*. Readers and professionals alike really responded to the story to a degree I hadn't anticipated." It was also included in 2019's *Detective Comics: 80 Years of Batman Deluxe Edition*.

It certainly helped that it was illustrated by former Batman editor and longtime artist Dick Giordano.

97. LEADING THE MUTANT ATTACK

In a possible future when a fifty-five-year-old Bruce Wayne has been out of uniform for a decade, things in Gotham City have only gotten worse. Crime is more prevalent than ever, and a teen gang, called the Mutants, runs rampant. When a fresh and even

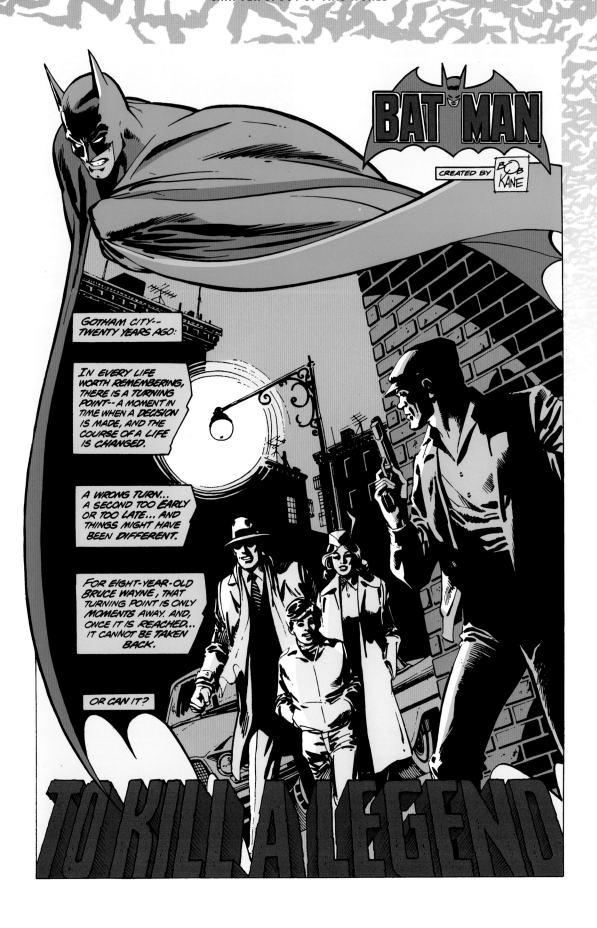

worse crime wave washes over the city, Wayne realizes he has little choice but to open the Batcave and put the uniform back on. However, his reflexes and strength aren't what they once were, so he arms himself with the most powerful Batmobile yet, a virtual tank. His uniform is augmented with armor-like pieces, his utility belt a virtual arsenal. Still, he's seriously outmatched.

Batman tracks down the Mutants and challenges their hulking leader to a battle. The fight is brutal and decisive, forcing the youth gang to disperse. Many, though, are inspired by the returned Dark Knight and style themselves after him, down to blue bat-shaped tattoos on their faces. Calling themselves the Sons of Batman, they take it upon themselves to patrol the city and help

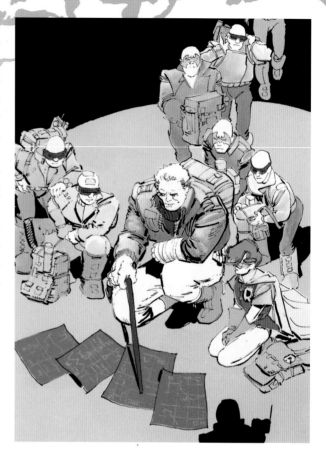

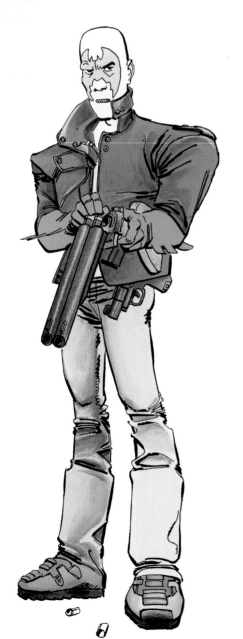

restore order, although they are little better than their criminal incarnation.

In time, Batman and his newfound Robin decide to take them under their wings and train them. When an electromagnetic pulse blacks out Gotham City, chaos reigns. To restore order and prevent further looting and damage, a Dark Knight on horseback leads a charge of former Mutants into the fray.

After faking his death, Batman goes underground and continues to train and lead his "sons."

98. THE DARK KNIGHT VERSUS JACK THE RIPPER

Brian Augustyn had been on the DC Comics editorial staff for several years before he began pitching story ideas. All it took was one idea to make a permanent mark on the company and on Batman.

"Well, it was a book that no one saw coming, including those of us involved in it," he told Bleeding Cool News. "It was also a genre that didn't really exist

until then either. It started as a casual idea for a *Secret Origins—Alternate Origins* special, edited then by my pal Mark Waid—and it spontaneously exploded from there. Before anyone saw it coming the enormously talented Mike Mignola was drawing it, the equally stellar P. Craig Russell was inking it and we were a stand-alone graphic novel in Prestige Format!"

The pitch was a turn-of-the-century Gotham City and its version of Jack the Ripper, resulting in a Victorian-era Dark Knight rising to the challenge.

"*Gotham by Gaslight* is probably my single most remembered work, and that's great by me—I remain very proud of it," Augustyn said. "That first book went on to sell more than 500,000 copies and its sequel (*Batman: Master of the Future*) sold close to 200,000—so the impact is pretty huge overall, I'd say. It led to many similar alternate looks at many DC characters and became its own long-running genre—quickly known as Elseworlds."

Not only did the story provide fertile ground for what became the Elseworlds imprint, but it has spawned tie-in toys and an animated feature film adaptation.

99. "HELLO, BILLY"

There came a day when the Justice League of America stepped out of the spotlight and the void was filled by Magog, a hero with no qualms about killing the guilty. He was followed by a new generation of heroes and villains, who battled with enough frequency to frighten the common man. When Magog fought the Parasite, things got out of control and the Midwest was nearly annihilated, disrupting the food chain. This prompted Wonder Woman to coax Superman, mourning Lois Lane's death, back to the good fight.

He agreed and re-formed the Justice League, but Batman refused, blaming Superman for letting things spiral out of control for the last decade. At some point in that period, Batman's identity had been exposed, prompting Two-Face and Bane to destroy Wayne Manor. His activities and injuries also required him to permanently wear an exoskeleton.

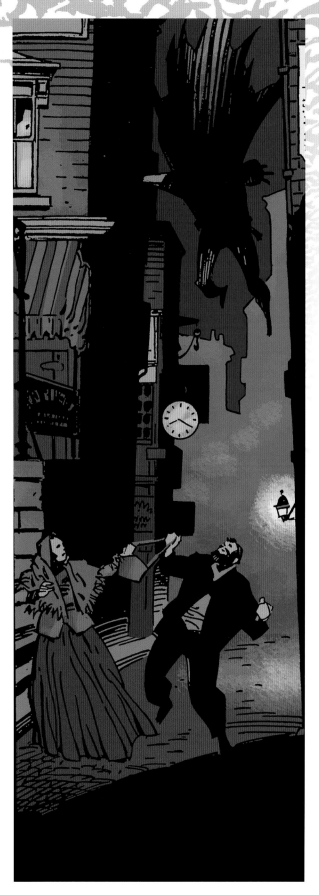

Instead of joining the Justice League, he activated his "Outsiders," hand-selected veterans and second-generation heroes, while his robotic Bat-Knights protected Gotham City.

Rising in opposition was Lex Luthor's Mankind Liberation Front, with Luthor's bodyguard a menacing figure. Wayne didn't trust the League or the MLF but seemingly allied with Luthor to stop Superman's team, preferring to let man decide his own destiny. It also didn't take much work for Wayne to determine that the bodyguard was an adult Billy Batson, somehow under Luthor's thrall. He exposed the secret, prompting Batson to say the magic word and transform into Captain Marvel, to oppose Superman.

In the end, the threat to mankind was ended, thanks to Captain Marvel's sacrifice. Wayne decided

to switch from guardian to healer, rebuilding the manor as a rehabilitation center. He also reconciled with both Dick Grayson (that reality's Red Robin) and his son with Talia, Ibn al Xu'ffasch.

100. BATMAN "MEETS" THOMAS WAYNE

As one of the seven acknowledged crises to reorder the multiverse, Flashpoint may have caused the greatest number of changes to the residents of Earth. For example, in that reality, Thomas and Martha Wayne survived the robbery that went wrong, resulting in the death of their son Bruce. Thomas grew bitter and fought crime as the costumed Batman. Martha couldn't handle the grief and went mad, becoming that reality's Joker.

Thomas Wayne's focus has been solely on Gotham, funding his war on crime through his successful casino business, managed by Oswald Chesterfield Cobblepot, the Penguin. This Gotham police force has been privatized, run by James Gordon, who knows Wayne's true identity.

Wayne was unaware of this world that couldn't be when Barry Allen, the Flash from New Earth, arrived and explained that things were out of whack. Wayne was ready to sacrifice himself if it meant his son could live. Of course, it wouldn't be easy and required that he help Allen rebuild a device that would recreate the chemical accident that granted Allen access to the Speed Force.

In the end, Thomas Wayne was wounded by the Enchantress but managed to give a letter to the Flash, knowing the speedster would restore reality as it should be. The Flash did manage to create the New 52 reality, not restore the previous one, but it was close enough. He handed the letter to Batman, telling his colleague that Thomas had helped restore reality. Batman read the letter in silence.

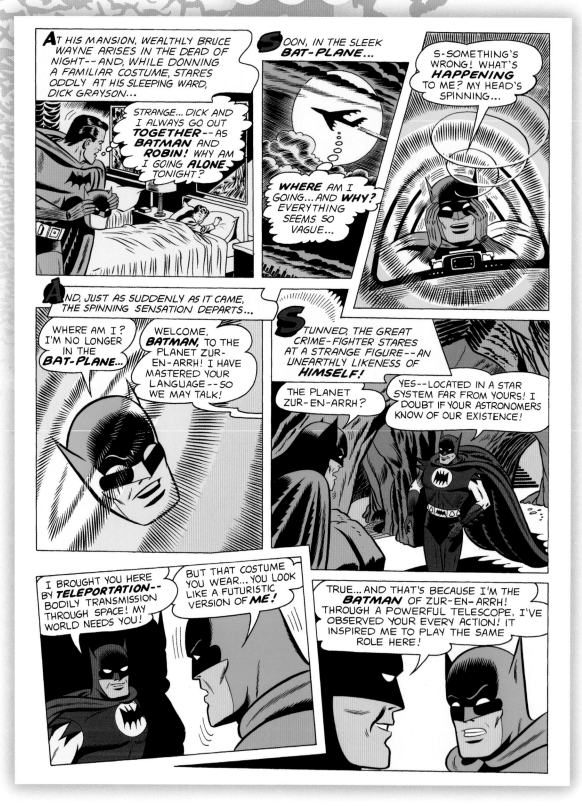

Batman is transported to the planet Zur-En-Arrh to help a robotic crime fighter on a case, a story that would become important fifty years later.

Batman #113, February 1958
Writer: Ed Herron *Artists:* Dick Sprang & Charles Paris

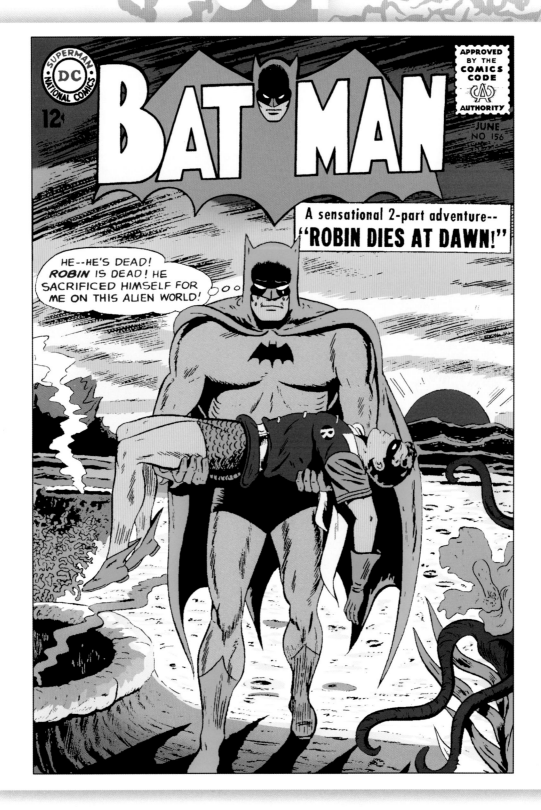

While it may have been a nightmare to Batman, this cover and story proved one of the memorable high points of Batman's 1960s exploits.

Batman #156, June 1963
Artists: Sheldon Moldoff & Charles Paris

Batman #156, June 1963
Writer: Bill Finger *Artists:* Sheldon Moldoff & Charles Paris

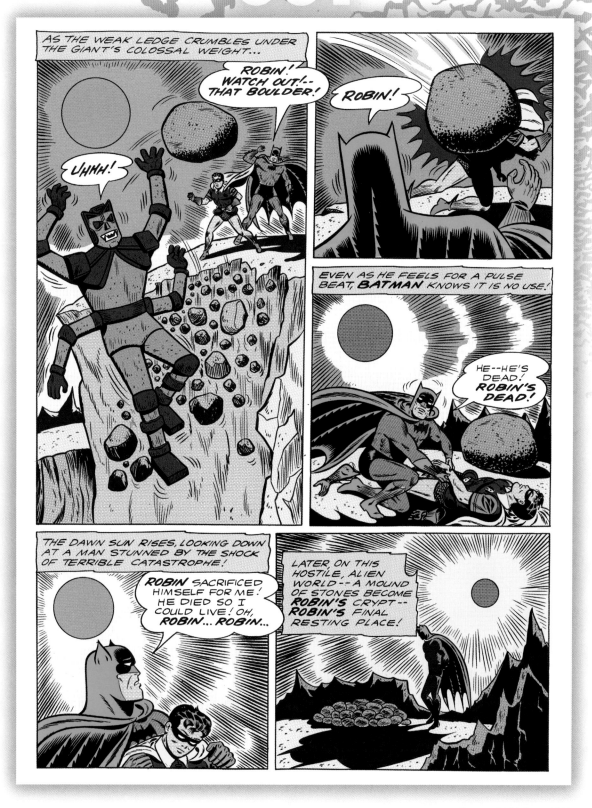

Batman #156, June 1963
Writer: Bill Finger Artists: Sheldon Moldoff & Charles Paris

Batman proves himself not only the World's Greatest Detective, but also the most prepared super hero of all time. Here, he discovers the White Martians' insidious plan to conquer the world.

JLA #3, March 1997
Writer: Grant Morrison *Artists:* Howard Porter & John Dell

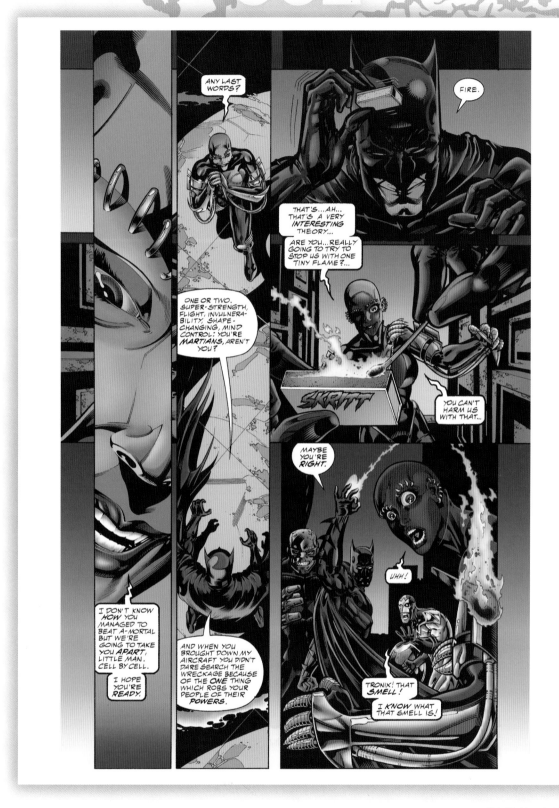

JLA #3, March 1997
Writer: Grant Morrison *Artists:* Howard Porter & John Dell

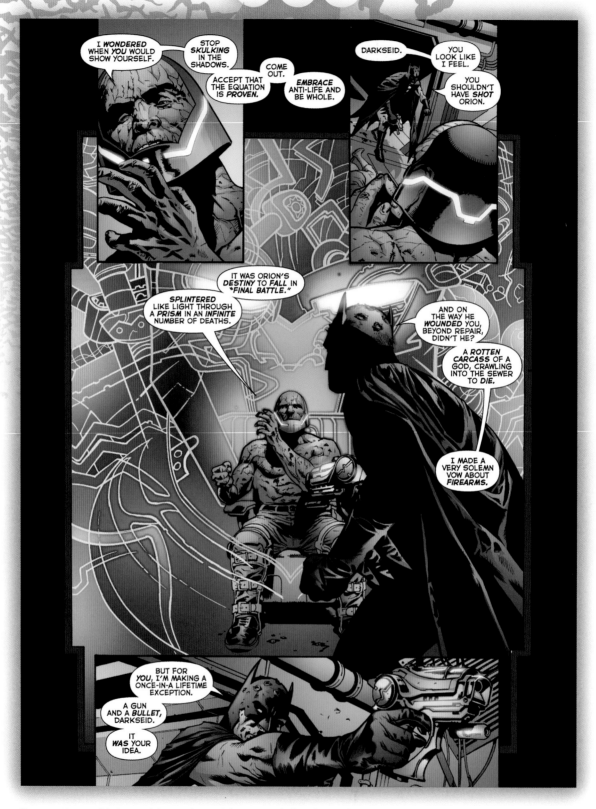

Batman is not frightened by gods, and here, amid the chaos, he stealthily prepares and fires a hopefully killing shot at Darkseid. In return, the would-be conqueror seemingly kills Batman.

Final Crisis #6, January 2009
Writer: Grant Morrison *Artists:* J. G. Jones, Carlos Pacheco, Doug Mahnke, Marco Rudy, Christian Alamy, Jesús Merino & Marco Rudy

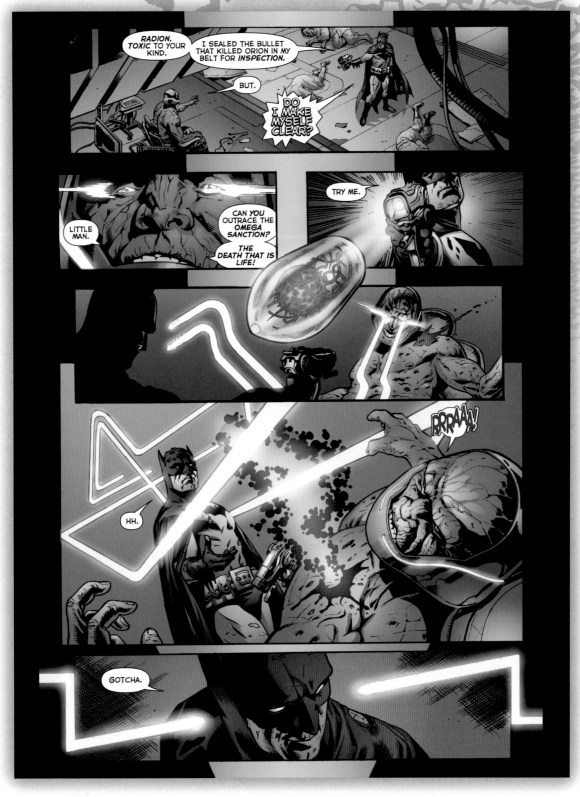

Final Crisis #6, January 2009
Writer: Grant Morrison *Artists:* J. G. Jones, Carlos Pacheco, Doug Mahnke,
Marco Rudy, Christian Alamy, Jesús Merino & Marco Rudy

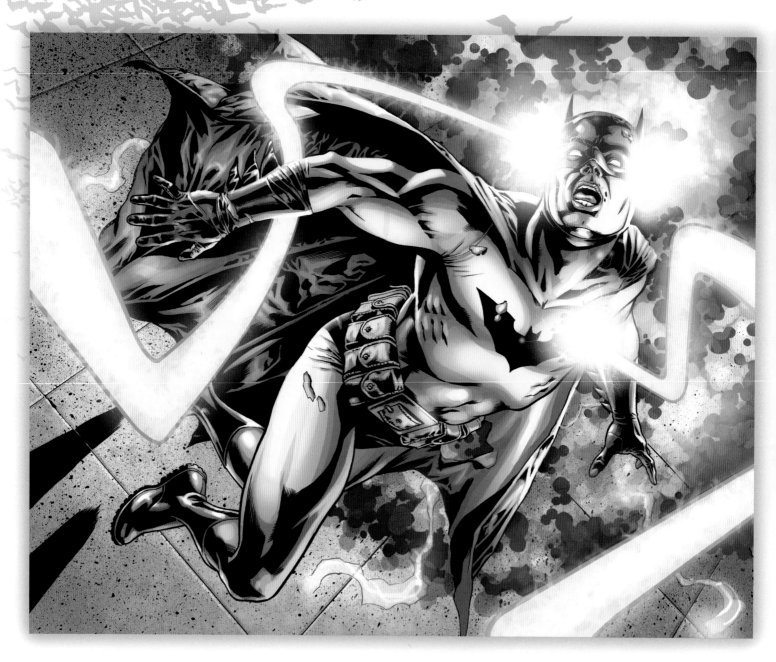

Final Crisis #6, January 2009
Writer: Grant Morrison *Artists:* J. G. Jones, Carlos Pacheco, Doug Mahnke,
Marco Rudy, Christian Alamy, Jesús Merino & Marco Rudy

When Batman gains access to Metron's Mobius Chair, it latches on to him, transforming the crime fighter into an all-knowing New God, able to foresee and stop crime—but at what price?

Justice League #42, September 2015
Writer: Geoff Johns *Artist:* Jason Fabok

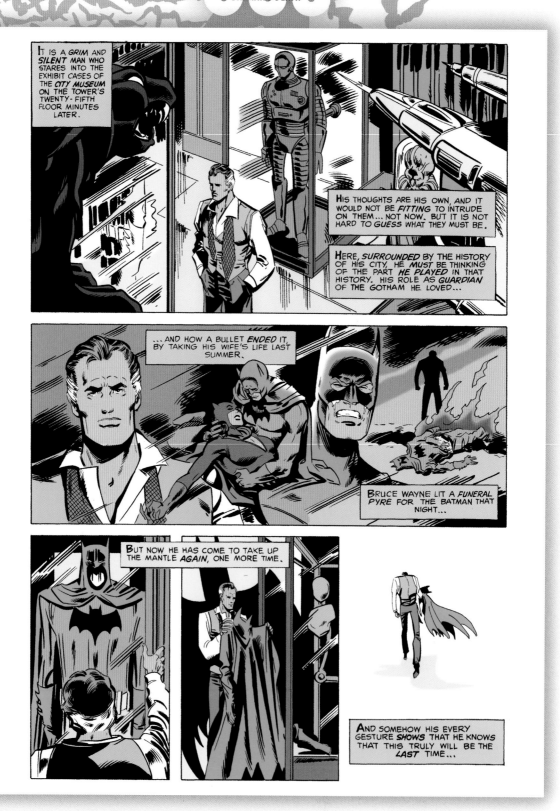

The Earth-2 Batman could never restfully retire and once more donned the cape and cowl to protect the innocent. This time, though, he paid the ultimate price.

Adventure Comics #462, April 1979
Writer: Paul Levitz *Artists:* Joe Staton & Dick Giordano

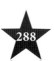

Adventure Comics #462, April 1979
Writer: Paul Levitz *Artists:* Joe Staton & Dick Giordano

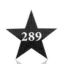

The Phantom Stranger shows Batman a world where his parents were not gunned down, but circumstances show that every world may need a Batman.

Detective Comics #500, March 1981
Writer: Alan Brennert *Artist:* Dick Giordano

Detective Comics #500, March 1981
Writer: Alan Brennert *Artist:* Dick Giordano

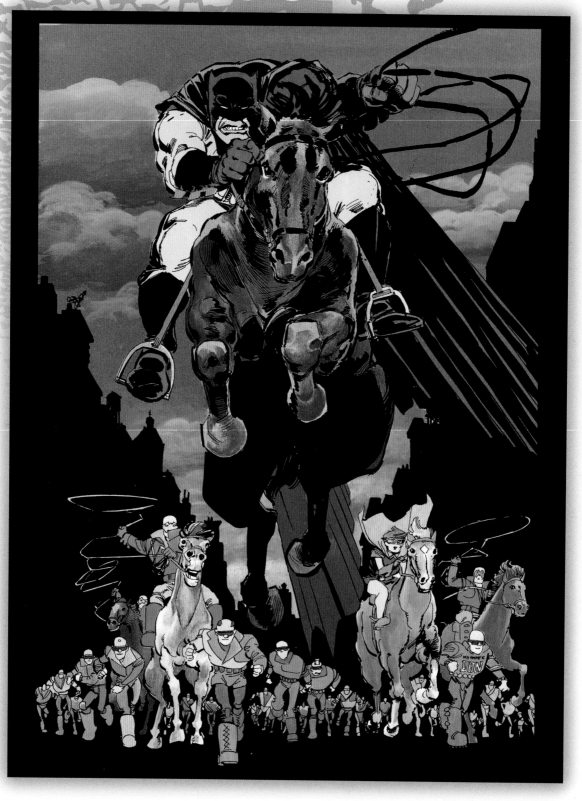

Batman has rallied an underground mutant population to join him in saving Gotham City from fascist threats, including the Joker's final gambit.

Batman: The Dark Knight #4, December 1986
Writer/Penciller: Frank Miller *Inkers:* Frank Miller & Klaus Janson

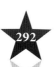

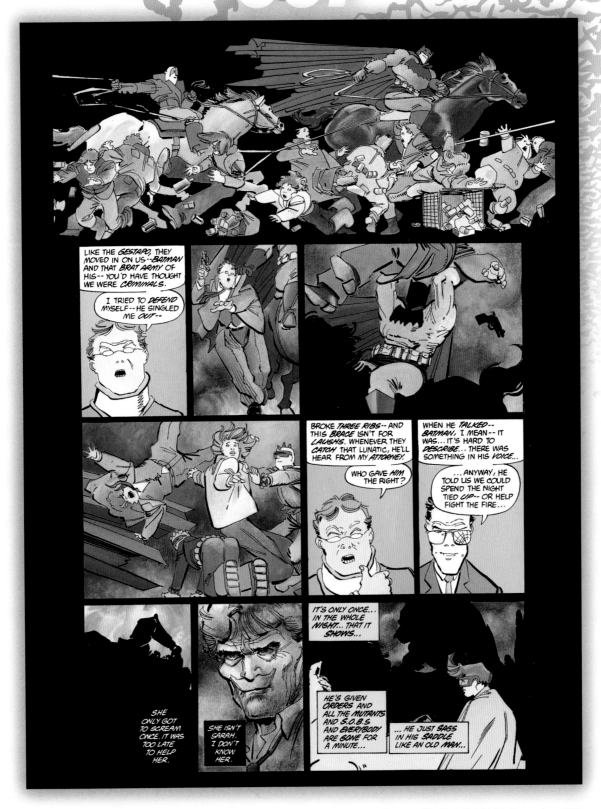

Batman: The Dark Knight #4, December 1986
Writer/Penciller: Frank Miller *Inkers:* Frank Miller & Klaus Janson

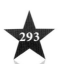

In a forerunner to the Elseworlds imprint, this fanciful story reimagines Bruce Wayne, Alfred, James Gordon, and others in a Victorian-era Gotham, complete with its own serial killer.

Batman: Gotham by Gaslight, September 1989
Writer: Brian Augustyn *Artists:* Mike Mignola & P. Craig Russell

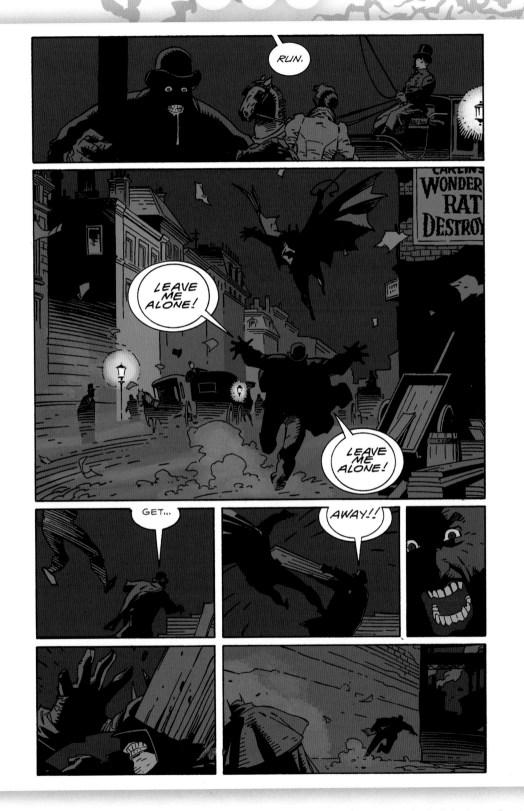

Batman: Gotham by Gaslight, September 1989
Writer: Brian Augustyn *Artists:* Mike Mignola & P. Craig Russell

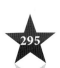

Batman: Gotham by Gaslight, September 1989
Writer: Brian Augustyn Artists: Mike Mignola & P. Craig Russell

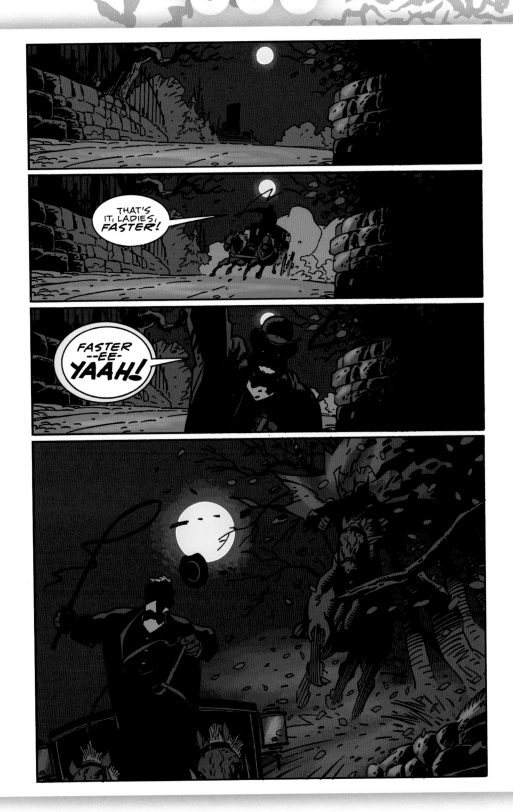

Batman: Gotham by Gaslight, September 1989
Writer: Brian Augustyn *Artists:* Mike Mignola & P. Craig Russell

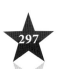

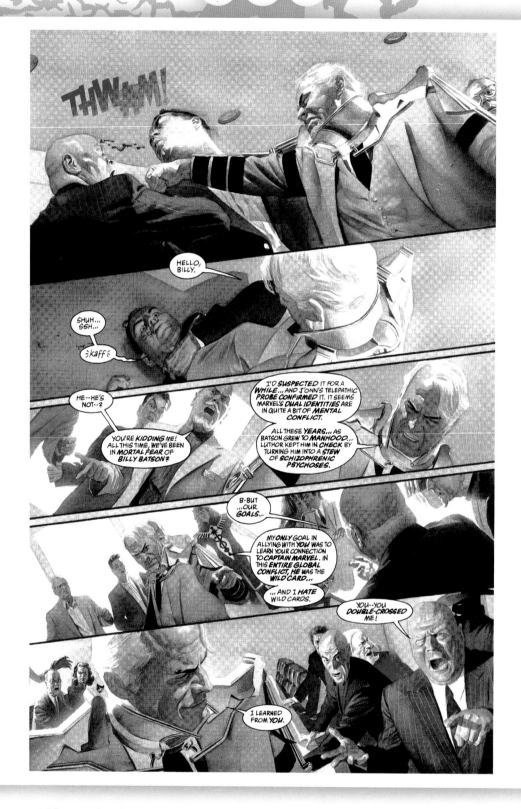

In a potential future, a handicapped Bruce Wayne has been working from the shadows to keep people safe but emerges to confront Lex Luthor's cabal and his personal protector, an adult Billy Batson.

Kingdom Come #3, July 1996
Writer: Mark Waid *Artist:* Alex Ross

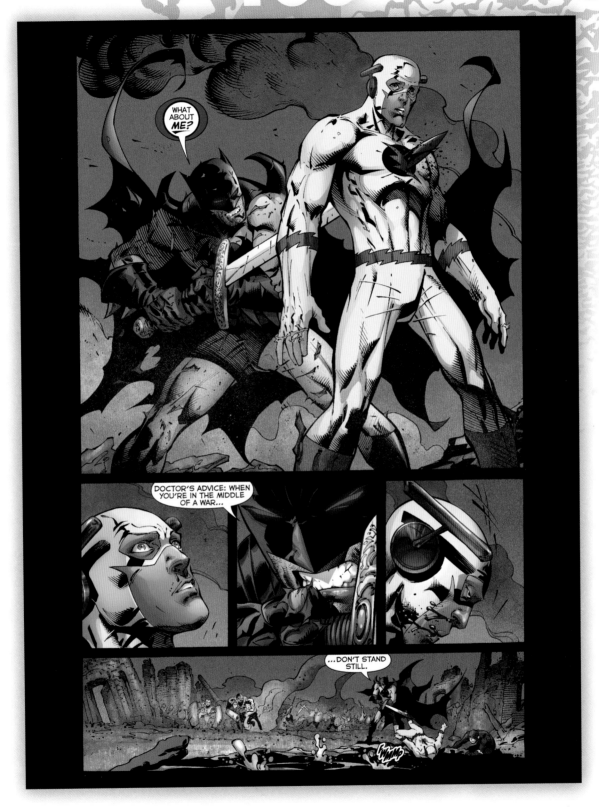

In a world that wasn't meant to be, Thomas Wayne became a vicious Batman, but after helping the Flash put reality back on course, he left a note for his adult son.

Flashpoint #5, October 2011
Writer: Geoff Johns *Artists:* Adam Kubert, Sandra Hope & Jesse Delperdang

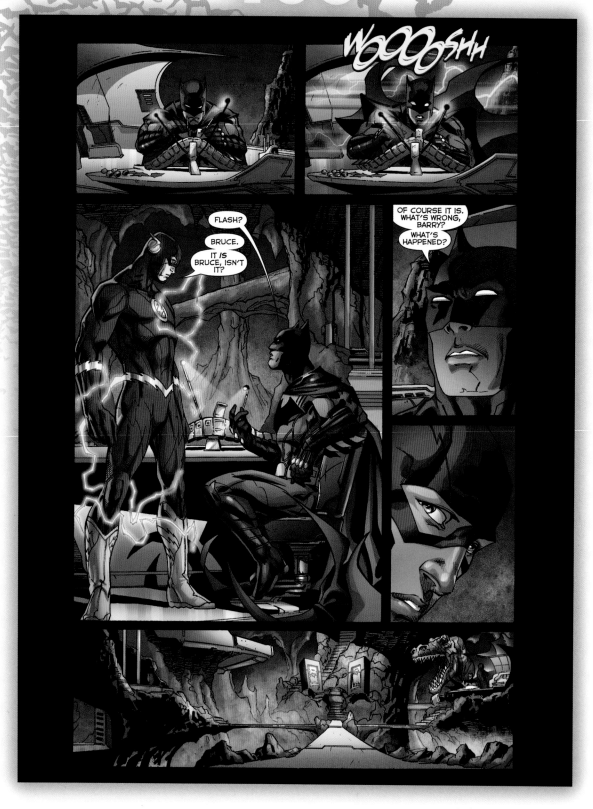

Flashpoint #5, October 2011
Writer: Geoff Johns *Artists:* Adam Kubert, Sandra Hope & Jesse Delperdang

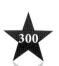

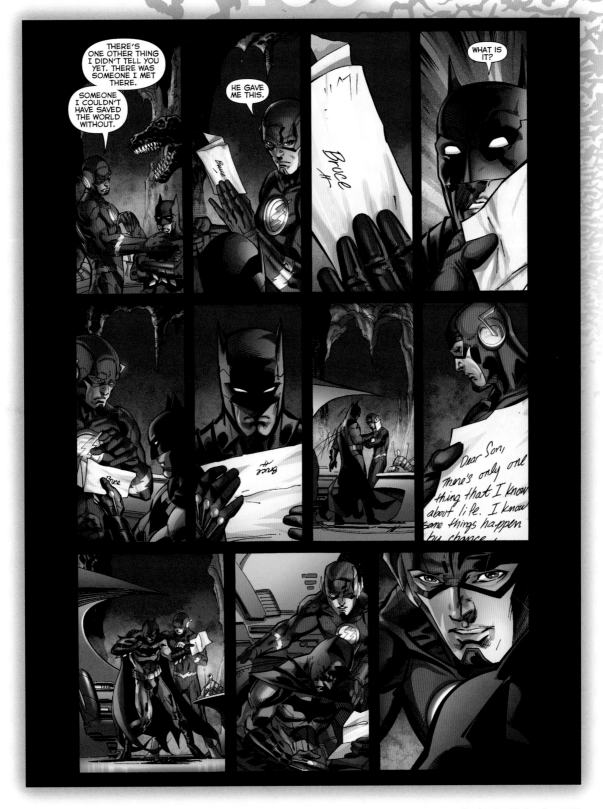

Flashpoint #5, October 2011
Writer: Geoff Johns *Artists:* Adam Kubert, Sandra Hope & Jesse Delperdang

Flashpoint #5, October 2011
Writer: Geoff Johns *Artists:* Adam Kubert, Sandra Hope & Jesse Delperdang

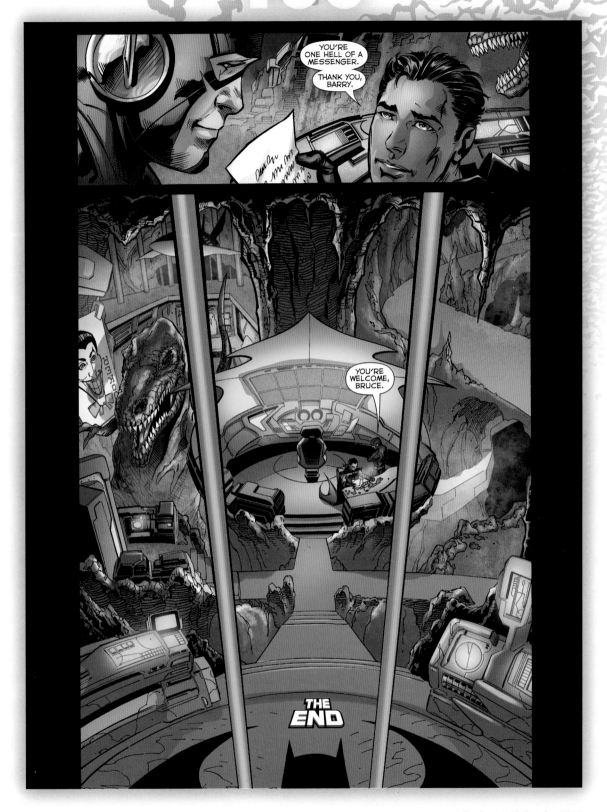

Flashpoint #5, October 2011
Writer: Geoff Johns *Artists:* Adam Kubert, Sandra Hope & Jesse Delperdang

A BATMAN FOR ALL SEASONS

He is an avenging creature of the night when society needs a force for justice. He's a friend and ally who protects America's interests and promotes the general welfare. He's the always alert, always prepared hero, ready to do whatever it takes to keep people safe.

Writers and artists have been telling his stories for eight decades, with no letup in sight. Batman remains a powerful figure to identify with, showing readers what training and diligence can accomplish. Readers enjoy his current monthly adventures while reveling in the nostalgia generated by the 1960s television series or the various animated incarnations. He has continued to battle evil wherever it is found, including the realms of novels, video games, and the big screen.

He was one of the first and greatest of the super heroes and has brought out the very best in his creators. So powerful is his origin, so pure his mission, that as long as there are superstitious cowardly criminals, there will be a caped and cowled figure ready to strike fear in their hearts before bringing them to justice.

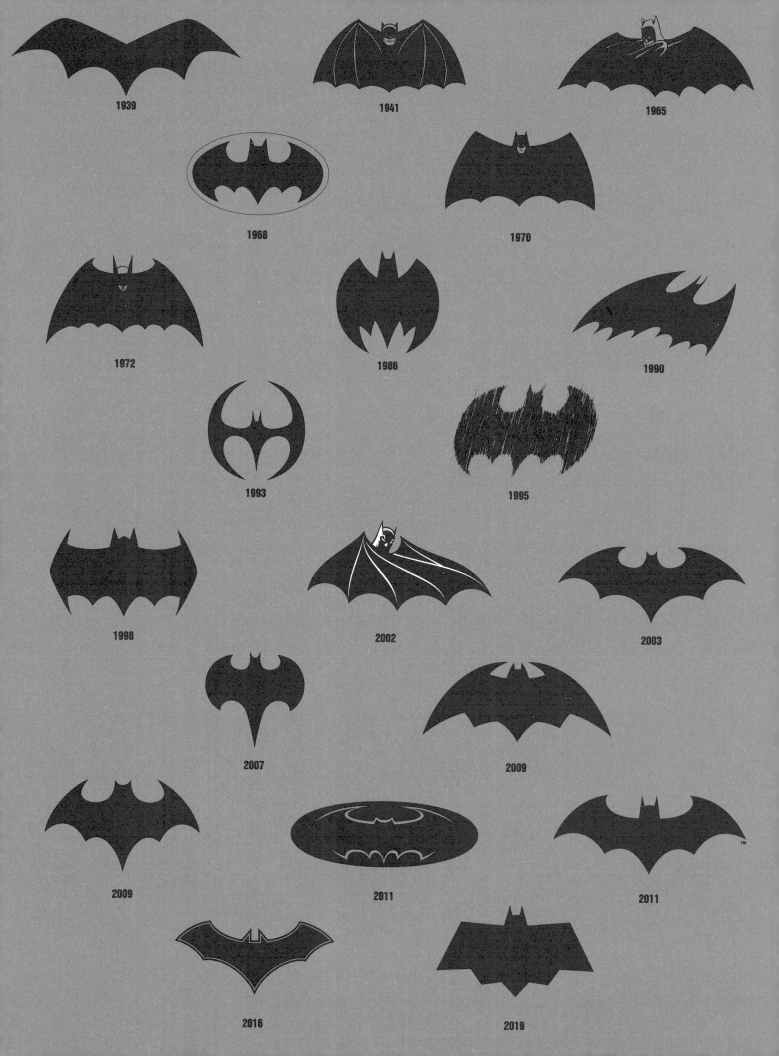

1939

1941

1965

1968

1970

1972

1986

1990

1993

1995

1998

2002

2003

2007

2009

2009

2011

2011

2016

2019